BERYL COOK

THE BUMPER EDITION

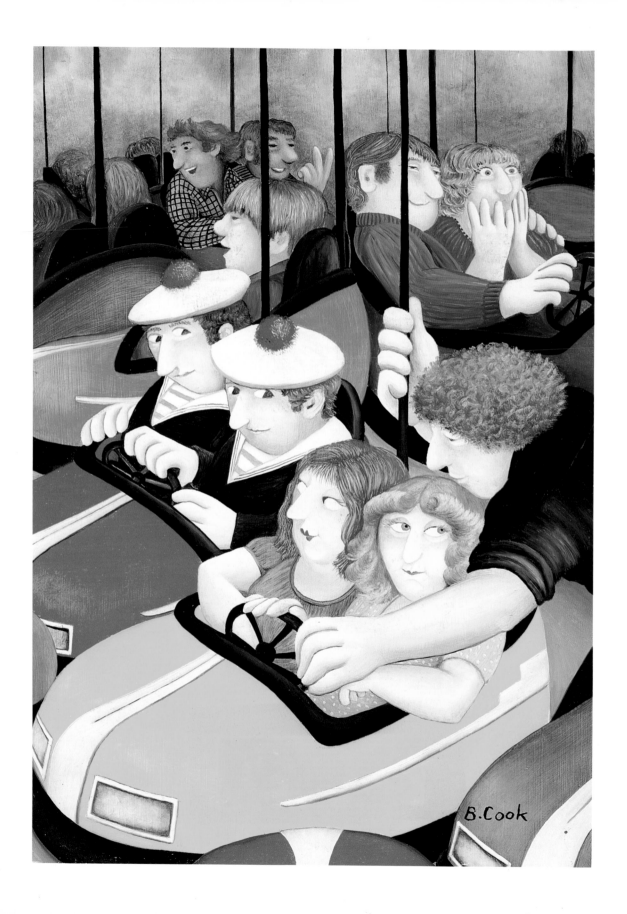

B.Cook

BERYL COOK

THE BUMPER EDITION

Edited by

Joe Whitlock Blundell

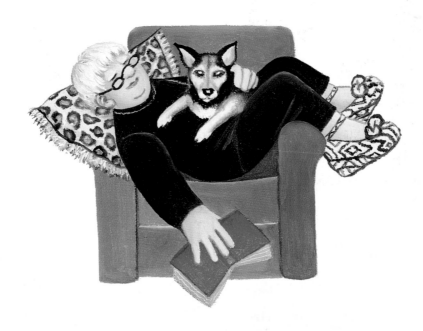

Weidenfeld & Nicolson
LONDON

Bumper Cars

(frontispiece)

I love watching the people at funfairs. I saw these two
French sailors walking with their girlfriends and soon after-
wards squeezing them into one of these bumper cars, which
were much admired by me for their spotless condition and
bright colours. This is one of the very few paintings I have
liked as soon as I had finished it, possibly because I found
it easy to both draw and paint.

First published in Great Britain in 2000 by
Victor Gollancz

This paperback edition published in 2001 by
Weidenfeld & Nicolson

Copyright © 2000 Beryl Cook
Introduction copyright © 2000 Joe Whitlock Blundell

The Orion Publishing Group
Orion House, 5 Upper St Martin's Lane,
London WC2H 9EA

A CIP catalogue record for this book
is available from the British Library

ISBN 0297 607847

Printed and bound in Italy by Printer Trento S.r.l.

Contents

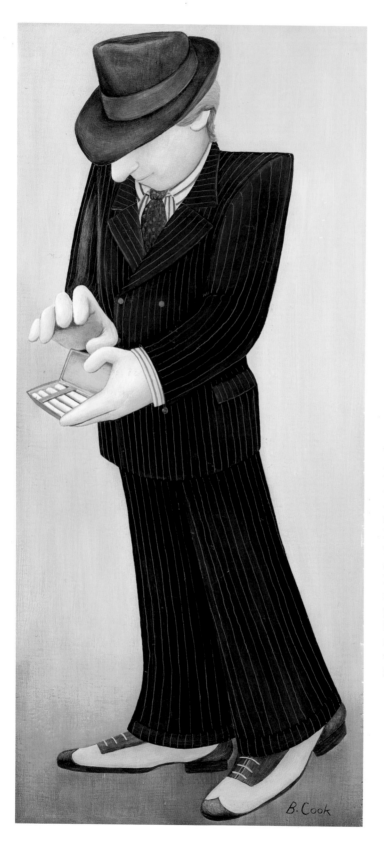

B. Cook

Joe's Shoes

Here is Joe wearing one of his favourite outfits. I was not fortunate enough to see the shoes for he liked them so much he wore them out, but I liked the sound of them so much I decided to paint them anyway. I'm always interested in fashions as they come and go, particularly shoes, and am very indignant when I can't persuade my daughter-in-law Teresa to wear the bargains I purchase from junk shops.

BERYL COOK – *A Personal Memoir*

I first met Beryl in a pub. Not very surprising, you might think, but what did surprise me was that she and John stayed for no more than fifteen minutes, drank a rapid half-pint and were gone. In this short time I learned one important thing about Beryl: she is not plump and extrovert, the life and soul of the party – the popular image arising from her paintings. On the contrary, she is quite tall and reserved, and does not particularly enjoy the prospect of meeting new people.

I suppose that during those fifteen minutes Beryl must have decided that I wasn't too dreadful. Indeed, I was probably just as nervous as she was, since I was a mere fledgling at the venerable publishing house of John Murray, and this was my first attempt at commissioning a book. It was not long before she invited me down to stay for the weekend in Plymouth, to plan her first book, *The Works*. Beryl and John lived in a lovely Edwardian house on the Hoe, a minute or two's walk from the greensward long famous for the bowls played by Sir Francis Drake before his defeat of the Armada, but since then equally memorably immortalised by Beryl in 'Sabotage'. The house was filled with an astonishing array of bric-a-brac – art deco lamps and teapots, Bonzo memorabilia, dozens of cruets, egg-cups and ashtrays, and several gems of the advertiser's art – plaster toucans offering Guinness for Strength, a sailor in bas-relief complete with real Player's cigarette and a shapely figure demonstrating the merits of a brand of male corsetry. Their two diminutive yet vociferous dogs and two cats were always in evidence around one's feet.

'Planning the book' had two phases. First we went to the pub – starting at the Dolphin on the Barbican, and moving on to a few other select locations – and talked about everything but the book. We sat at a corner table and chatted away, laughing raucously. Then, suddenly, Beryl fell

silent – her attention had been caught by a hairstyle, a pair of shoes, an embrace, and she gazed at it, absorbing every detail. She extracted a little card from her handbag and surreptitiously sketched some aspect of the scene to help her recall it later. So many of her paintings had their genesis in this way – details accumulated from a variety of sources and later assembled into the final composition. Later we meandered back to the house, Beryl and John arm in arm, for large ham sandwiches and more drinks before bed.

The other part of the planning was therefore conducted with a substantial hangover – on my part, that is. Beryl and John had the enviable ability to indulge to their hearts' content, yet still get up at six the next morning to walk the dogs, fresh as daisies – or so they claimed! I staggered down several hours later and was treated to a delicious cooked breakfast – for Beryl's skill in this enjoyable aspect of the landlady's life had not deserted her. Then we had more tea, while Beryl smoked her first tiny cigarette of the day. Eventually, the moment could not be postponed any longer, and we talked about the book. I suggested the idea of printing short comments explaining who the people were and how the paintings came about. Beryl was a bit worried about this at first and then came up with the brainwave: '*I* can tell you about them and *you* can write the words.' This I attempted to do, but when she had corrected some of the captions and rewritten others it was clear that she had a way of her own with words, and quickly evolved a style which has stood her in good stead ever since. Her eccentric notions of authorship were demonstrated on a later occasion when I told her I was planning a book on Alfred Wallis, the Cornish primitive painter – 'Oh good,' she said, 'you do the words and I'll paint the pictures!'

Subsequent books (we have now worked together on twelve) followed a similar pattern: the arrival, the examining of the new paintings, the lengthy session in the pub, the hangover, the breakfast, the brief chat about the book, the walk on the Hoe (now the Downs in Clifton), the pub again, and so on. My most memorable evening of all was at

Diamond Lil's, a rather seedy venue in Union Street, where Brian, the celebrated drag artiste, regaled us with a magnificent act in a stunning costume ('thousands of sequins', whispered Beryl, 'and he sews them all on himself, you know') including a rendition of 'Viva Suspenders' to the tune of 'Viva L'España'. Brian later became famous to the world at large as Ruby Venezuela, the star of Madam Jo-Jo's in Soho, and he appears several times in these pages.

John Murray's was not the most obvious publisher for Beryl's colourful, sometimes camp, subject matter. They were more famous for Byron and Darwin, John Betjeman and Kenneth Clark, but Jock Murray was immensely tickled by Beryl's work, and once he had backed the idea, it was sure to succeed. In due course Jock, intrigued by this apparently outgoing but strangely invisible artist, expressed the desire to meet Beryl. 'Only in a pub,' I stipulated; 'she would be far too nervous to come into the office. So we met at the Goat, Jock grandly ordering drinks in a manner that suggested his more natural habitat was Boodles or Brooks's, and they got on famously. This improbable association was a matter of some pride for both parties.

Pubs feature largely in my recollections of Beryl. We decided to hold a launch for Beryl's second book, *Private View*, at the Lamb and Flag in Covent Garden. Beryl had never attended a private view of her own work or any similar function, but she agreed to come to this one on condition that (a) it would be in a pub and (b) she would only stay for fifteen minutes. So early one evening I turned up at the Regent Palace Hotel, Beryl and John's preferred London residence at that time, and we proceeded on an innocent 'pub crawl'. After four or five pubs, we plunged into the Lamb and Flag, where for fifteen minutes she was the centre of attention. For Beryl this was truly an ordeal, and was her first and last appearance at a book launch. 'In future,' she said, '*you'll* have to go and impersonate me.'

Beryl and John are always together, the most united couple I have ever known. They have complete respect for each other's judgement and will

always defer to each other's opinion – 'I think that'll be all right, but I'll just ask Beryl,' says John, and vice versa. Beryl has always said that she can only paint thanks to John's emotional support – 'I suppose that means I can't be a famous artist, then,' she chortled. 'Famous artists are supposed to be driven to painting by unhappiness, but I'm not like that at all. I can only paint when I'm happy.' Now in their seventies, Beryl and John famously embody the dictum 'Youth is not the prerogative of the young'. They may have given up smoking, drink somewhat less than they did, and leave the pub rather earlier than before, but they remain fascinated by the world around them, taking unceasing delight in fashions, hairstyles and human behaviour. There is always something new in their lives – a new city to visit, or a new pub; a new television series (for they are TV addicts, and now require two video recorders to capture all their favourites while they are busy out at the pub); a new house to buy, either for themselves or their family. Nothing is allowed to get stale, so life is never boring – and this is the key to their happiness.

Over the last twenty years, Beryl has produced eight books of paintings for John Murray and Victor Gollancz, together with three children's books and three marvellous sets of illustrations for The Folio Society. It was originally intended that this bumper book should contain a selection of all her work, a Best of Beryl. But it was so hard to leave anything out that we decided in the end to include all the paintings from the eight books, rearranged into themes (chronological organisation would be quite impossible, since none of them is dated, and Beryl has only a hazy recollection of when some of them were produced), and with the texts adapted to reflect the passage of time. Of all the books it has been the most enjoyable to work on, rekindling memories of many happy evenings together. I'm glad to say that the happy evenings continue, the paintings continue to appear with astonishing variety, and we can expect plenty more to come. One of her early admirers wrote to her in gratitude 'for brightening my life'. I couldn't put it better.

Joe Whitlock Blundell

To John and our family

Plymouth by Night

For over twenty years my husband John and I lived on Plymouth Hoe. He was in the motor trade and I was landlady of our boarding house until I found I was busier with my painting than with the lodgers, and it eventually took over completely. Our chief pleasure in life came in the evenings, when we would visit one or two of a number of small local pubs, all lively and filled with colourful characters. Sadly, many of these have now become 'fun pubs', changed beyond recognition, but one which has survived intact is the Dolphin – we always call in there for a drink and chat with Billy, the landlord, when we go back to Plymouth now.

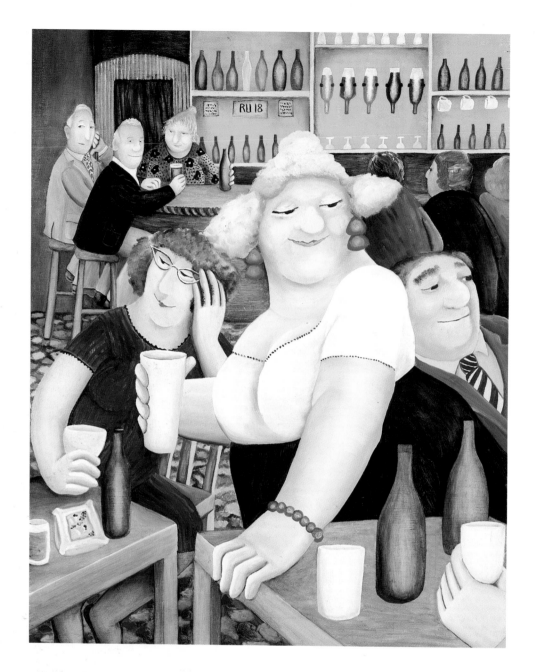

The Lockyer Tavern

This is the first of several pictures I painted of this pub, and it was only after many struggles that I actually managed to make the people recognisable. None of them knew I had been busy at home painting them, and I was rather nervous about going into the Lockyer after the pictures appeared in the *Sunday Times*: I wasn't sure how they would feel about it. They didn't mind, though, and I was allowed to continue drinking there. Many happy hours were whiled away in here until we were encouraged to take our drinking, dancing and drag parties elsewhere. There were two bars – one of them gay – with singing and dancing, talent competitions and pantomime in drag, all performed by the locals and much appreciated by me. I hope my pictures convey some of this pleasure.

Brian Entertains

It was cabaret night at the Lockyer, and Brian was at his best, dancing away to Len's accompaniment at the organ and our loud cheers. Suddenly I looked outside and noticed three men looking in on the performance. They were doubled up with laughter and I know just how they felt. Brian's magnificent headdress deserved real sequins, I thought, but I found it a bit tricky sticking them on.

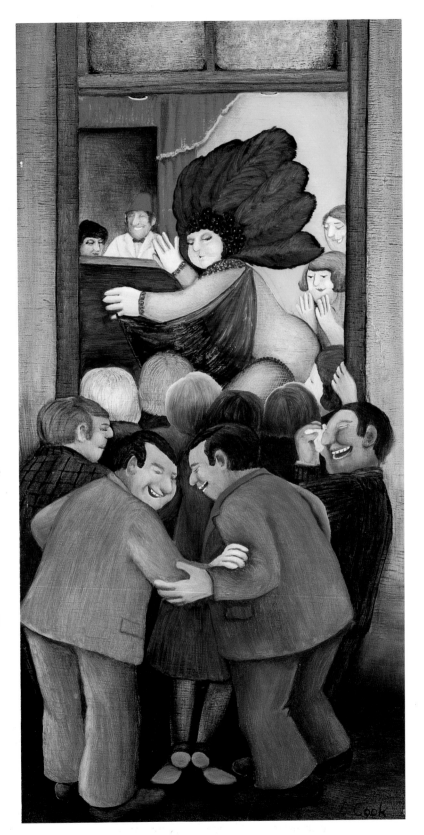

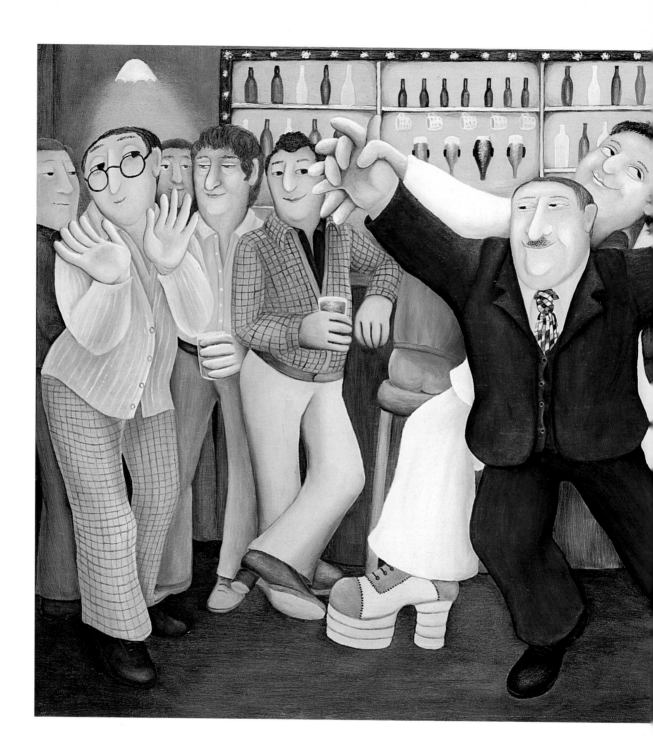

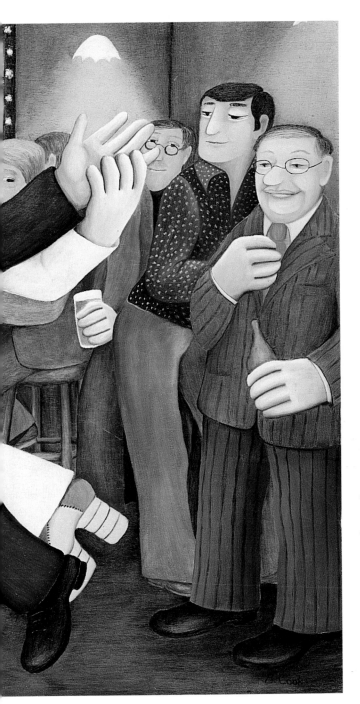

Tom Dancing

Tom, who is wearing the blue suit, was the land-
lord of the Lockyer when I painted this picture,
and he used to keep the back bar in some sort of
order with great good humour. He didn't often
smile, but when Brian picked him up and started
whirling him round the room he couldn't resist
the fun and a small grin appeared. This bar had
its own special atmosphere and was a popular
meeting place for about thirty years, I believe,
before closing down. I'm glad I was lucky
enough to see it in its heyday.

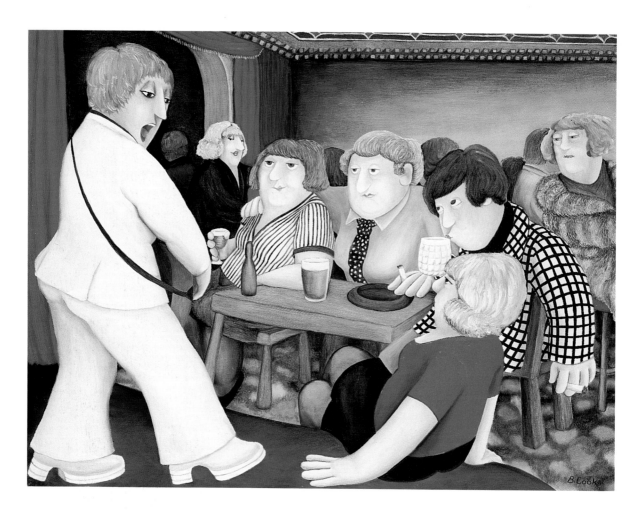

Angela Singing

These girls are part of the gay crowd, great fans of Angela, who used to entertain us in the front bar of the Lockyer on Sunday mornings. There was a very decorative ceiling in here and Frank, who took over as landlord from Tom, used to keep a wary eye on it in case the vibrations from the choral renditions brought it down. I don't think he ever had a dull moment during the year he was in charge, or a peaceful one.

Sylvia

Sylvia used to be a man and is now a lady. Here she is, greeting a couple of rather surprised sailors, one with a nicely tattooed arm. I'm very interested in tattooing and have once or twice been very tempted to have one done myself. But is this in keeping with my image as a gentlewoman, I wonder?

Three Ladies

Now aren't these lovely. They arrived in the Phoenix one hot summer's night, with a sort of entourage of gentlemen, and paused for a while at a table near us, which gave me a chance to admire their finery. In the painting I've given one of them a very pretty necklace I bought in the market.

Conversation Piece

I saw these two in a bar and I took such a fancy to his hair and the way he was leaning on the table that I made a small sketch on the spot. But difficulties arose when I tried to paint him, and I grew so tired of the whole thing I hastily finished her off in a plain dress so that I could go on to something else.

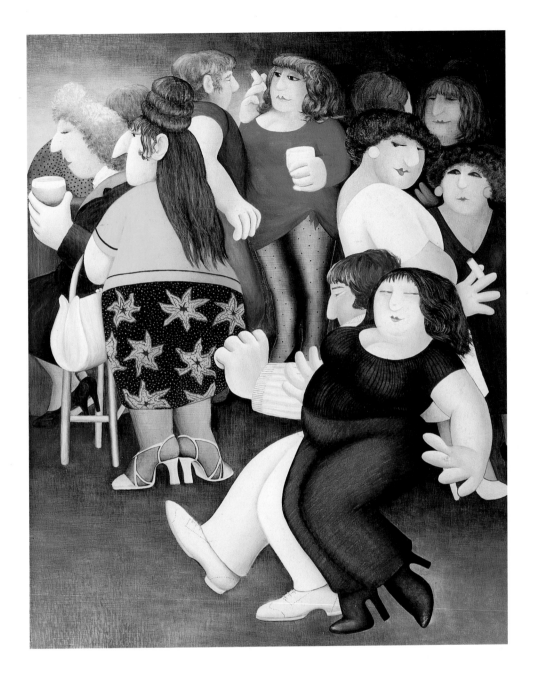

Union Street

A walk along Union Street on a warm summer's evening, with the boys and girls dressed up and out to enjoy themselves, used to give me great pleasure. One night we visited several pubs and Diamond Lil's club, and afterwards I painted this picture, putting together all the things I had seen and liked. It was fashionable then for girls to wear no skirt, just a long sweater tied on the thigh, and we saw one girl wearing a particularly nice one, her outfit completed by black spotted tights.

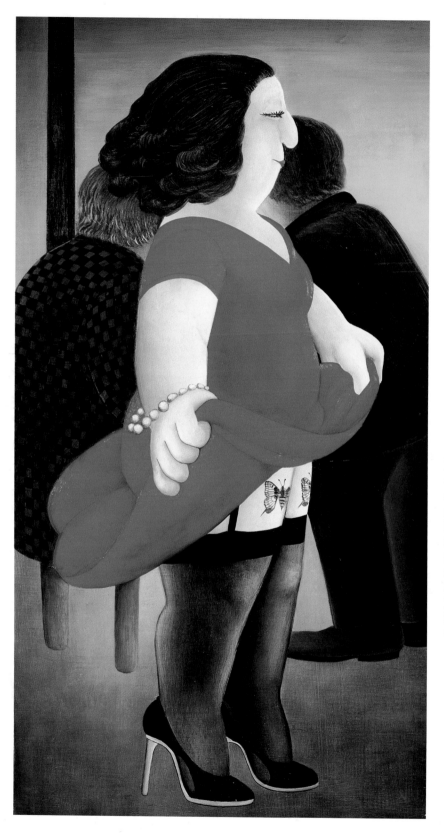

Girl with Tattoos

I did not really get a glimpse of these tattoos – in fact she assured us that she hadn't any, as she lifted her skirt high to demonstrate. For me, though, she became tattooed the minute I was told that they were on her thighs, and this is how I painted her. I liked her so much I painted her twice, the second time with even bigger tattoos.

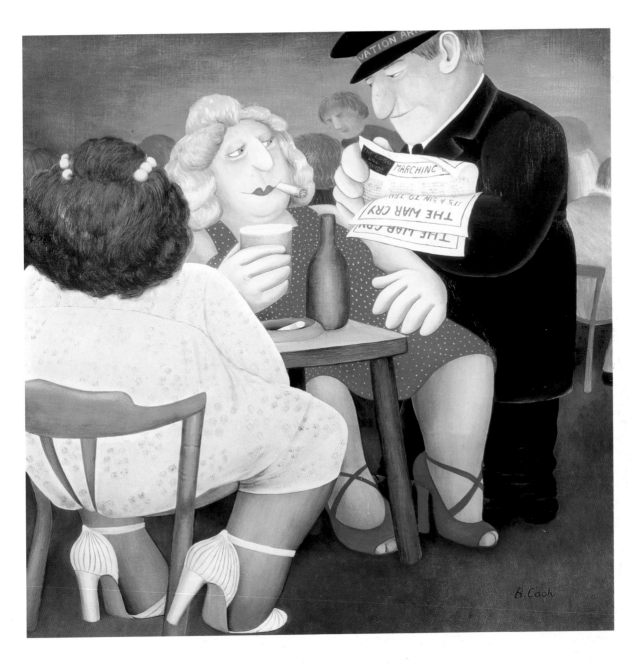

The War Cry

I painted this because I liked the back view of the white dress. I also liked to see the Salvation Army officers with their magazines threading their way through all the people. I hope it doesn't become too noticeable that the people get larger and the backgrounds get smaller (or non-existent) in the public house pictures. It was to save me the trouble of painting all those bottles on bars, partly because I am lazy, but also because I'm very impatient to get on with painting the people.

Dancing on the Bar

A friend told us to hurry along to this
pub one night as the barmaids would
shortly be dancing on the bar. What
a treat. I'd never seen this before (and
never have since), so I did some little
drawings. Clearing the tables were
handsome boys dressed only in the
skimpiest of shorts. Sadly, the next
time we went there both the dancing
barmaids and the boys had disappeared.

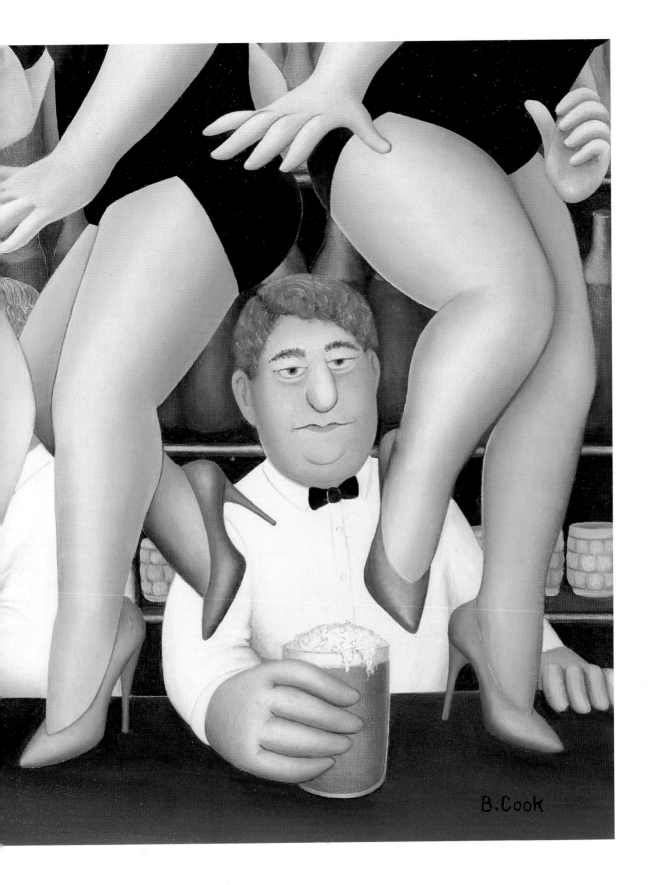

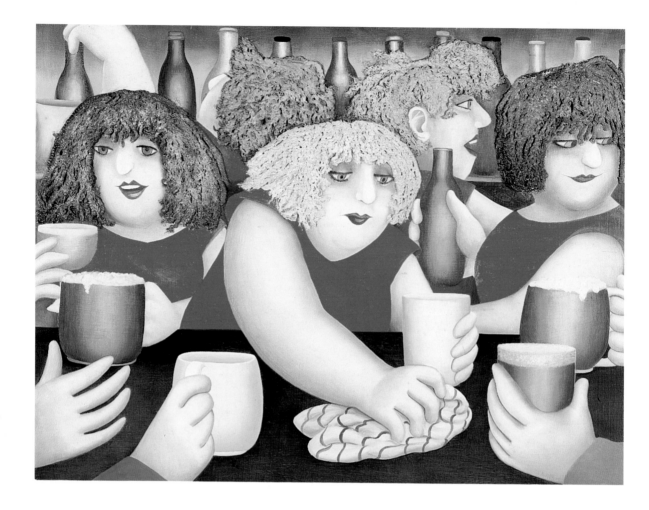

Mop Heads

In a bar in Union Street at one time, all the barmaids used to wear little red T-shirts and their hair teased out to extravagant heights. In fact the teasing and arranging of the various styles would often be in progress as we entered the bar early in the evening, the girls taking turns with the tongs and curry comb. I didn't think I could do justice to the hair using only paint, and decided to unravel a cotton mop head to achieve sufficient volume. Days later, I was still covered in sticky fluff from trying to attach it all to the heads in the picture – not quite with the effect I had hoped to achieve.

Ticklish

(opposite page)

I would like to stress that I do not spend all my time in public houses. Most of it is spent painting – or thinking about painting. But we did just happen to be in a pub when these two were messing about. He had been teasing her for some time when she suddenly turned on him and he, helpless with laughter, tried to stave her off. There is a roundness about this painting that I like very much.

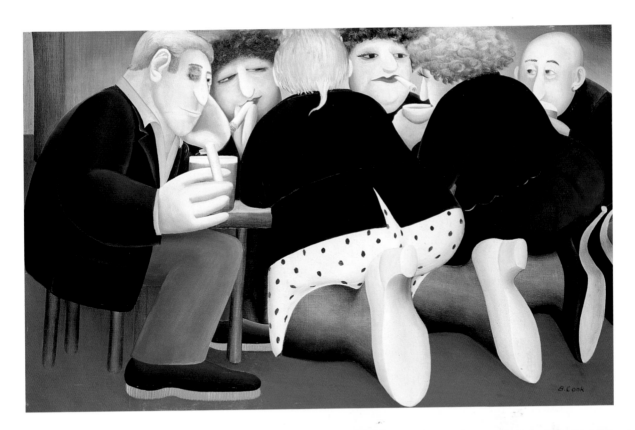

Punks in a Bar

I am fond of this picture, painted in memory of a seedy little pub full of characters I no longer see, for – alas – it has been completely modernised. The tables were rather low, so when these two girls arrived and no seats were available they knelt down side by side, leaning forward and joining in the conversation. Once I saw a row of customers in here sitting silently with drinks, and every single one had either a bandage, bruises or a black eye.

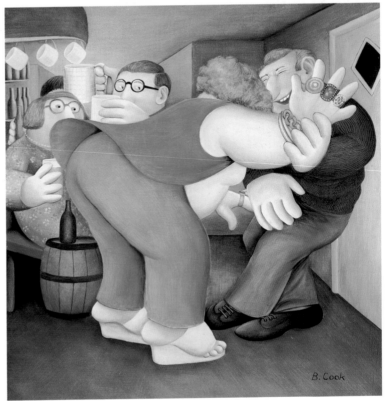

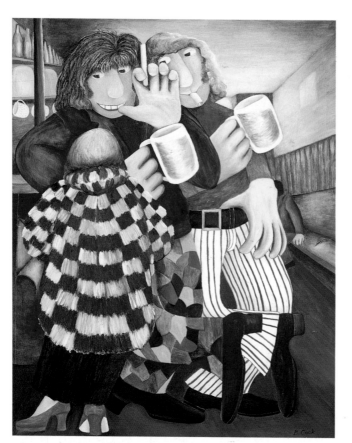

Two Men and Small Lady

I painted this some years ago when patchwork trousers were in vogue. I remember how taken I was with this very little lady, wearing a large fur coat and deep in conversation with her friends.

Musical Evening

This is another very old painting, dating from when hippies gave up wearing shoes. Opposite us sat two men who were suddenly joined by a friend with a very noticeable squint. Comfortably seated on a lap, she pulled out a mouth-organ and played while they sang for the next half hour or so; we enjoyed the performance as much as they all did.

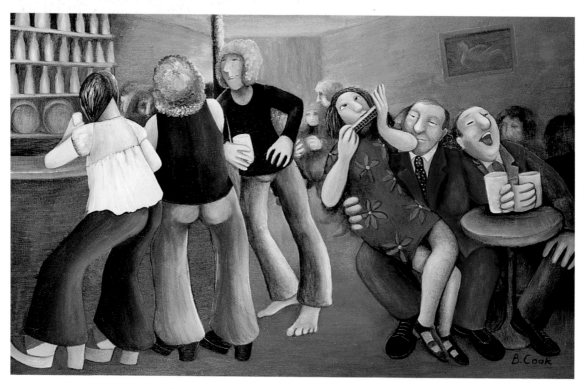

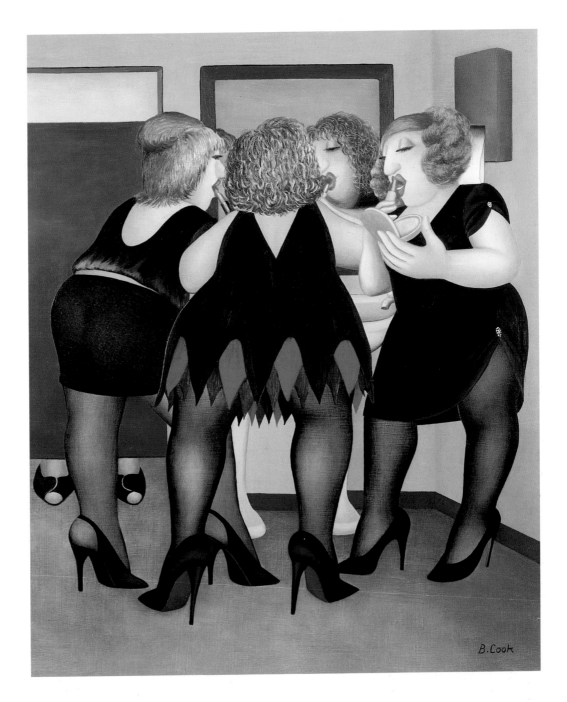

Getting Ready

I was very taken by the dress with points that this girl was wearing in the Ladies. The three of them were leaning forward to add the final touches to their make-up, getting ready for whatever amusement the evening would bring. A last flick of the comb through the curls and the girls departed through the door, the many-pointed skirt shown off to full advantage when its owner did a little dance on the disco floor.

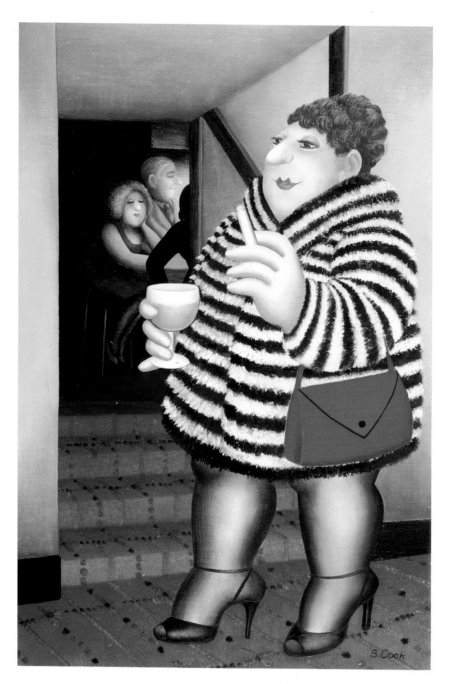

The Fun Fur

In this little pub there were two rooms, one up a few stairs and very dark except for the light at the bar. On one of our visits I saw this small stout lady standing on her own, wearing a big fun fur. I always carry small white cards and pencils with me when I'm out, and do any drawings I need in the concealment of my handbag. Sometimes it is years before I use them and, although I've more or less lost my memory for most things now, I can remember immediately any drawing I need and where to find it amongst the pile of cards stacked on a shelf. I had often seen the view of the further bar and wondered whether I could reproduce it, and this lady made up my mind to do something about it.

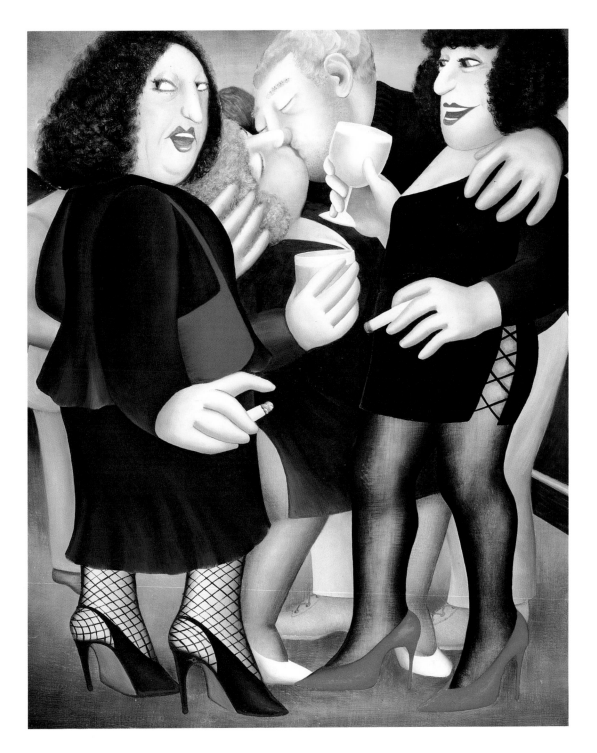

Kissing Time

This episode stayed in my mind because of the roughness of the man kissing the girl in the middle. The group were quietly drinking at the bar when he ambled up to join the conversation, and soon afterwards he took the girl in his arms for a passionate kiss. I didn't envy her, but no punch-ups followed so he must have been a friend – of sorts.

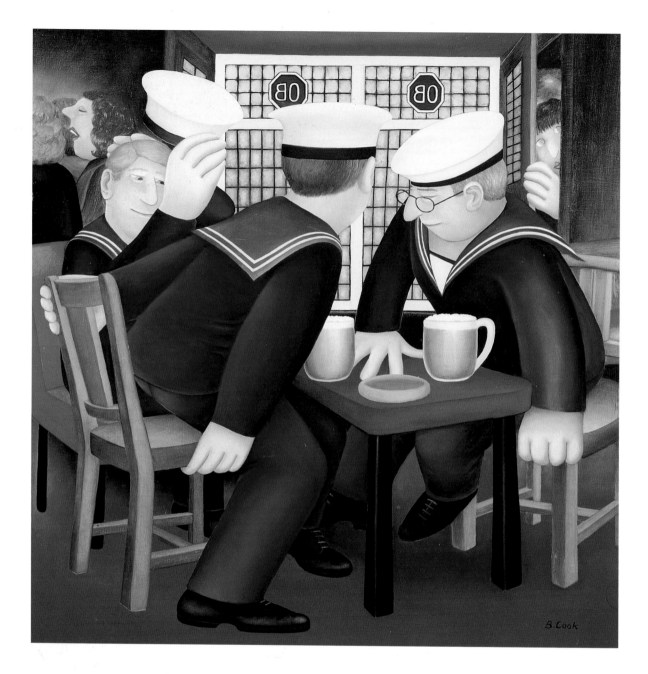

Sailors

The beer has just been purchased and the sailors are about to sit down, actions I noted very carefully at the time and most faithfully reproduced in this picture. I used to like it when the large foreign training ships visited Plymouth; sailors from many countries appeared in the streets and pubs, and they looked so smart and confident in their uniforms. I stood about near them until they gave me funny looks: I wasn't really trying to pick one up – only draw them!

Dog in the Dolphin

Dogs of all sorts come in here and I'm always pleased to see them. They aren't allowed in many pubs, for reasons of hygiene, I think. I'd rather have more dog and less hygiene as in France, where they are fed titbits from the restaurant tables and happily lounge about on chairs in bars. The one in this picture arrived beside our table and stood gazing into space for some time: he was so good-looking that I took his photograph. When I began to arrange the picture I remembered these two girls passing by, wobbling a little on very high heels, and so here they are to make a rather nice background.

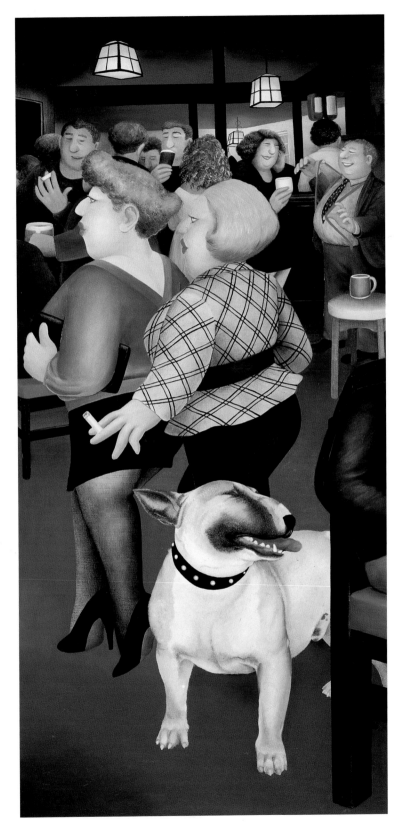

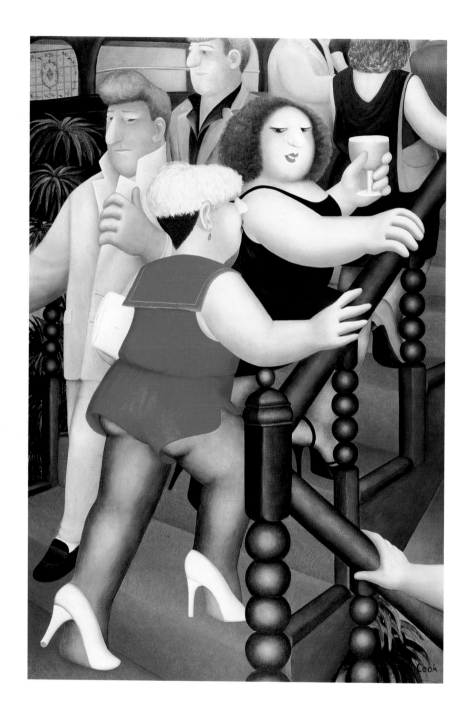

The Staircase

This pub is on two levels with a very attractive centrally-placed staircase. As it is always busy and full of youngsters there is constant movement up and down the stairs, with people looking for seats or companions, or going to the upper bar. At the bottom of the staircase is a comfortable banquette, the ideal place for an all-round view, which I always hoped to get to before anyone else. I like to paint staircase pictures when the opportunity arises as it enables me to do tall paintings without having too much trouble with perspective.

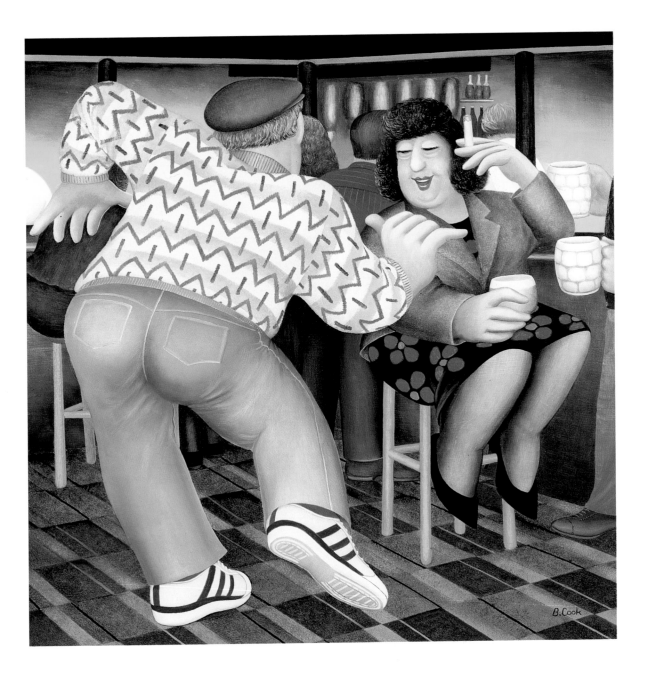

The Dancer

Here is a happy man. He couldn't resist the music and frequently put down his glass to dance a little more. Sometimes his friend continued her conversation with the others, and sometimes she watched him, but he didn't really mind either way. He danced off and on for the two hours or so I was in the pub, and I daresay all the way home, too. Now he dances in the picture, forever seduced by the rhythm of the music.

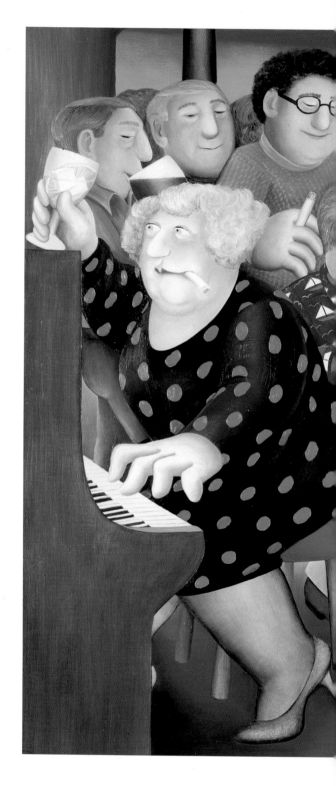

The Banjo Players

There used to be a concert every
year in the Dolphin when these
two players came here on holiday
and joined Betty, the landlady, at
the piano. I have always liked the
banjo, not so often heard now, so
on their arrival at the pub I ener-
getically elbowed my way to the
front, determined not to miss
such a treat. They were so good,
feet tapping while fingers flew,
and the session seemed to be
over all too soon.

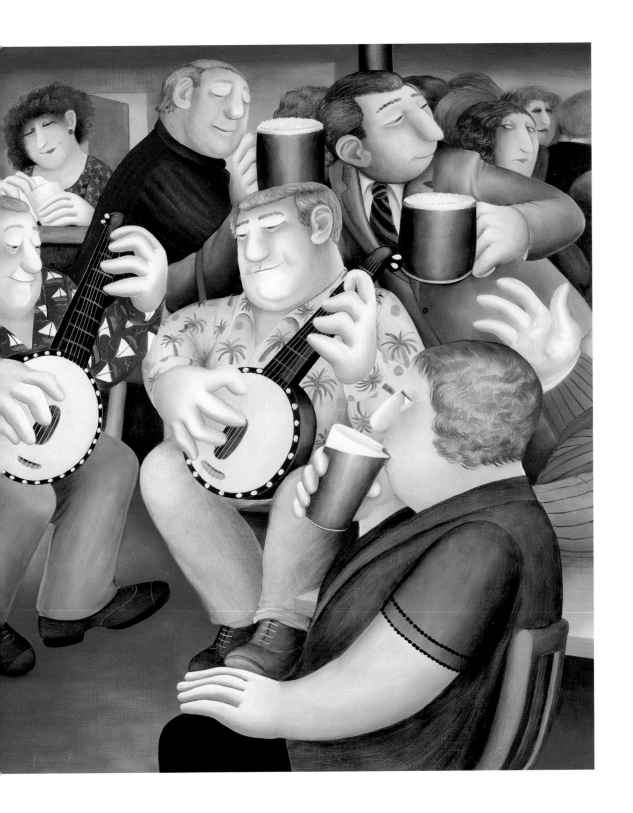

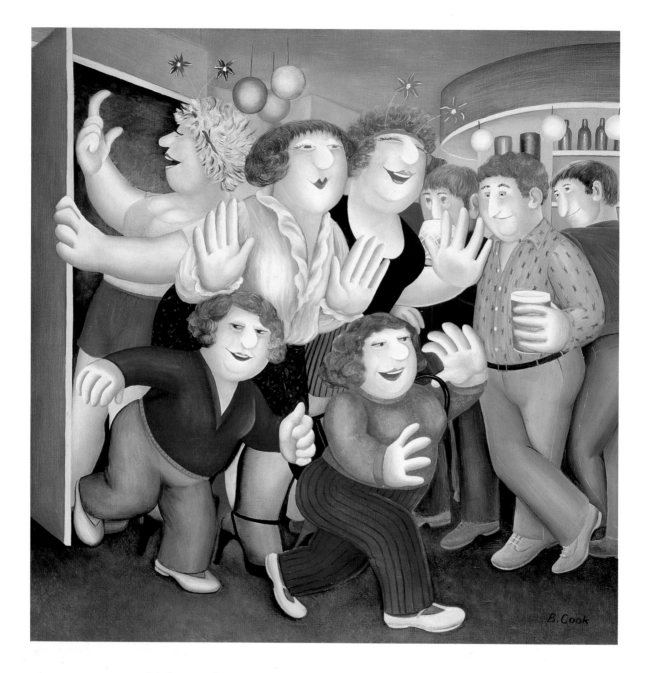

Girls on the Town

The door of the pub burst open and this group tumbled in. Led by two tiny girls, they were getting into the Christmas spirit, singing, clapping and joggling the stars some of them wore in their hair on bandeaus. The men standing at the bar were rather pleased at the sudden change in atmosphere, since it had been rather quiet until then. And it soon was again, for they didn't stay long – just long enough for me to sketch this picture.

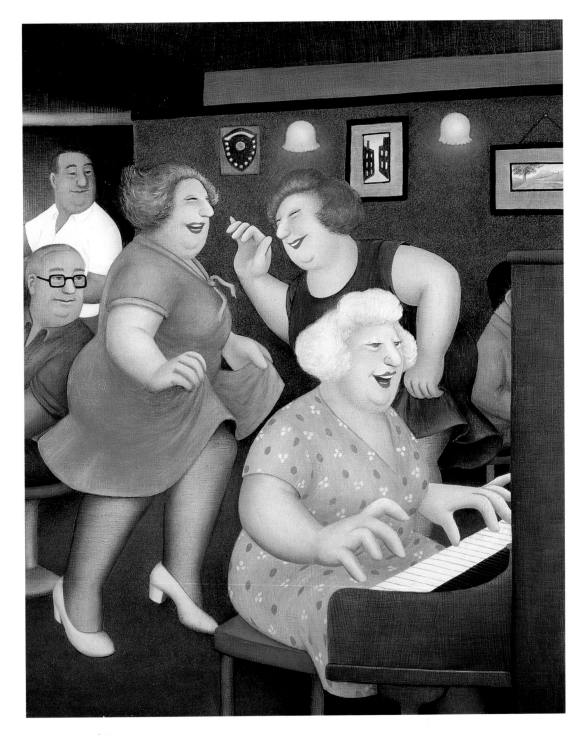

Song and Dance

Here's another merry interlude. I don't see people dancing in pubs so much these days, or playing pianos, but years ago we had plenty of episodes like this and it was mostly women who did the dancing. The one playing the piano is based on an ancient man I saw performing in a seaside pub, more or less toothless and happily singing along as he belted out the tunes. I thoroughly enjoyed his concert but decided to change him to a woman for the painting.

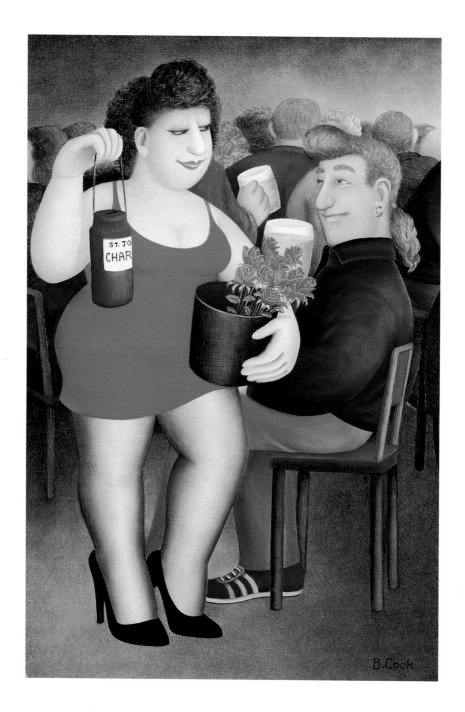

Sweet Charity

This pretty girl in a tiny red dress used to appear in our local pub every week-
end. She was very attractive so she probably did well collecting for her charity.
Here she is tempting someone to buy a rose and, to be in fashion, I've given
him a big bushy ponytail. I wasn't quite sure what to do with the front of his
hair but eventually arranged something bouffant. The roses I painted from a
gardening catalogue: they're quite effective, aren't they?

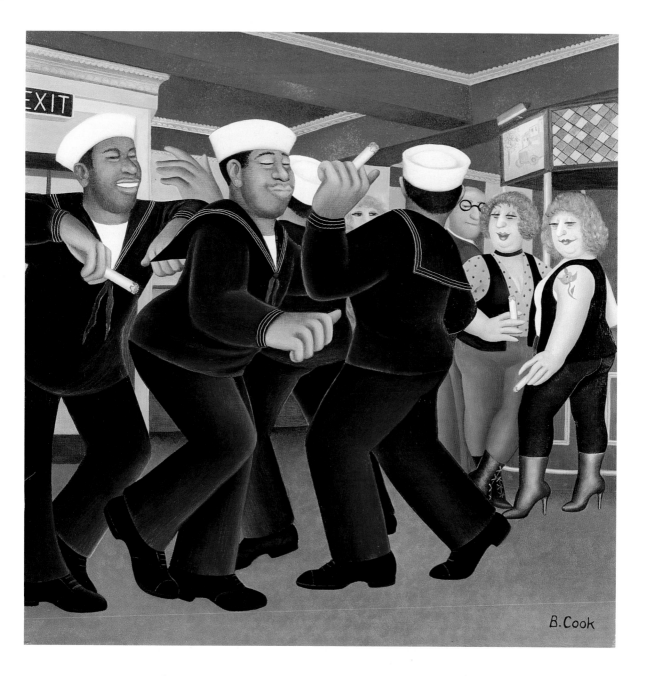

Sailors Dancing

Now it is the sailors' turn for a dance. Not quite the hornpipe, but most enjoyable never-theless. There was a buzz through Union Street – the nightclub area – when the news came through that a large American ship would be there for a few days. This group was sitting in the booth next to ours, dressed in civilian clothes, but I dearly love uniforms (especially sailors'), so this is how they appear here. The girls look on admiringly but the sailors seemed to me to be much more interested in drinking, laughing and dancing.

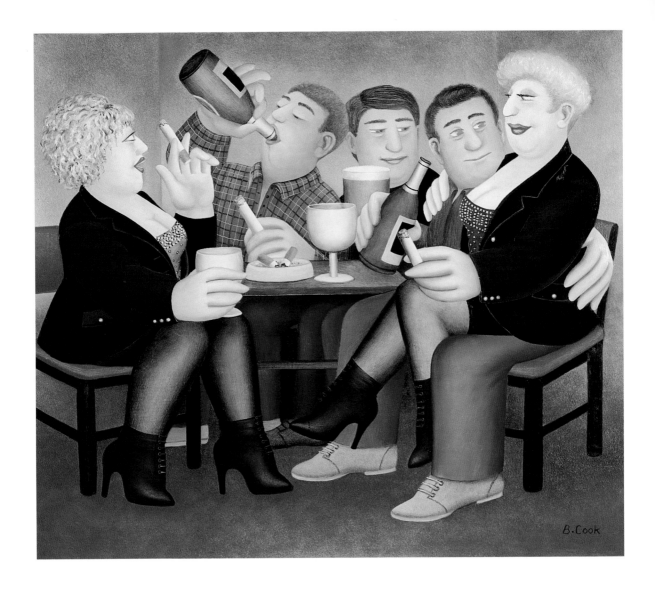

Bosom Pals

This was a group I noticed one evening because the two girls were dressed in identical black suits and bootees, the only difference being the colour of their bodices, scarcely covering enormous bosoms. They had come into the bar alone but it was not long before they found seats, one on a pair of knees, with these young fellows at a nearby table. When I came to paint the scene I needed some cigarette stubs for the ashtray and suddenly remembered that I don't smoke any more (worse luck). Friends kindly donated their dog-ends and now I keep these to hand, ready for use when required.

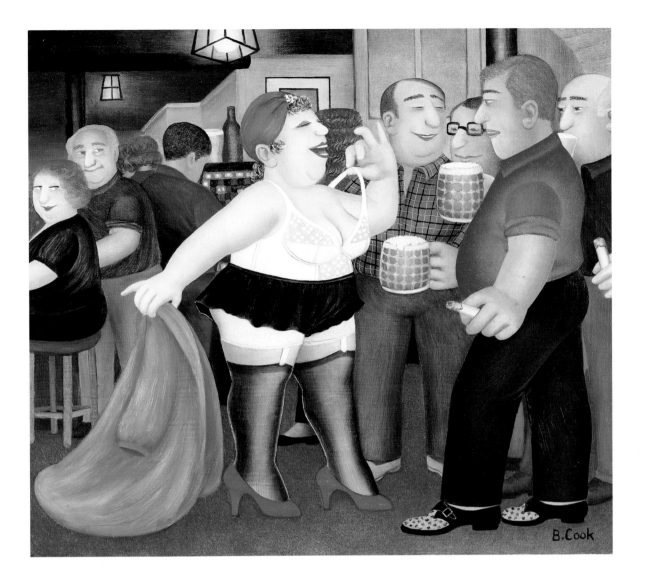

Strippergram

This group of men was standing together in front of our table in the Dolphin one evening when they were joined by a fat little lady in a blue coat. Singling out the birthday boy she suddenly peeled off the coat, revealing this slightly grubby corset and black lace knickers. Open-mouthed, we watched as he was made to kneel and have his head massaged by her now-naked bosom. I'm not sure what he thought about his birthday present: I was hastily sketching the incident inside my handbag.

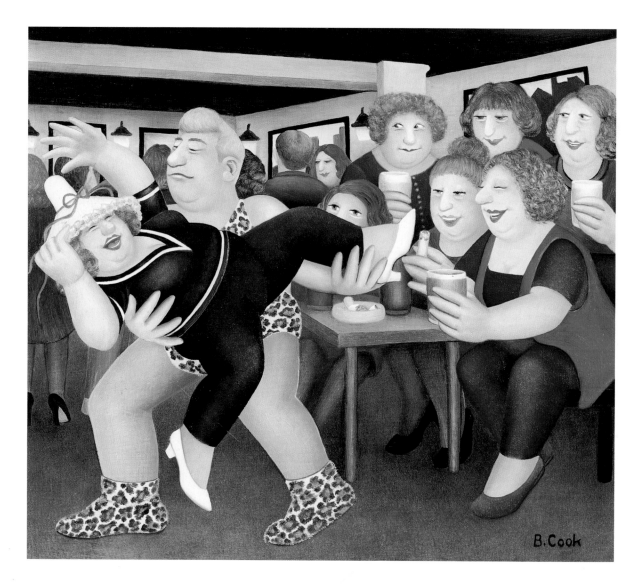

Tarzanogram 1

This is a friend having a hen party. Her mother arranged for Tarzan to appear during the proceedings, but as she is rather nicely rounded I don't think Tarzan managed to throw her about as much as he'd planned. She is wearing her special hen party hat. I always enjoy these rituals and like to see the groups of girls going through the streets singing and laughing. They are often so loud we know they're on their way before we see them.

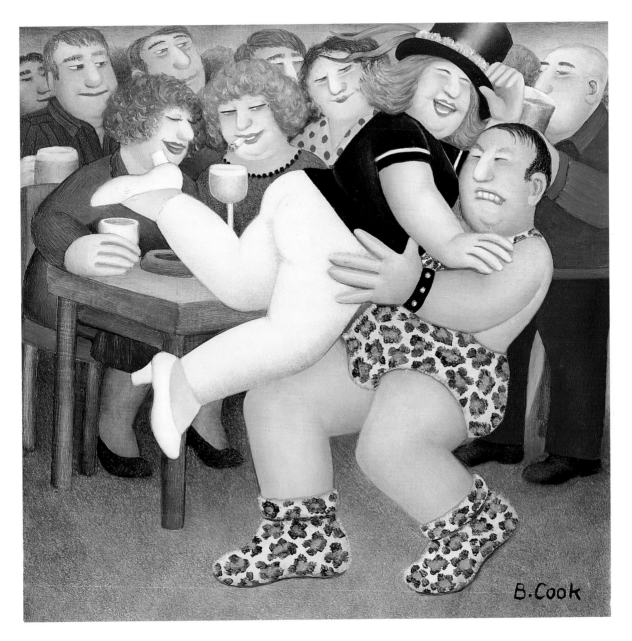

B.Cook

Tarzanogram 2

When Sue told me that she'd had two special hats for her party I decided to paint another picture. She also told me that Tarzan had tried to get her up on his shoulder but had been quite unable to manage it. I felt I needed to show the supreme effort he made, so I gave him a look of anguish. I think poor Tarzan has probably retired with a hernia by now.

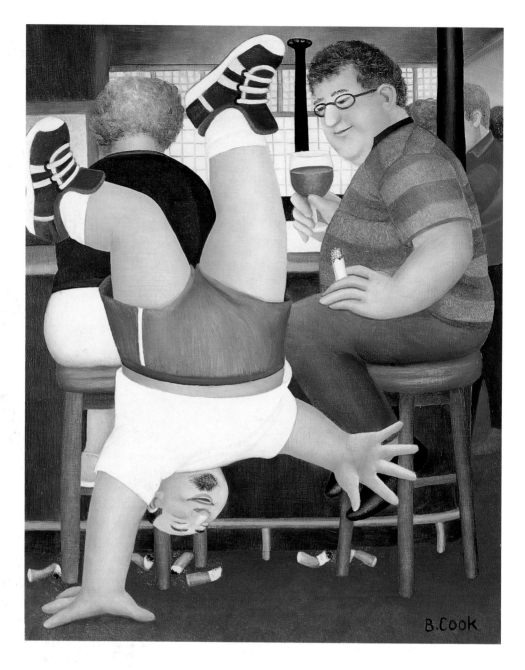

A Cartwheel for Billy

Billy was sitting near us chatting to a friend one evening in the Dolphin. Later he came across to talk and told us that this friend once did a series of cartwheels through the bar after they had been out together. This is only one of many unusual things to happen in this pub, and it formed an immediate picture in my mind. Quite recently I met the cartwheel man, but he didn't offer to repeat the performance for me.

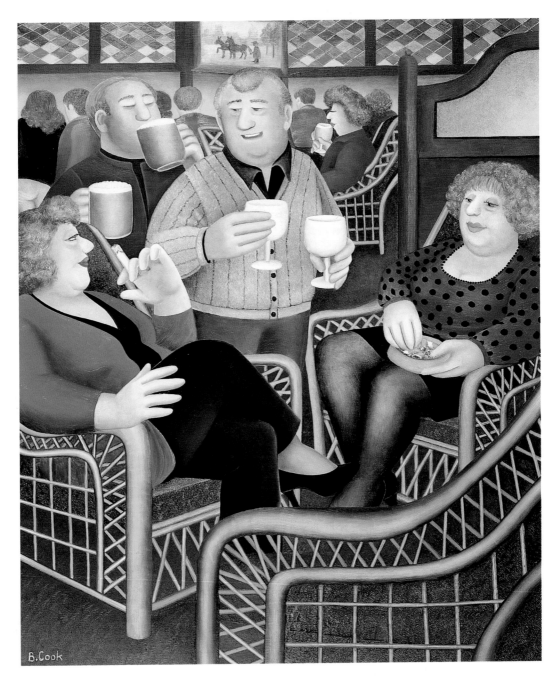

B.Cook

Cane Chairs

Aren't these chairs nice? In the time it took me to paint them I could have woven all of them by hand. But having started the painting I felt I must continue. The surprising thing was that they suddenly appeared in the front bar of a rather seedy pub. I'm not sure what impression the owners were aiming at, but I think these chairs were a mistake, for the only position once seated was to recline, after which it was not so easy to rise at regular intervals to replenish your glass. Knowing I would be painting them we made several visits, and were often the only customers enjoying these luxury objects.

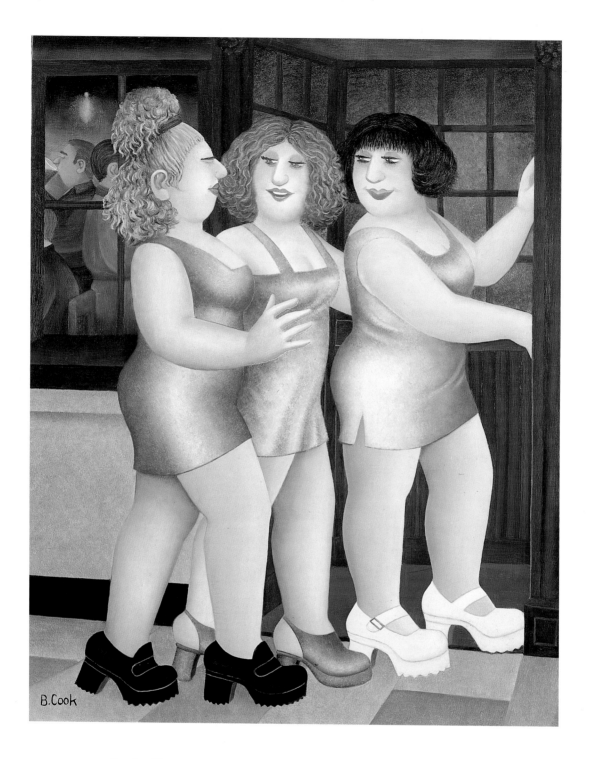

Satin Dresses

I like to see the girls out and about enjoying themselves in the evenings. They all start appearing, ready for fun, just as we oldies are wending our way home. These three were entering one pub door as we were leaving another. They wore tiny little satin dresses and very large shoes, and had frizzy hair; they looked all set for a lovely evening.

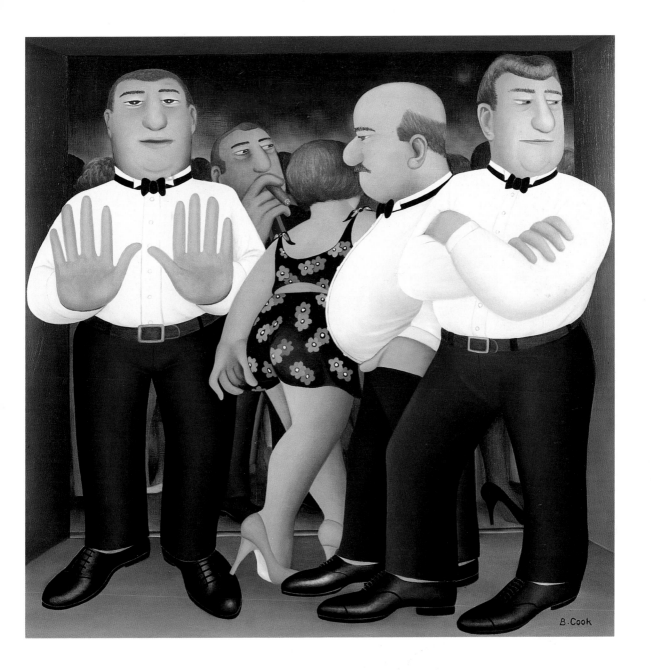

Bouncers

Many's the time I've sipped half-pints of beer and watched the bouncers getting ready. They are usually just assembling for action when we arrive, talking and adjusting their bow ties. They have to be very strict about who they let in, but this girl is all right. She is adjusting her shorts, something I find they have to do quite often, and especially the little tiny stretch skirts. She is coming to join a cheerful group visiting pubs before going on duty themselves as bar staff. I remember them well because as they sang and danced together one of them punctuated the music with shrill blasts on a whistle she carried, and I wasn't sorry when the time came for them to depart for work.

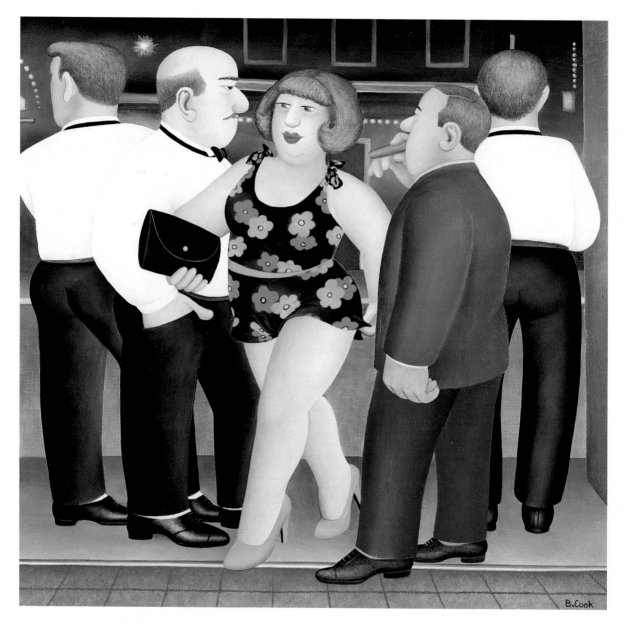

Bouncers Back

The bouncers from behind – the view I have when
they gather in the doorway ready for business.
Usually we sit near the doorway, so as to get a
good view of people arriving and to see what the
latest fashions are. The great drawback here is the
volume of sound from the videos, so loud that even
the seats throb in time to the music. The level rises
as the evening wears on and then we know it is
time for great-grandparents to leave.

Man with Blue Eyes

(opposite page)

I found these little doll's eyes in the flea-market in
Amsterdam, and knew at once that they were just what
I needed for a painting. This was a grave mistake, for
three weeks later they were still staring at me reproach-
fully. I felt I must use them at all costs, so I stuck them
on here, where luckily they fit quite well. I like adding
oddments to the paintings sometimes and have handy
pieces of hair, old spectacles, teeth, dolls' hands and
all sorts of things stored away. In my view most things
will come in useful one day, but this habit does tend to
restrict movement through the house.

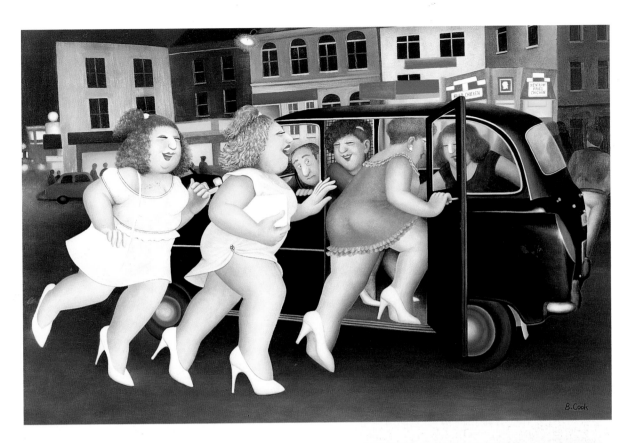

Girls in a Taxi

Here are some girls getting a lift to the next port of call, a nightclub, I expect. They certainly enjoy themselves when they are out together going from pub to pub, sometimes pausing to sing and clap if a suitable record is playing. A manageress told us once that she didn't allow 'Nelly the Elephant' to be played any longer, that it made the fellows turn funny and do peculiar things. I was sorry that she'd banned it before I'd seen just what things. The taxis wait for custom outside Colonel Sanders' emporium, which is handy for a take-away supper. Whilst waiting for his chicken to be fried my husband asked the assistant if she'd seen the Colonel lately. She told him no – she'd only been there two weeks. I seem to be rather fond of taxis: I like riding in them and painting them, always striving to get better highlights so they look as shiny as they really are.

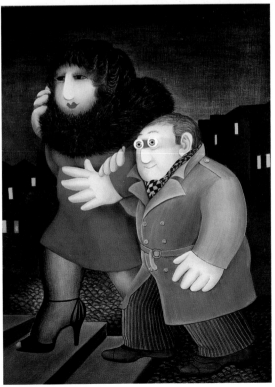

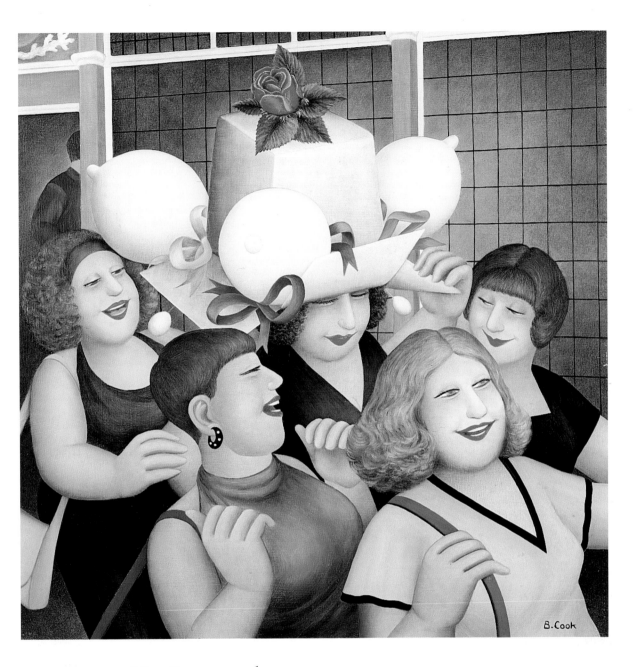

Hen Party 1 and 2

This is something we saw quite often – a bride-to-be being escorted from pub to pub by her friends, pausing for a drink in each. The friends make the bride a hat (in this case a large cardboard box covered in silver paper and saucy decorations), and there is much singing and hooting as they go through the streets. I am interested in these customs and learned that a bride getting married for the second time will also have a hat, but a much smaller one and more subdued. After finishing the first painting I decided to do another with a much larger version of the hat, for by this time it had become an obsession. So here it is, with the girls slightly altered. I'm glad to say I have been able to leave this subject alone since then.

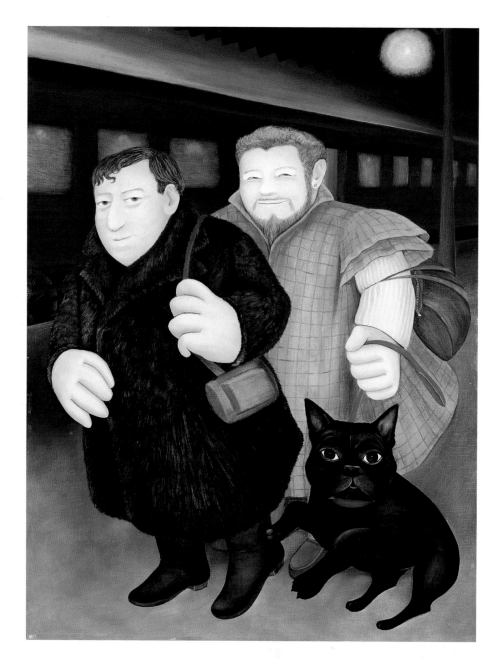

Ted and Heinrich

These are friends arriving on a cold winter's night at Plymouth Station, where we had gone to meet them. I loved the effect of the fur coat, the cloak, and Bertie straining at the leash, and I decided to celebrate it all with a picture. My problem here was painting a train, and to disguise the fact that mine didn't seem to look like the one I was copying from a book, I made the figures as large as possible.

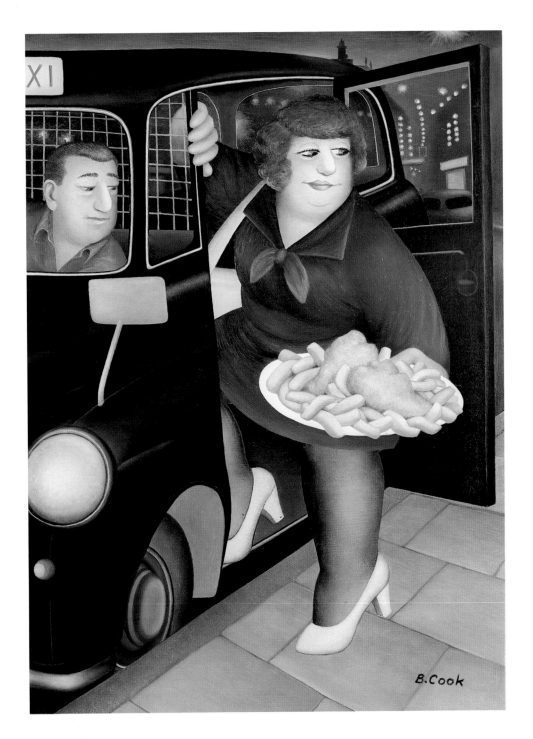

Dinner for One

I saw this as I sat looking out of the window in a pub one evening. Taxis were continually drawing up to offload groups of boys and girls, but when the door of this one opened I was surprised to see a large plate of fish and chips emerge. It was followed by a tubby little lady who, after paying the taxi driver, rushed it through the doorway where it was lost to sight in the crowds.

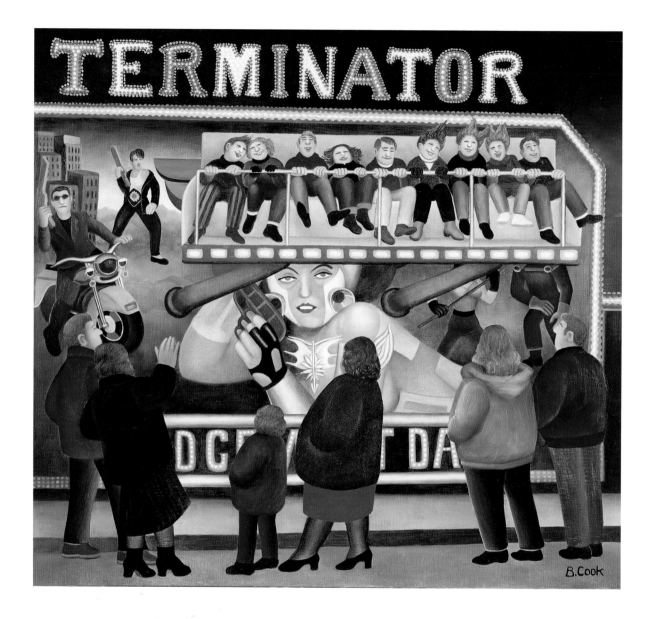

The Terminator

On winter nights in the city centre fairground rides are set up in various places. They are popular with the youngsters, and I liked watching this one, which caused loud screams and flying hair as the machinery arm hurled the seating up and down. I was also fascinated by the decoration, so I took a photograph. After a great deal of hard labour and much swearing this picture was produced. I think I'll stick to just looking at these things in future.

Plymouth by Day

Though the night life was what most fascinated us in Plymouth, it is also a city with plenty going on by day, filled with seaside holidaymakers in the summer, and many interesting characters – and their dogs – on the Hoe at all times of the year. I also greatly enjoyed the shops, and many of these have now found themselves immortalised in paint.

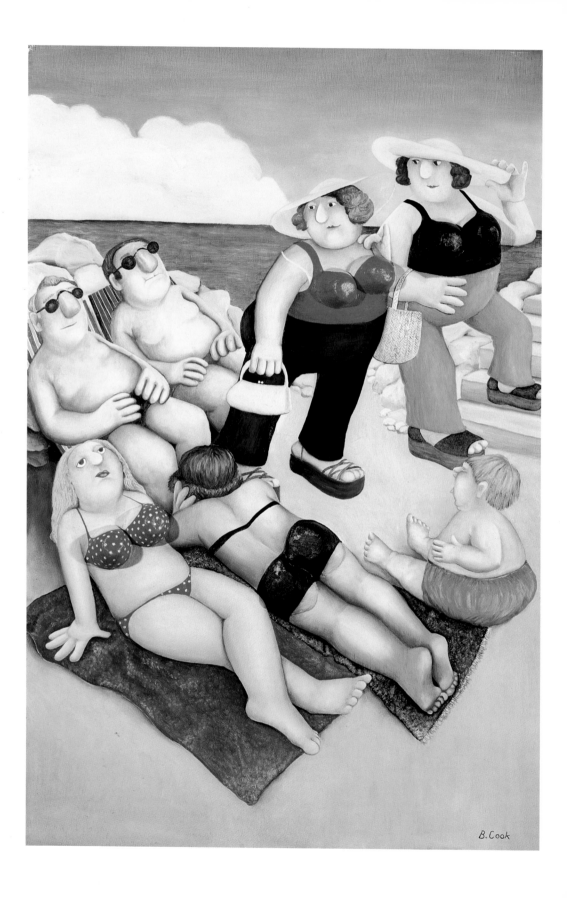

Beside the Seaside

Some people accuse me of exaggerating the figures in my pictures; they say people aren't really like that. Believe me, they are. These two ladies walked past me on the Hoe one morning, and they went into the picture just as they were. I particularly like painting big, sturdy women and much admired the large expanses of bright colour. To give additional roundness I stuck on pieces of eggbox in the appropriate places.

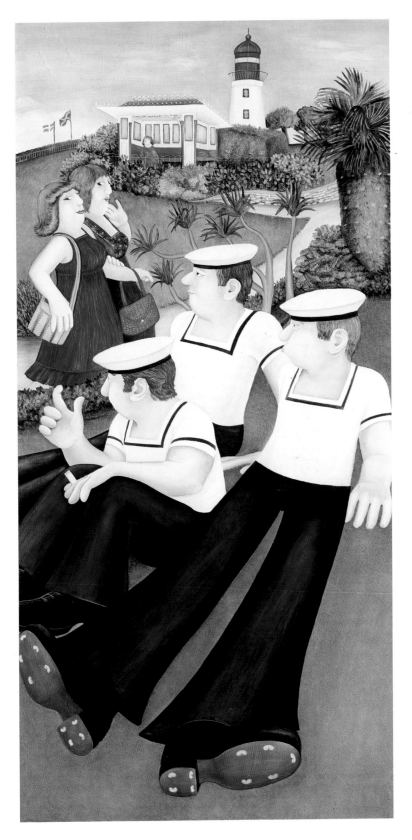

Sailors and Virgins

I saw these sailors on the Hoe one summer, looking absolutely sparkling in their uniforms, and stored them away in my mind until something came along to complete the picture. Then one night we were coming back from the Phoenix in Union Street and saw two girls being followed by some young sailors shouting 'Are you virgins?' The question grew louder and louder, so did the giggles from the girls, and to my regret we never learned the answer.

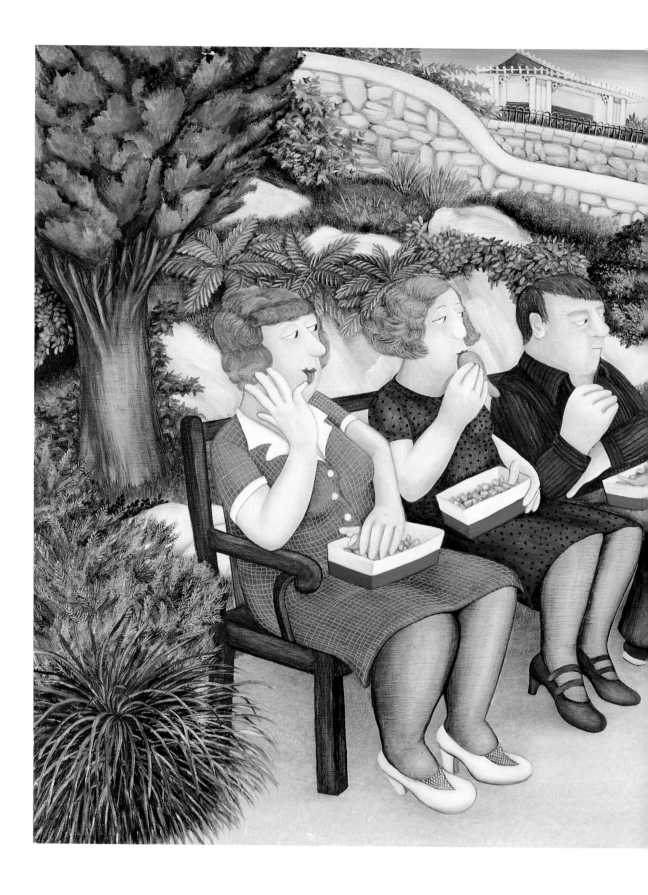

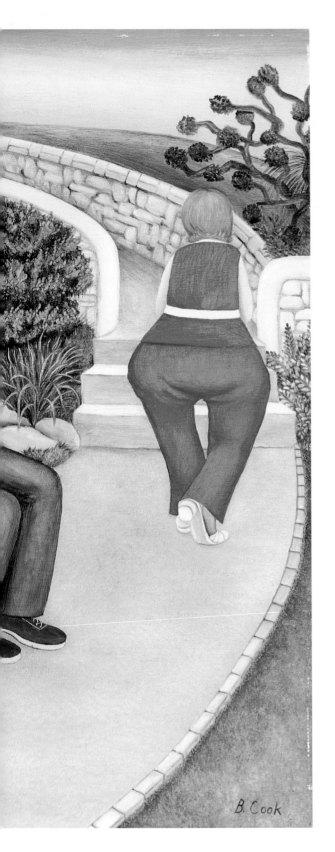

Hips and Chips

This is another figure which you would think must be exaggerated. I must say I couldn't believe my eyes when I saw her in the supermarket, and I'm ashamed to say I followed her all over the shop. In summer the Hoe is crowded with people eating takeaways and dropping the cartons all over the place, and for some time I had been thinking of painting them; the large lady was just right to complete the picture.

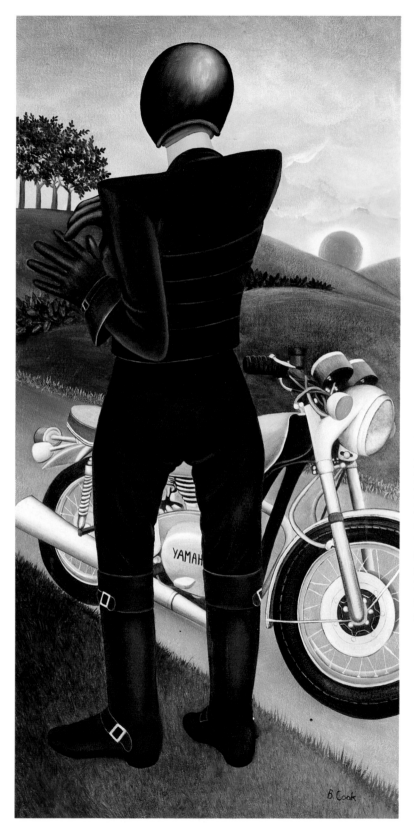

Black Leather

I saw him just outside one of the Little Chef cafés on the A30. He had just bought his new gear and looked really smashing in it – and didn't he know it. I couldn't decide what to do with him for a while and eventually brought him back to Plymouth and put him on the Hoe. I copied the motorbike from a brochure, condensing the engine rather to make it fit the picture.

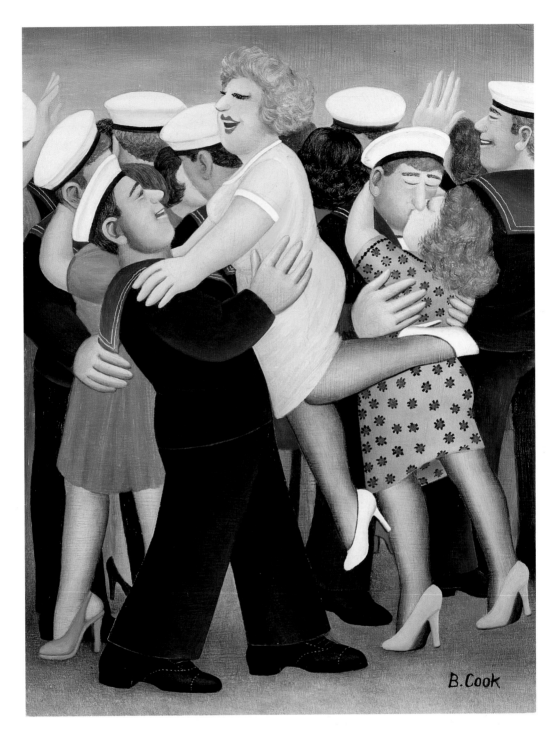

Sailors and Sweethearts

I like this kissing picture. I've seen the wives and girlfriends sadly waving the sailors off on a tour of duty, and it must be wonderful greeting them home again. This painting started with just the one sailor lifting his girlfriend into the air, but when I saw I'd need to fill in a background I hastily decided to add a few more bodies – which I'd much rather paint – instead.

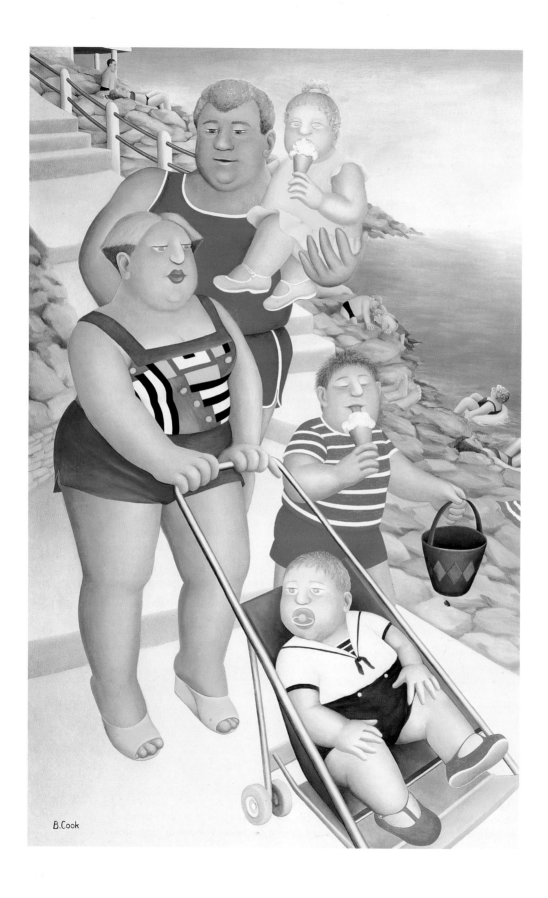

B.Cook

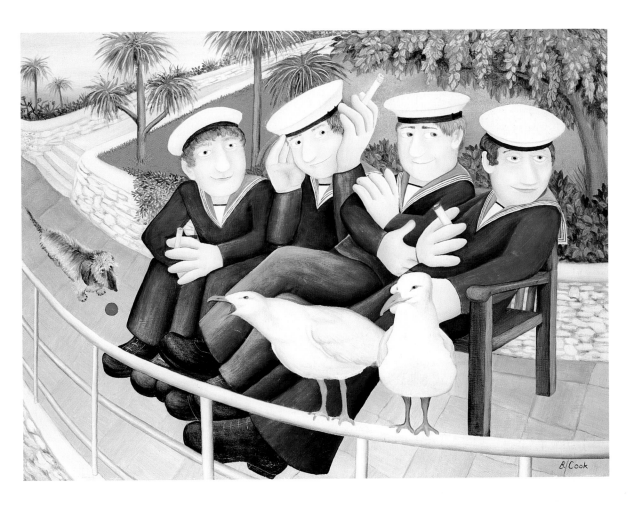

Sailors and Seagulls

I often used to watch the seagulls but they were not very obliging about staying still for me to draw them and eventually I had to use some I found in a book. The sailors are eyeing a likely prospect just about to enter the picture, whilst Bonzo waits hopefully for someone to throw his ball. He's actually there because he was just the right shape to fit the pathway.

Going Swimming

I saw this young family walking on the Hoe but I wanted a picture of the sea so that is where they are going now. There isn't much sand in Plymouth, but there are lots of little sunbathing terraces among the rocks, where people spread their towels and lie sunning themselves. I hope these boys won't be too disappointed by the lack of sand, but at least one of them has an ice cream for consolation.

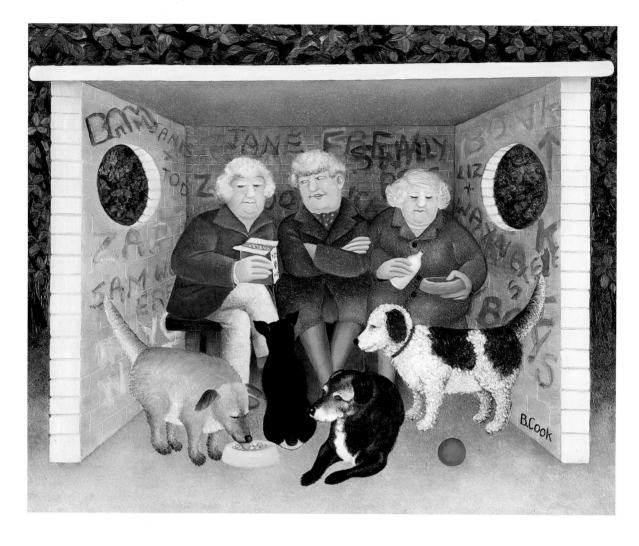

A Short Pause

We used to take our little terrier, Lizzie, for walks through a large park, and our route took us by this hut. It had been covered in graffiti so often that eventually no effort was made to clean it – an invitation to meet Steve in there at six o'clock for something revolting always caught my eye. Regardless of their surroundings these ladies always met there to chat and provide titbits and drinks for their dogs at about three o'clock every afternoon. I've added a back view of Lizzie to the group; she would willingly have joined them for a biscuit. Years of graffiti on walls takes quite a long time to reproduce, I found.

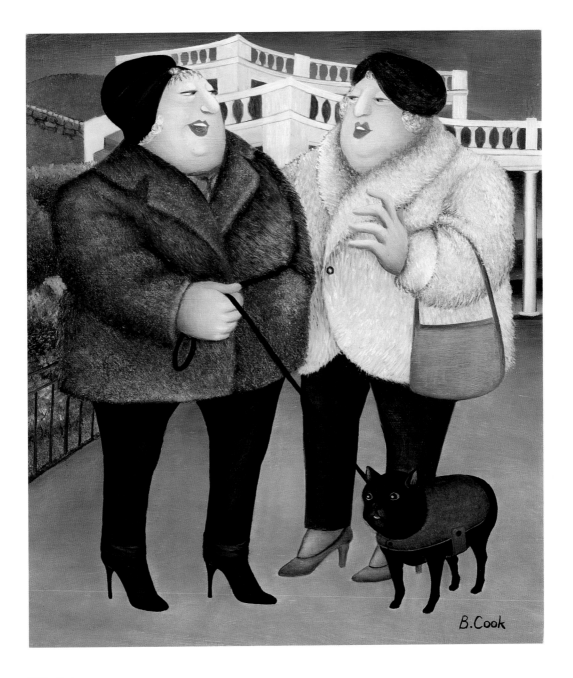

Walkies

Here are two ladies I used to see on the Hoe. One cold day I found them chatting together, with the portly little dog patiently waiting for the conversation to finish. All three were dressed for winter and looking very cosy in thick warm coats. I had often wondered how I could get the decorative white colonnade on one of the paths leading to the sea front into one of my paintings, and this proved to be my opportunity.

Punks on the Hoe

After Bonzo and I saw these punks rollerskating on the
Hoe I hurried home to record as many details of their
clothes and hairstyles as possible, a never-ending source of
pleasure to me. My own choice would be leopard-skin
hair. I have been told that the way to get the hair standing
in peaks is by using soap. I feel that I haven't got time for
this in the mornings, but my hair often looks like that
anyway.

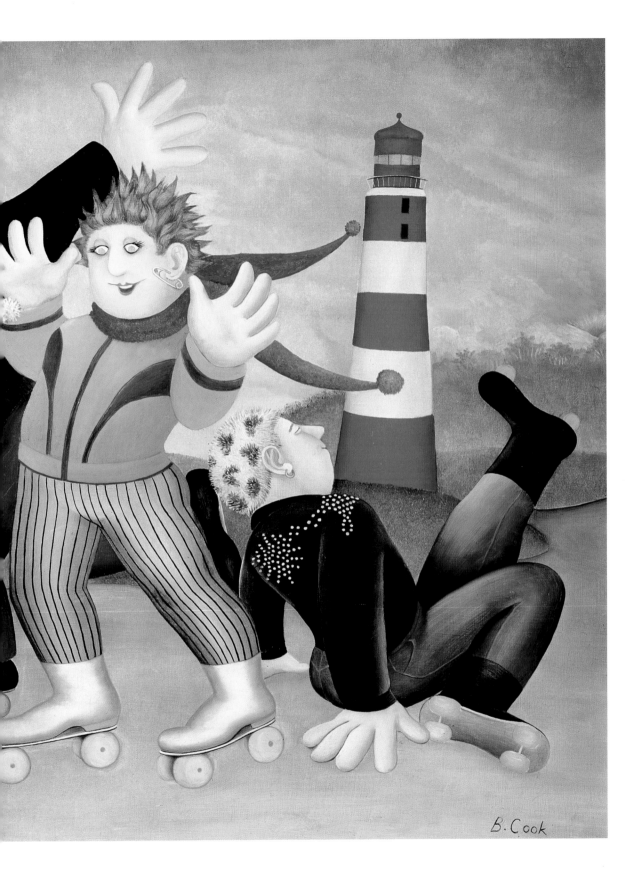

B. Cook

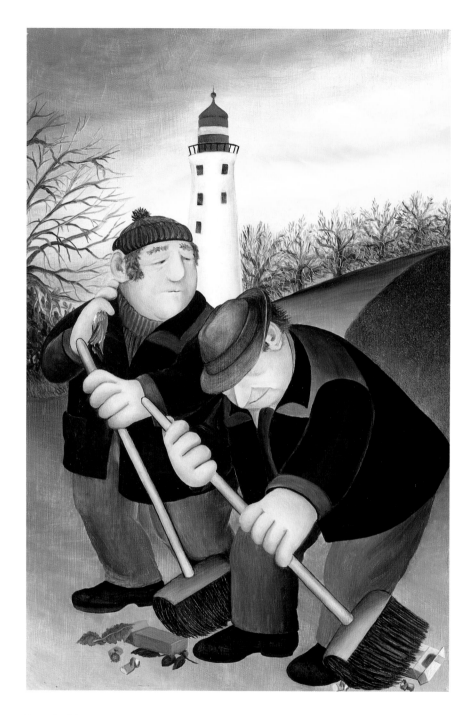

Park-Keepers

I would like to be able to paint the spectacular skies I see sometimes on cold winter mornings, but I'm afraid my efforts turn out to be rather feeble. However, here is my version of the Hoe in winter, with two park-keepers. They are very hardworking and are starting work early in the morning, just as we are taking Bonzo for a walk.

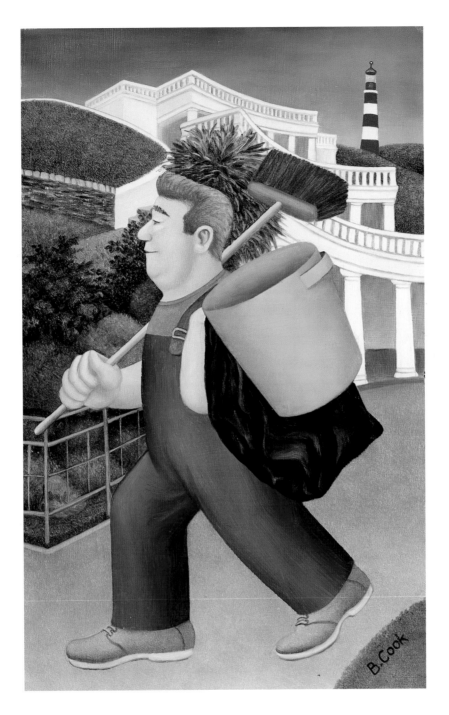

Gardener on the Hoe

Here is one of the Hoe gardeners: I saw him marching along with his bucket and black bag and decided to paint him. The gardeners wear smart green uniforms and do a very good job all over the city. Whenever I painted the Hoe I always liked to include the lighthouse if possible, and here it fits nicely into the corner.

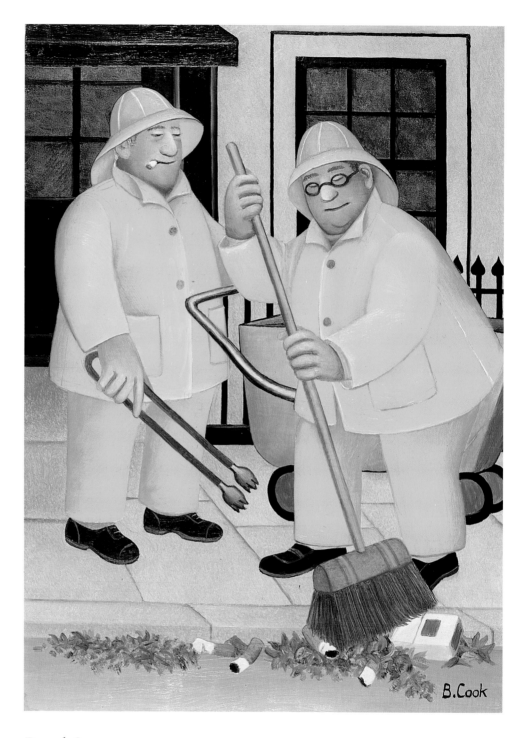

B.Cook

Road-Sweepers

The bright yellow outfits must be the attraction for me as I've done several paintings of road-sweepers and workmen. This one was painted for a charity some years ago, and I remember following these men around as they busily swept the pavements. They were wearing hats as it was pouring with rain, which I haven't managed to depict, but the gutter is rather good, isn't it?

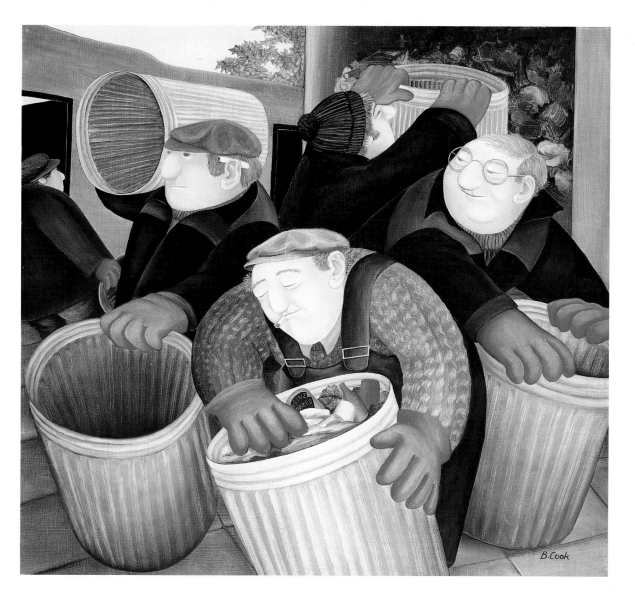

Dustbin Men

I little knew that this picture I painted of the dustbin men cheerfully getting rid of our rubbish would be all that I'd see of them for a month or so, since the very next day they all went out on strike. I had gone out to open the back gate for them and liked all the bustle and activity going on, especially with the large rubber gloves. Not *quite* so large or tomato red in reality, I suspect.

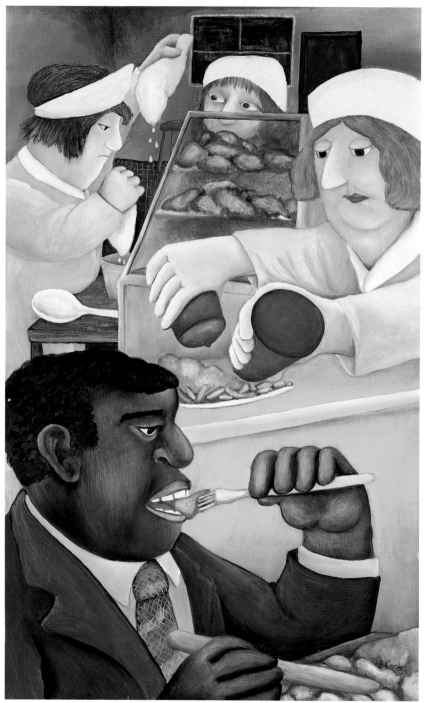

Fish and Chips

I like painting cafés (I like painting *everything*). I had some difficulty getting a figure into the front of this one until I remembered a black man I'd seen in Looe, had a go at fitting him in here, but was surprised at the contrast of colours. So much so that I put it away in a cupboard, the treatment some of my paintings receive when they don't turn out as expected.

Breakfast Time

(opposite page)

They serve wonderful breakfasts in Littlewoods. I have never actually indulged myself, but I was terribly tempted each time I went in there, which was often. When I last looked there was a choice of five items for only 99p. It is such a bargain that an orderly queue always forms as soon as the restaurant opens. As you can see, I had many a good look at the food passing by, and admired the excellent cooking. The weather was cold when I painted this, just right for a piping hot breakfast, so one of the customers is warmly dressed in a big spotted mock fur.

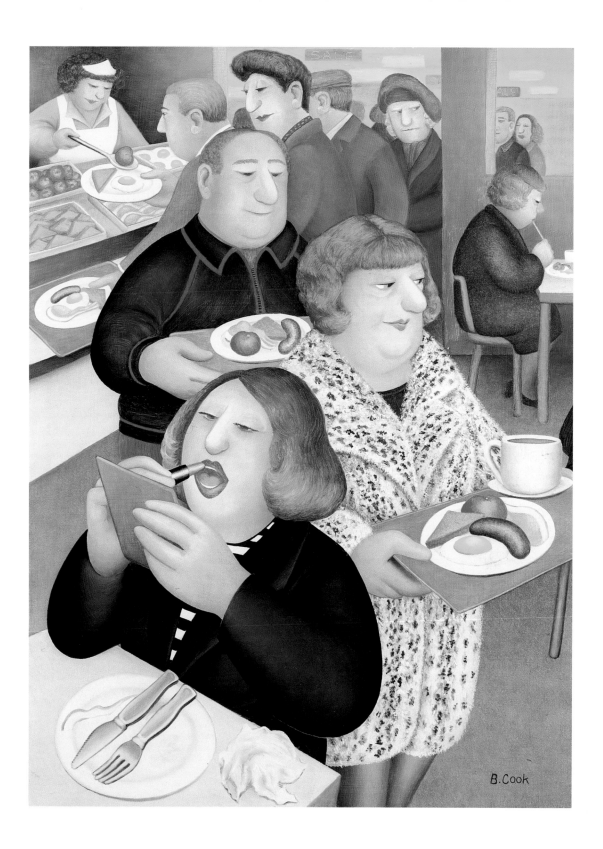

B. Cook

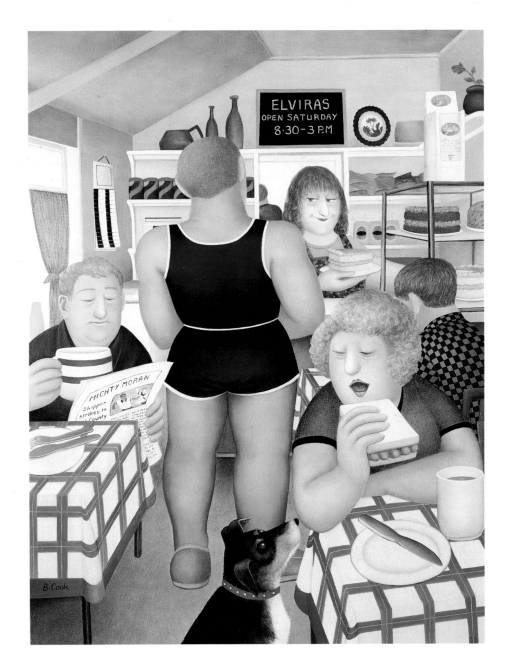

Elvira's Café 1

This is a picture of my son and daughter-in-law's café, in which they serve sausage sandwiches, amongst other things. It was the first time I had heard of these tasty items and I questioned Teresa closely about how they were assembled and how many sausages were used. Here you see one about to be tackled by the lady in front, with Teresa enjoying the view she had of one of the many handsome marines who frequent the café, for they are stationed in barracks just around the corner. In the summer they sometimes arrive in sporting gear, like this vest and tiny shorts. Dogs go in with their owners as well and they often get little treats from the leftovers.

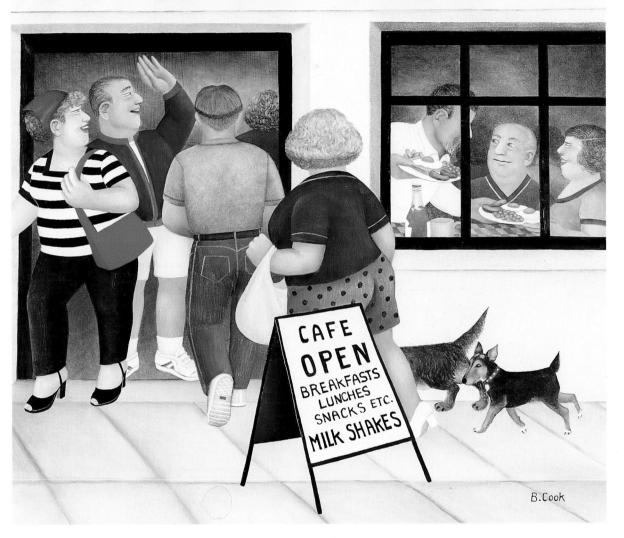

Elvira's Café 2

After I'd painted a picture of the interior the building was enlarged, and this is a view of the outside of the café. There's also a glimpse of our son through the window, serving breakfast. He's more likely, though, to be found at the back, cooking.

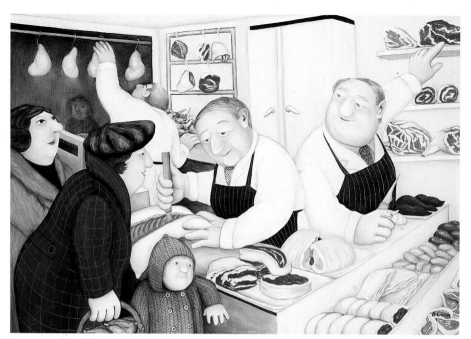

Butchers

This is the butcher's shop early in the morning. I'm always rather nervous when they're chopping or sawing the meat, and became mesmerised by the bandaged fingers whilst waiting for my order one day. I got the shape of the joints from a diagram in a cookery book but feel I haven't done justice to the luscious pieces of beef usually on display.

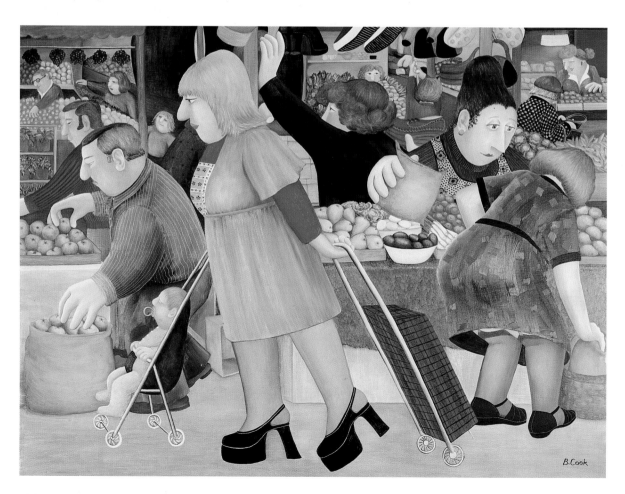

Tesco

Once a week we go shopping for our groceries, and the necessities – such as beer. I like supermarkets, with all the activity and bustle, and I have made many attempts at painting them. This was the first time I succeeded in getting a picture, and very hard work it was doing all those tins. The assistant with the large foot is not flying through the air, but climbing up to stack the top shelf.

The Market

One of several pictures I painted of the market, which I visited most mornings. Early, too, as I liked to see all the fruit and vegetables being arranged as well as being on the spot when the best bargains were to be had from the junk stalls. The girl in the front, expertly manoeuvring both baby and shopping trolley, hadn't quite reached the market when I saw her but was heading rapidly towards it.

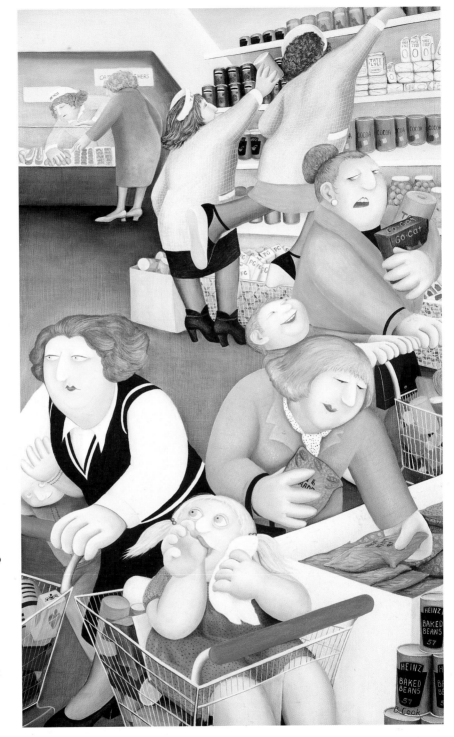

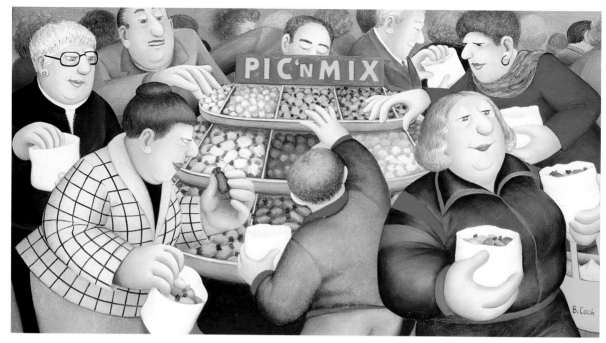

Pic 'n' Mix

Pic 'n' mix is one of my favourite occupations, always followed by sit 'n' munch as I'm painting or drawing. I don't feel guilty about the large floppy waistline this activity has produced – old age allows these little indulgences, I tell myself. I used to feel very guilty indeed, though, as I crept in to steal my granddaughter's sweets while she was asleep in bed. I am the only grandmother I know who would stoop as low as that. Now she is slender and graceful and I am pearshaped, so perhaps I've got my just deserts. I didn't have too much trouble preparing the materials for this picture – an extra large pic 'n' mix was purchased specially for it.

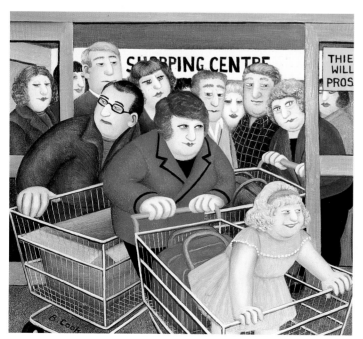

Shopping

We prefer to go shopping early in the mornings and sometimes have to wait for the supermarket to open. There is always a small crowd gathered – a large crowd if it is the start of a bank holiday, which is when shopping frenzy reaches its peak. We experienced shoppers really come into our own then, edging to the front by ruthless manipulation of the trolleys and rushing first through the doors when they are opened. I'm so fast I've already left this picture and am at the other end of the store with my trolley nearly full.

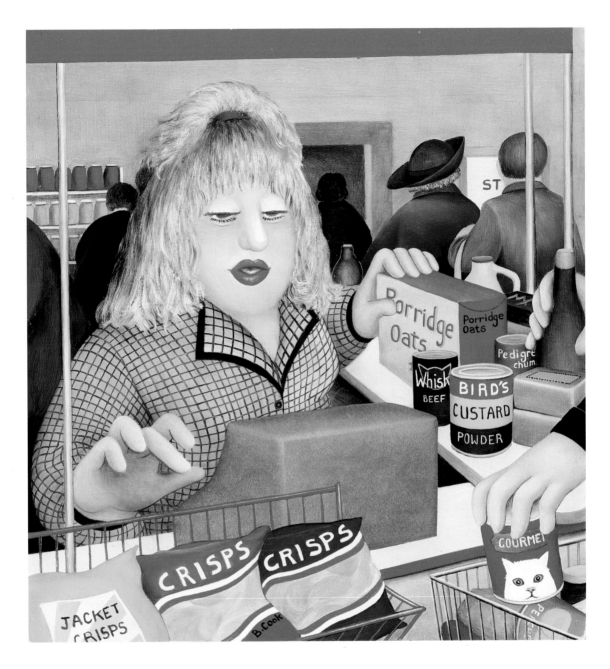

Checkout Girl

I grew fascinated by this girl at the checkout till in one of our supermarkets, and always waited in her queue. The mountain of hair first drew my attention, and then I saw what a perfect mouth she had, painted a glistening scarlet. She was always very pleasant and great was my disappointment when she suddenly disappeared, for I had started a picture of her. The hair was the most difficult part of this painting and I strove long and hard to get a sufficient quantity of golden tresses to cascade from her head.

Window-Dresser

I am intrigued by the mannequins I see in shop windows, perhaps because of the rather grotesque positions they are forced into in order to show off the clothes. My attention was first drawn to a little, well-rounded window-dresser who changed the outfits every morning. She was so different from the models she was clothing and extremely nattily dressed herself, often in clinging tights or micro skirt.

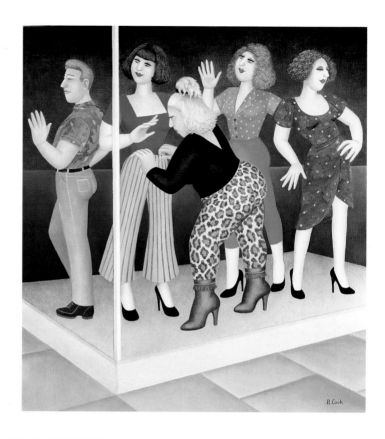

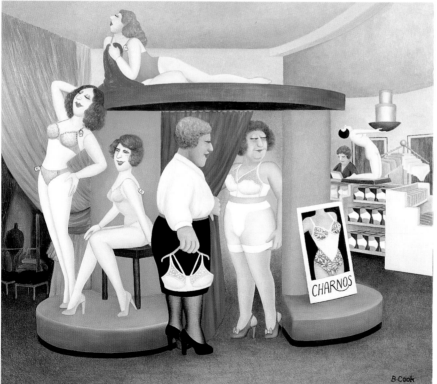

Underwear

The lady in the dressing room is wearing a bargain I found in the sales, when I was in the corsetry department of one of our large stores examining the latest aids to obtaining a more svelte figure. This little purchase I tried on at home, causing such mirth that after I'd used it for the painting it was put to rest at the bottom of a drawer, never to see daylight again. The customer here looks quite pleased with the effect, though: I think she'll buy it.

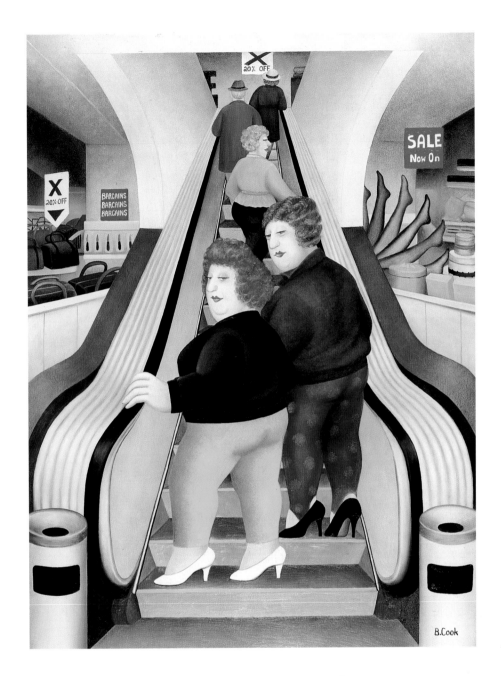

The Escalator

I'm quite often requested to paint ladies in leggings. I've even been sent photographs of suitable models, and this escalator seemed an ideal place to put some. I had taken a photograph of it in a local store and liked the striking design it made. Leggings were very popular in Plymouth, those of really exotic clashing colours being the most popular of all, though I'm sorry I was not able to depict them here. But I did have a chance to include the row of elegant legs used for displaying stockings, which rather pleased me.

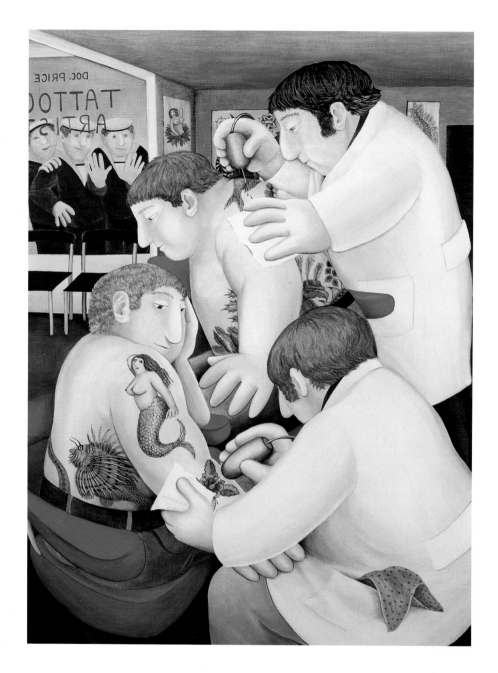

Tattoo Artists

When I used to pass Doc. Price's tattoo shop I was often tempted to have one done myself: something rather genteel, I think – like my paintings. Once I saw some sailors peering through the window to see what was going on, and another time I was able to watch a young man having his arm tattooed with a flower. To my surprise I found that blood appears as the needles trace out the pattern; it had not dawned on me before that the procedure might be painful. I put both incidents together in the painting and gave him a mermaid and a fish as well, both rather suitable for a seaman.

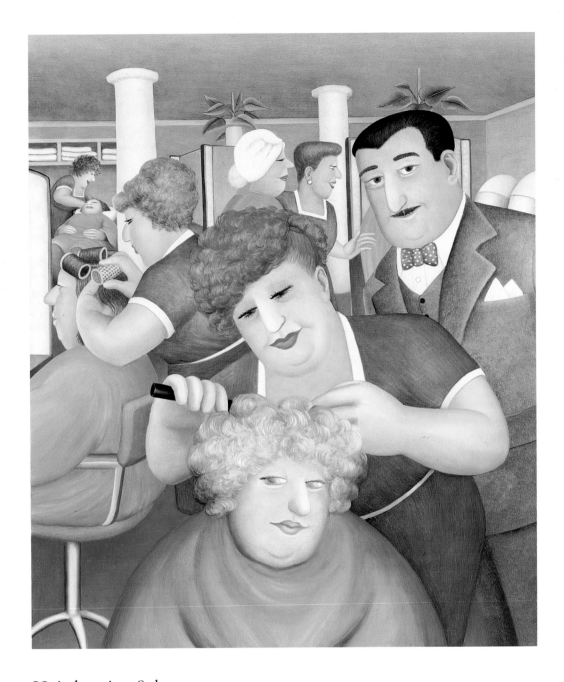

Hairdressing Salon

I'm always interested in busy hands at the hairdressers, and in the various new methods that arrive for teasing and crimping the hair. Shampooing, tinting, cutting and curling are going on all around me, and in the many mirrors I see reflections of the smart hairstyles gradually emerging from the capable hands of the assistants. There was only one gentleman in this salon – the head of the department – and he sometimes walked through to see that everything was going well, which I'm glad to say it was.

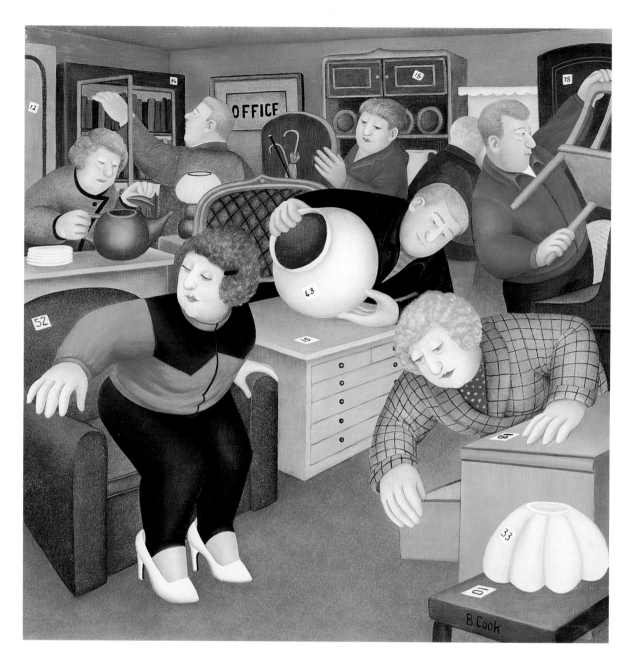

Auction Room

This is where a lot of the treasures in our house came from, here and the junk stalls. I visited this saleroom so many times, and found the seriousness with which each item was examined so appealing, that I decided to have a go at painting it. I didn't go down to bid, only to view. John did the bidding, and he told me once that one of our friends decided to play 'In the Mood' on an old piano during the proceedings, and received a sharp reproof from the auctioneer for his trouble. I was sorry I'd missed this episode, I must say. We now try to control our buying – there simply isn't any more room to pack it all in.

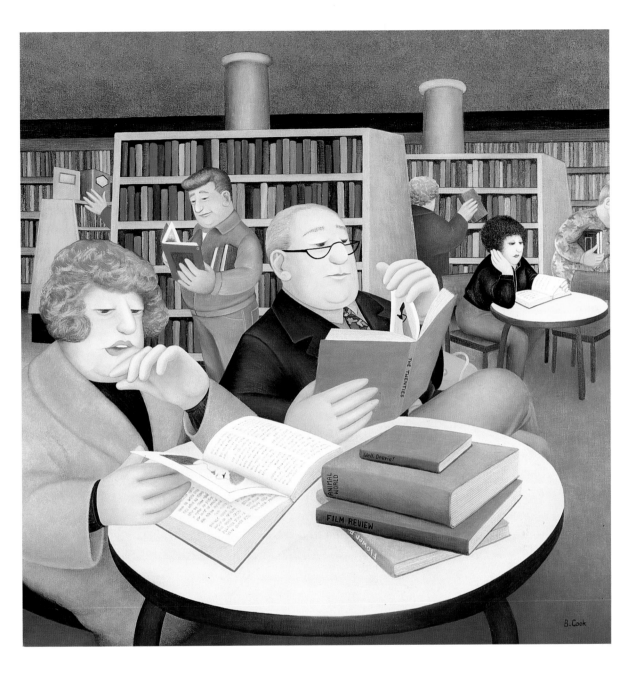

Public Library

I love reading, and used this library for many years. Libraries can offer me books for pleasure, books to tell me about other countries when we are planning to travel, books to show me what a bassoon looks like if I should suddenly need to paint one, and even a book to teach me how to paint it if necessary! For this painting I took notes of the bookshelves and furniture each time I made a visit so I could try to make it authentic. To get the books right I copied a pile of my own, artistically arranged on a nearby table.

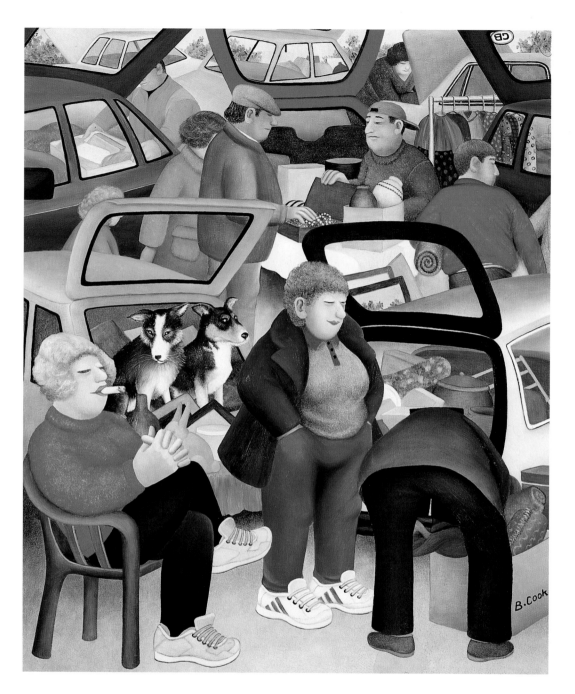

Car Boot Sale

I've been to several of these, but although I've bought many a little gem for 25 p I have never found out later on the *Antiques Road Show* that one of them was worth thousands of pounds. This is rather a satisfactory painting for me because I succeeded in arranging five car boots in a fairly small space. I didn't have far to look for junk to be tastefully arranged in the boots, since it's all round our house, crying out to be painted. A friend obligingly removed her trainers for me to use as models for the ones worn by the lady seated in the front of the painting.

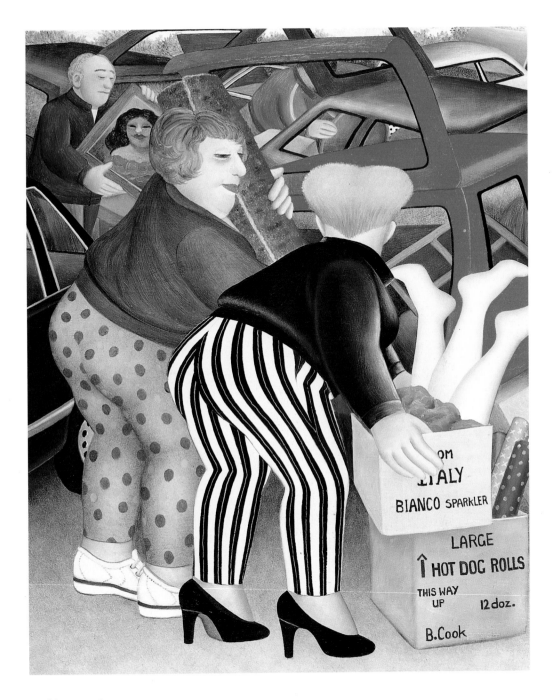

Off-Loading

After I'd finished the first car boot picture I found that I hadn't managed to include the legs. John bought twelve of these (by mistake) at an auction, and they were so popular amongst friends that I now only have three left. I like painting them and so I decided to do another car boot picture, which would also enable me to use a hairstyle I'd seen and sketched. This is the pale ginger back view, which had mesmerised me as I stood in a queue at a cash till.

Jubilee Day

This was the Queen's Silver Jubilee, more years ago than I care to remember. It was action-packed for us, and even more so for Harry, Tommy and Brian in this painting. Tommy sang and danced the whole way home in and out of the gutter, emphasising the high points of his song with the umbrella. Harry danced half way but gave up after a couple of falls and allowed us to support him whilst harmonising with Tommy. Afterwards I felt an urgent need to lie on the sofa but was startled to see Brian at the window dressed like this, a couple of hours later. In that time he had been home and made himself a complete Jubilee outfit and was setting off for the evening.

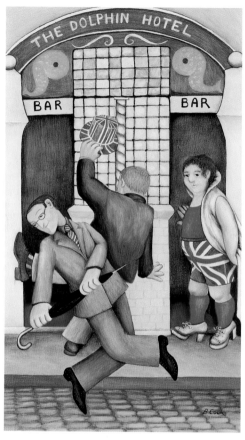

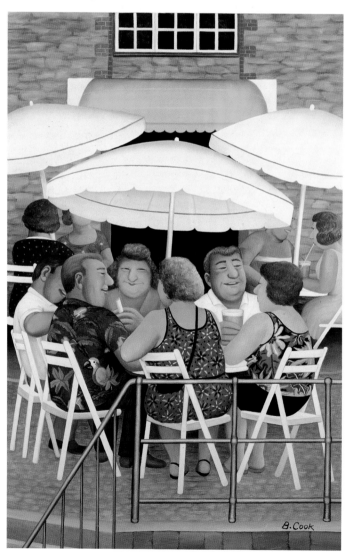

Summer Afternoon

These tables set out on the quay beside the water are always very well patronised in the hot summer sunshine. The children can look at the fishing boats and play around whilst the parents rest swollen ankles and drink in the shade of the umbrellas. One big family group has gathered round a table and are deep in conversation, with much laughter and occasional sorties through the door at the back to replenish their drinks. This picture always reminds me of hot summer days, and also gave me a chance to paint a favourite shirt of mine, covered in parrots and palm trees.

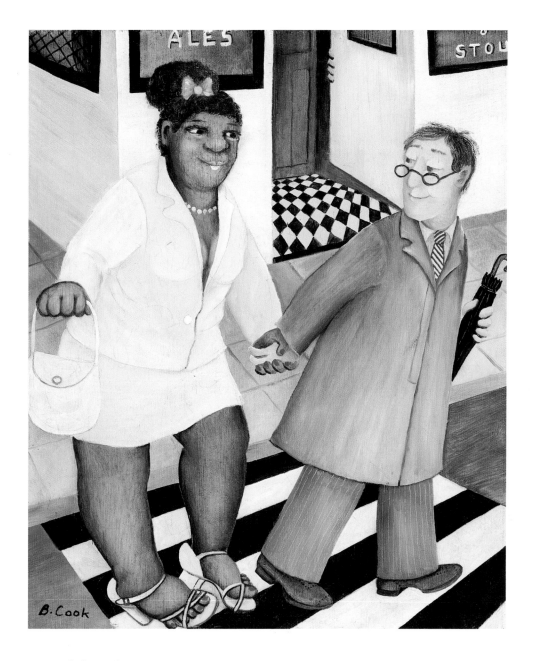

Handel and Liszt

We stopped to let these two pass – she rather unsteadily, and he most solicitous – and I drew them as soon as we got home. I was very disappointed with my attempts to get the tiles in perspective. How do other painters do it? I know they should be big at the front and small at the back but they still haven't come out right. Strangely enough I have been asked for advice on how to paint, and I hope one day to be able to give it.

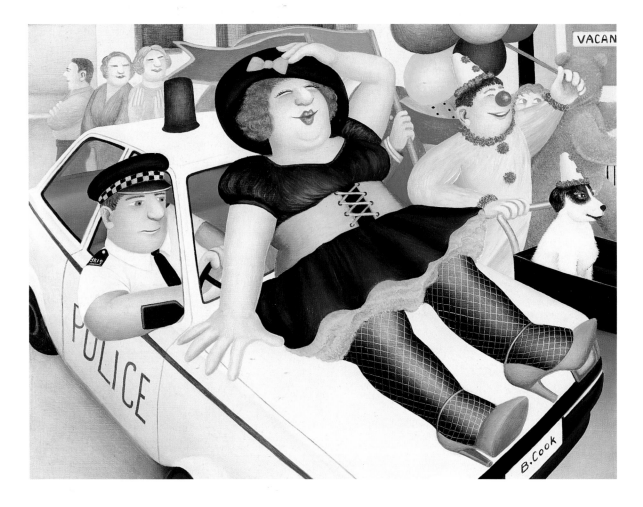

Carnival in Plymouth

A friendly Inspector from the Plymouth police force told me of a little episode that occurred while he was controlling the traffic during the Plymouth Carnival. Having marched, sung and cheered her way all round Plymouth, one of the performers was overcome by fatigue, and he kindly offered her a short lift on the bonnet of his car. I liked the story so much I decided to see if I could paint it. Our small dog Minnie makes an appearance, too, sitting quietly in a pram with a funny hat on – something she wouldn't have *dreamed* of doing in real life.

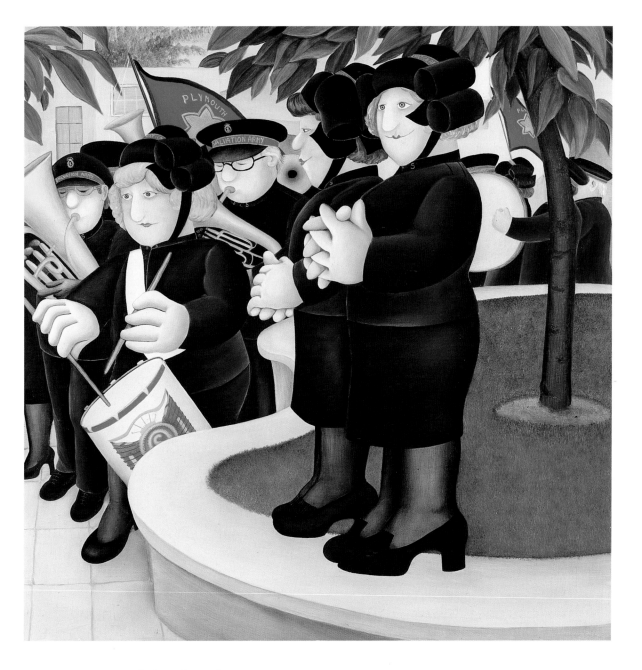

Salvation Army

The Salvation Army held a convention in the city centre one year. This I found very exciting for I love the bands and think the girls particularly attractive in their uniforms. I was greatly taken with these two, watching the marching and the banners flying, and after a lot of groaning and shuffling around copies of the *War Cry* (which we get in the pubs) I finally managed to draw and paint it.

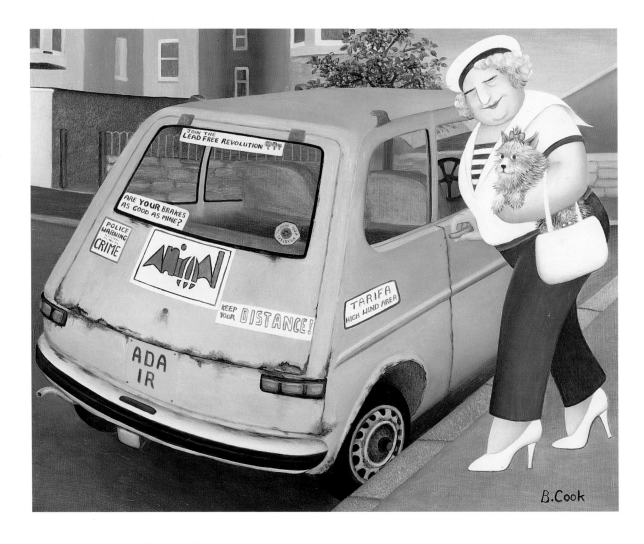

Rusty Car

For a long time this little car remained parked outside a house we passed each morning. I grew more and more interested as I read the messages and noticed the extensive rust, something I like painting very much. To finish the picture off I added the sort of person I thought might own a car like this, and then found a cherished registration number from one of the long lists they print in the Sunday papers.

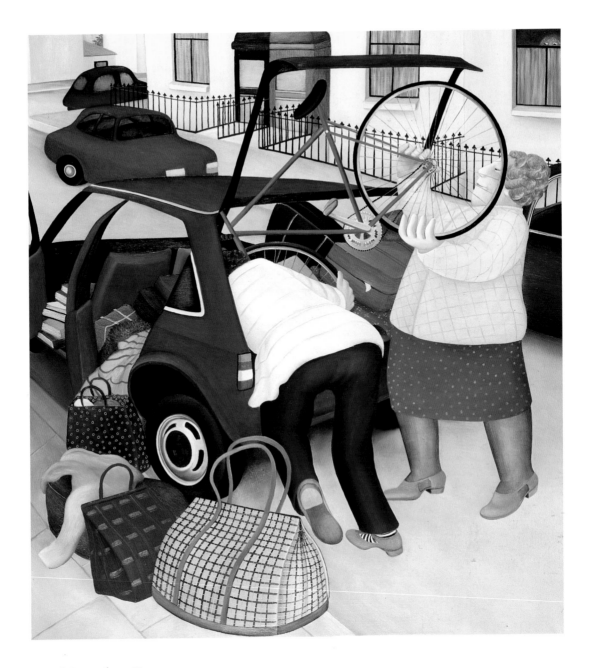

Packing the Car

Some friends of ours came to stay and this is a picture of them packing the car ready for departure. As you can see, there is rather a lot of luggage, even a big pile of books ready to fall off the front seat. This is one of my few attempts to paint the street where we lived – much busier in real life and with many more cars, but three was the most I could manage to fit in. Although I don't drive I rather like cars, especially those expressing the flamboyant tastes of their owners. One parked near here had a complete beach scene in the back window: the sand was a yellow fur fabric on which small furry animals reclined in bathing suits, with a few shells and a miniature bucket and spade adding the final touches. My husband has yet to be convinced that we too need something like this in the back of our car.

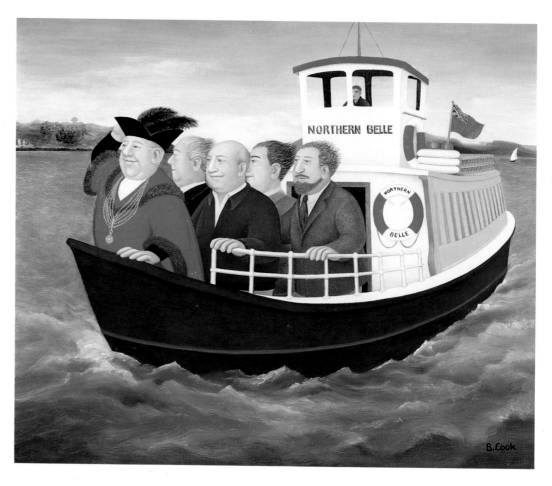

Going Towards Art

Some years ago Plymouth took part in an artistic celebration called the Four Cities Project, when artists were invited to set up various happenings around the city. Lights were strung in a pattern across Drake's Island, irregular spurts of water came from pipes in an old warehouse, and an attachment was made to an abandoned railway bridge. There was also an underground happening across the water at Mount Edgcumbe, and Bernard Samuels from the Arts Centre, who was explaining the scheme to me, said that the Mayor, himself and several others would be travelling across on the ferry. This was the most exciting happening of all to me, and in no time at all I had sought out a picture of the Mayor in his robes and taken a photo of the ferry. Bernard can be seen behind the Mayor, the others I made up – with carefully tousled hair, for it would have been a blustery crossing.

Picnic at Mount Edgcumbe

This is what the ferry party might have seen on their arrival. It is such a lovely park and playground, and so large that however many people go there it never seems crowded or uncomfortable. The dogs enjoy it just as much as the children, and there are benches and tables there for picnics. This one has some hefty sandwiches, and pasties too as we are in Cornwall. I saw this young woman playing ball and liked the way she threw herself up in the air. I felt I had to add our little dog Minnie to the group, since this was her favourite game.

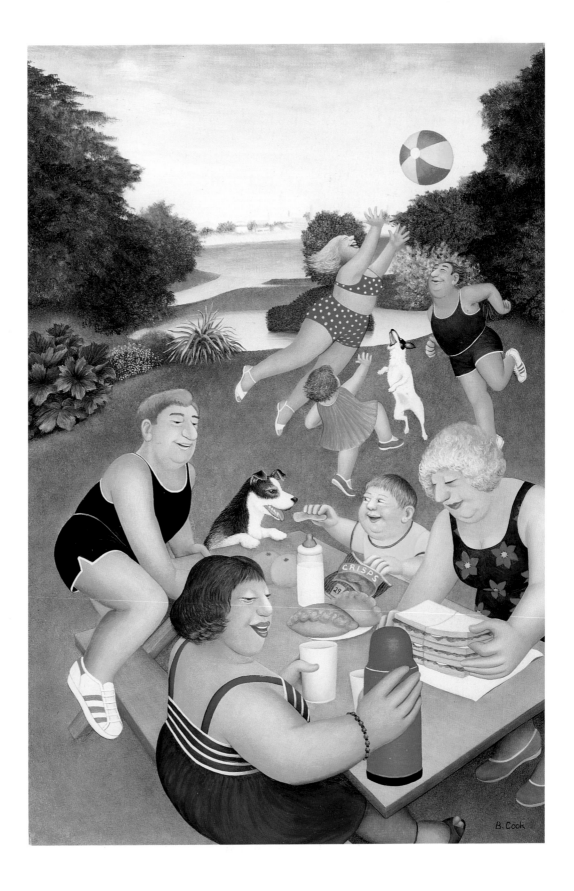

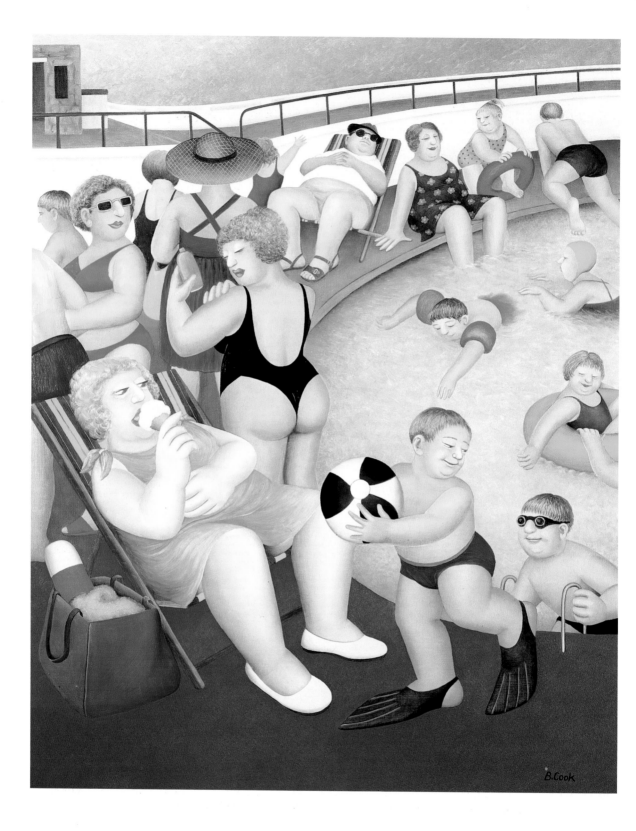

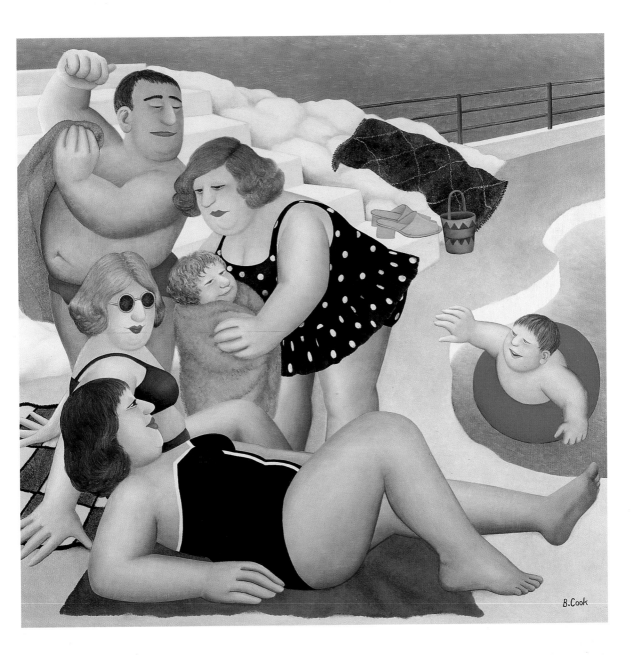

Bathing Pool

If only the outdoor pool was still humming with activity like this. It is very nicely placed on the seafront and years ago it did a thriving trade, with children playing in the fountains and deckchairs laid out all round for us onlookers. But a few bad summers and a lot of foreign holidays closed it down. When it seemed likely that this would happen I thought I would paint it in happier times, and include the girl wearing the cutaway swimsuit I'd recently seen on a nearby beach.

Summertime

Here is a corner of the same old swimming pool, which I chose as the background for this family party. I like watching everyone enjoying themselves in the sunshine, having picnics and swimming, so here they are, one little boy still in the water. What I haven't painted – but hope they have with them – is a huge picnic basket, full of goodies.

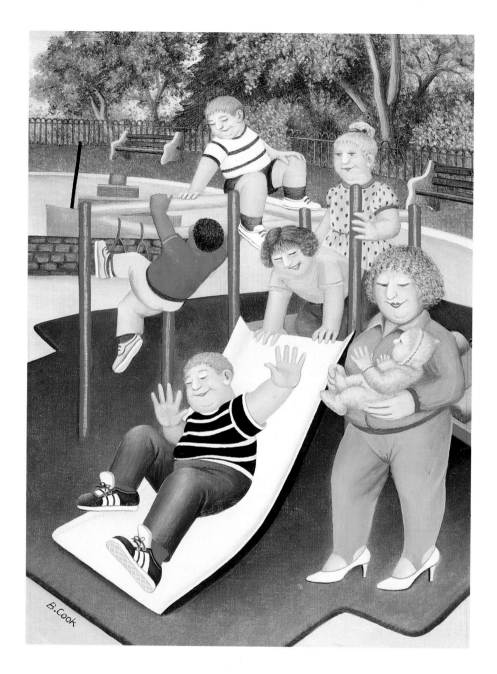

Children's Playground

The bathing pool may have closed down, but there are still some good playgrounds in the parks, one of which I used to pass nearly every morning when we were out with the dog. I was asked for a painting for a children's charity; sometimes I paint fairies for these but this time I decided to do the playground with children playing. The trainers the little boy wears have large tongues emerging from the laces, all the rage when I painted the picture.

London

I love cities – the constant bustle and colour at all times of day and night – and London is the best of all. We often go there for holidays, and it has proved a marvellous source for paintings. It is rare for me to return home from our visits without a picture or two forming in my mind. It might take a year or two before they get onto the boards though!

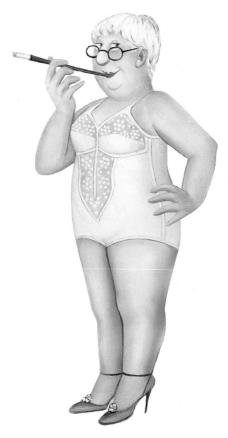

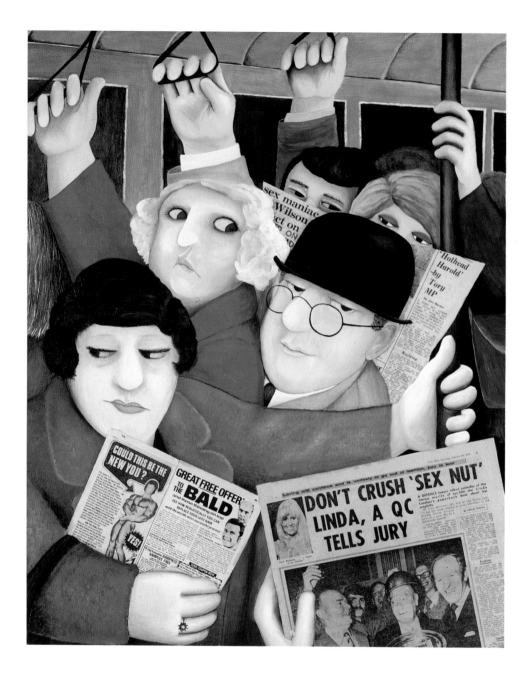

Togetherness

This picture contains some of my favourite subjects: large hands and lots of them, newspaper headlines, and a dirty old man. I don't know if there are many of them around now – when I was young there used to be plenty in the tube trains. I have painted him one way or another at least three times now, always making the girls suitably indignant.

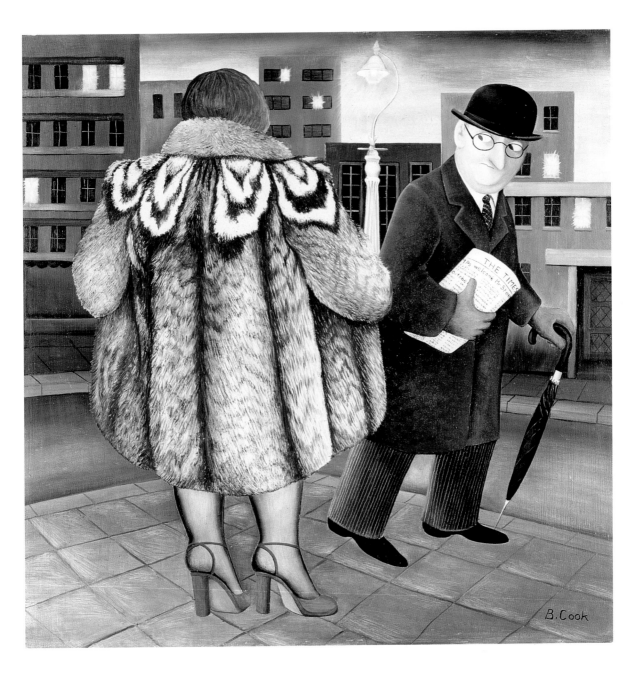

My Fur Coat

Having decided to paint my fur coat displayed to its best advantage – from the back and open wide – it only needed a gentleman passer-by to complete the picture. Believe me, it was not easy getting just the right expression of mingled horror and pleasure on his face.

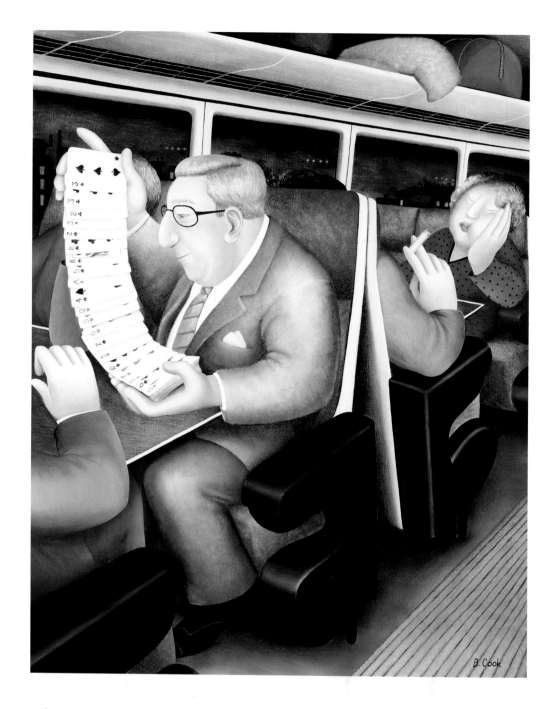

The Fan Shuffle

I like journeys to London on the train, even without the toasted bacon sandwiches that used to be served. There is the first rush on board to get a good seat, the stacking of the luggage, and finally we settle down to the coffee bought with foresight from the station bar. Seats are often reserved with newspapers and briefcases in some sections for the card schools, dedicated players sometimes drawing an audience. The clicking and shuffling of cards beside us on the way to London were the inspiration for this picture.

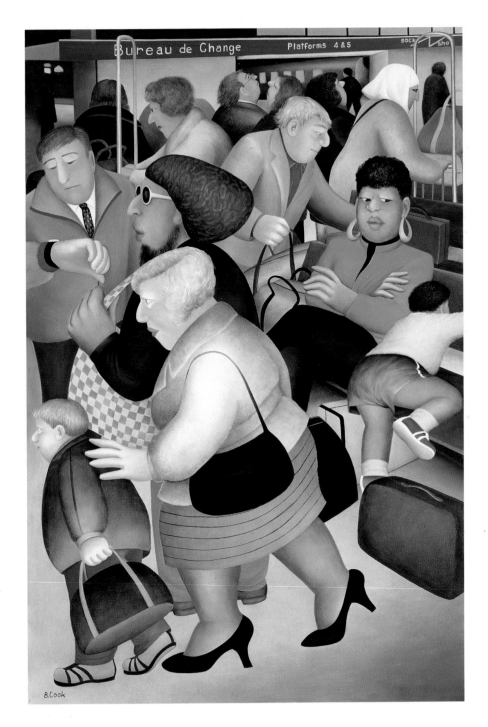

Paddington Station

I know more about Paddington than any other station in London. Years ago I travelled there daily from Reading and I remember the time when there were cosy coal fires in the buffet. In this picture I did a bit of rearranging of the station seating, to enable me to get in all the various activities of people starting and finishing their journeys. Or just sitting and waiting, sometimes impatiently, I expect: but not on my part, for there is always so much to watch.

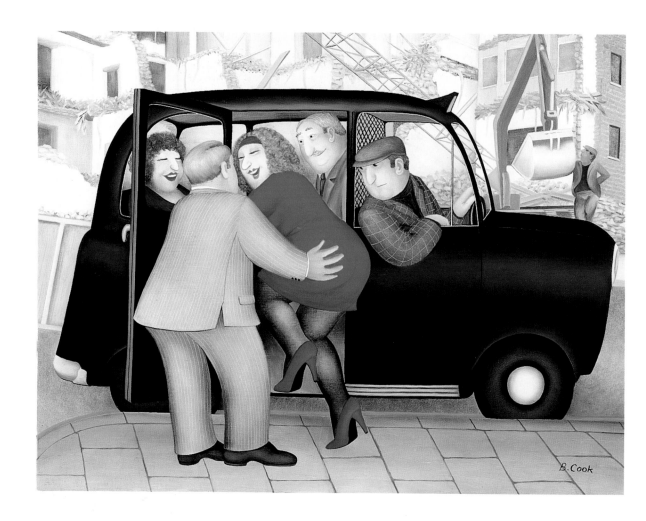

Taxi

And talking of taxis, here is one, chock-full with some colourful characters I thought the driver might like to carry. As there always seem to be massive building operations going on in London, and one of the biggest was right beside where we were staying, I used it as a background. I have trouble depicting highlights (paving stones as well, judging from the tiny size of these), so this is an old taxi that has seen better days instead of a nice bright and shiny one.

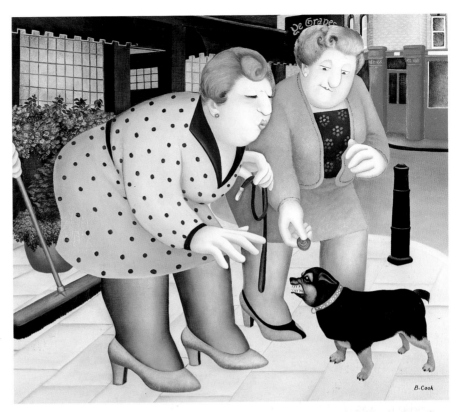

Buster

Near the Grapes in Shepherd Market, Buster, a tiny fat dog in a large jewelled collar, appeared, followed by his owner and a friend. He was most appealing and quite accustomed to being petted and admired. But things suddenly turned ugly and he snarled and growled with all his teeth bared when the time came for his lead to be attached. Fortunately the friend found a chocolate (from Fortnum & Mason, I hope), and after a certain amount of wrestling all three trotted off.

Albemarle Street

In Albemarle Street there are several small cafés with seats outside, one of them used by taxi drivers for their morning coffee. We often stop there for sustenance ourselves, and one day, swinging down the street, came this lady with her three little dogs. She was tastefully dressed with brolly to match and passed us twice, so she was evidently making a circular tour.

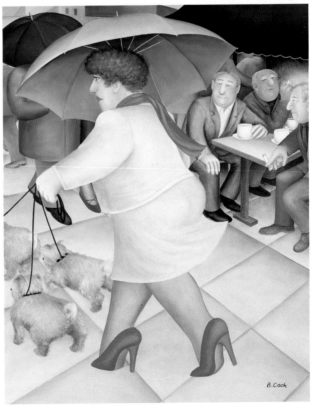

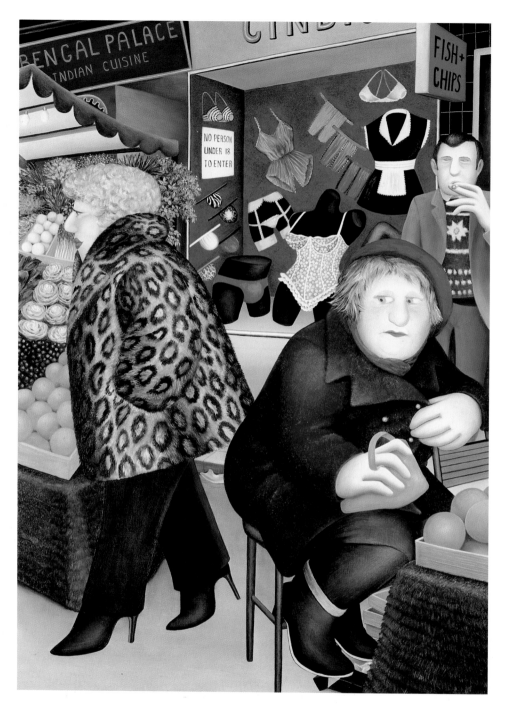

Street in Soho

I find it rather difficult to imagine myself in some of the underwear I see in the shops in Soho although I have tried to do so. We go past these on our way to buy fruit from the stalls in Berwick Street market, and lovely it looks too, all laid out to entice the customers. Another stop is the bookshop where I might find one of the annuals I used to read as a child in the 1930s. A big mock raccoon coat kept me warm on one visit, so I have given this to the blonde. The poor soul at the front is an old lady I saw perched on a stool beside her fruit stall, abstractedly watching the passers-by.

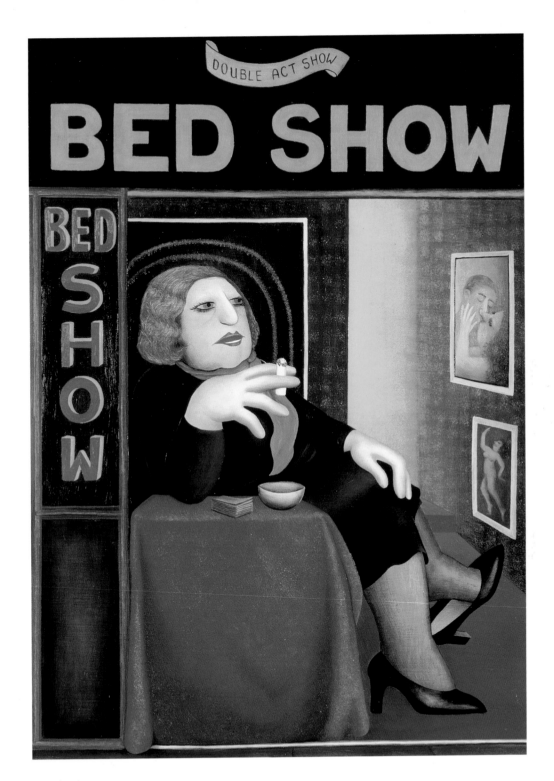

Bed Show

This lady, seated invitingly in an open doorway, was quite serene. The night was young and business was slow, but everything is ready for the rush. Meanwhile, a quiet smoke and some philosophical contemplation.

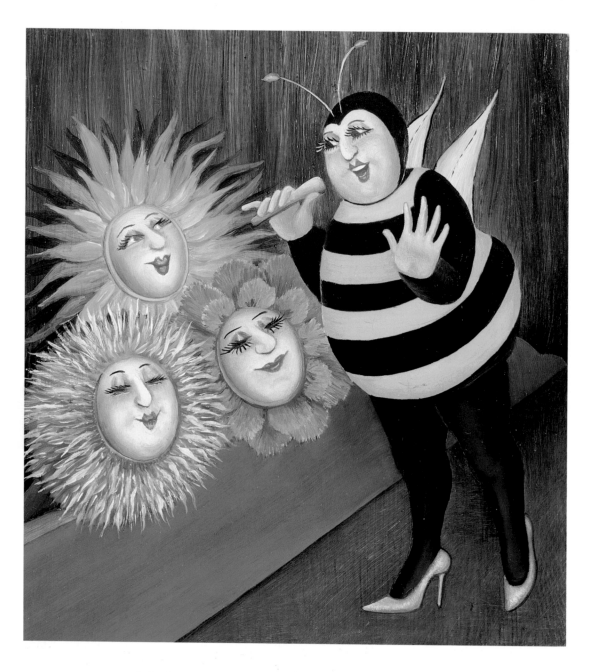

Madam Jo-Jo's

We passed the Bed Show on our way to Madam Jo-Jo's, a dear little theatre reached down a long flight of stairs. We sat in the balcony and watched the floor-show beneath us. To our great pleasure we discovered that Brian, an old friend from Plymouth, was appearing there. Here he is, dressed as a bumblebee and singing to some suitably attired 'flowers'.

Ruby Venezuela

The show was marvellous, such fun, and afterwards Brian asked if we would like to go to the Piano Bar where anyone who likes may sing a song at the piano. Some, I learned from 'Beryl' (who compères the show), may be allowed to sing longer than others, and there are just a few who will never be allowed to sing again after the first few bars! Here is Brian, dressed to kill in one of his Ruby Venezuela costumes, leading us up the stairs to get there.

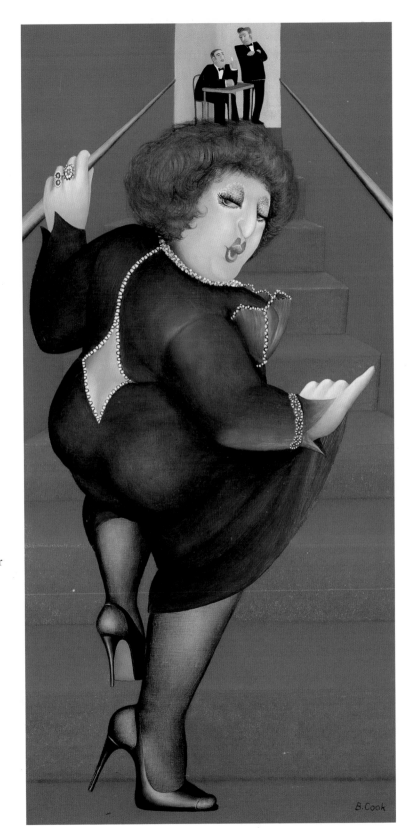

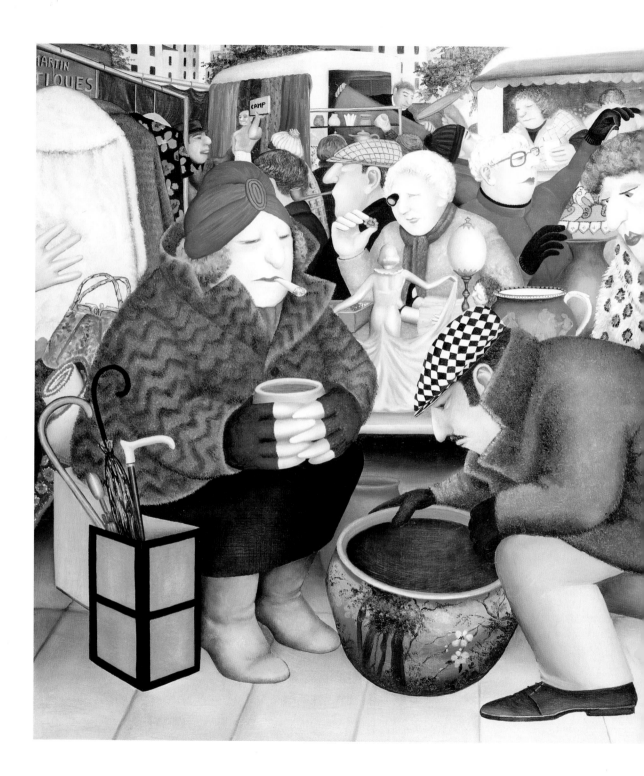

Bermondsey Market

All the best deals are done here before daylight in the
winter, and although we had breakfast at half past six,
by the time we got to the market, business had been brisk
for an hour or two. I'm addicted to junk, I'm afraid, and
will give a good home to any number of cracked, chipped
and unnecessary items. This of course involves further
purchases of cupboards and cabinets to put them in, and
I'm surprised we haven't yet had to purchase a warehouse
to contain it all. Some of this junk actually became useful
at last and has been carefully painted into this picture.
The ostrich egg is a particular favourite.

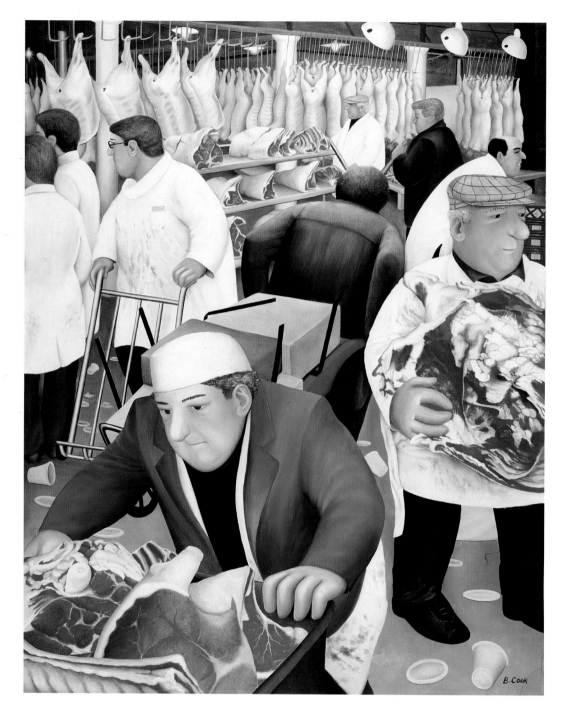

Smithfield Market

Another early morning visit. Exciting too with all the bustle and activity, great big sides of beef manoeuvred into place and row upon row of lambs' carcasses. Best of all were the dozens of porters busily lifting and pushing, and I have brought as many as possible into the picture. I needed to consult our own butcher several times when I came to paint the meat, and the fine large sirloin behind the shoulder of the man with the trolley is the one we enjoyed after it had served as a model.

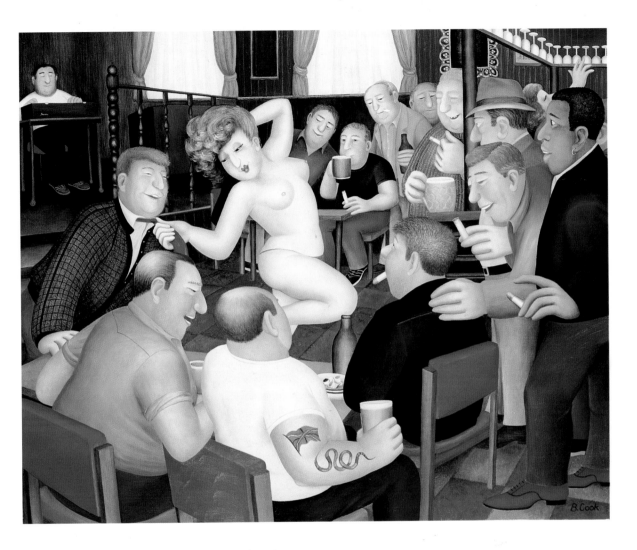

Lunchtime Refreshment

Down near the docks one morning we entered this nice old-fashioned pub, the Queen, for a well-earned drink, and a cheerful voice called out, 'Are you strippers?' The friend with us is in her eighties and I am a great-grandmother so in fits of giggles we settled down to a half-pint of beer and a doorstep sandwich each. To our surprise a lovely girl suddenly appeared and, dancing to music, peeled off most of her clothes. This was only a teaser, and a round of drinks later we had the full performance. What a bonus – and we'd only gone in to rest our feet for a half hour or so. Refreshed, we left to continue our journey.

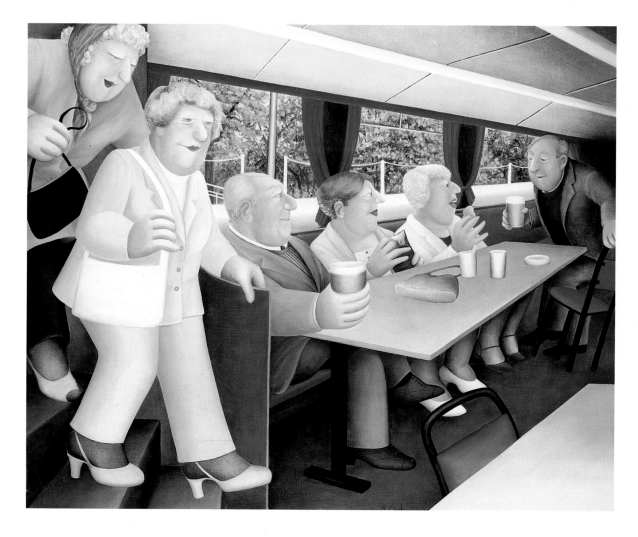

Riverboat

We decided to take the boat back to London from Kew, and this is the Queen Elizabeth, tiny riverboat sister to the QE2. Our sojourn on it was not long, alas. We arranged ourselves in good seats with a view, but as soon as it had filled up (to overflowing) we were told to get off as it had been booked for a private party. We were there long enough, however, for me to take some notes. I had been looking forward to the river trip, and it was a most comfortable boat with bar and refreshments which, fortunately, we had already sampled.

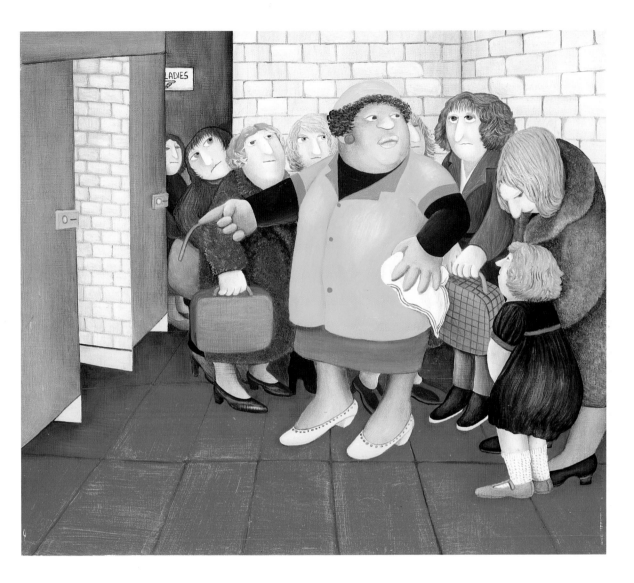

Ladies

This scene greeted me when I found a shabby old Ladies at Victoria Station, and I dutifully joined the patient queue. It did rather surprise me that we all so uncomplainingly shuffled along, jumping to obey the shouted commands. One poor soul mistakenly held a door open for the next eager occupant, and had to be very sternly reprimanded. She won't do that again.

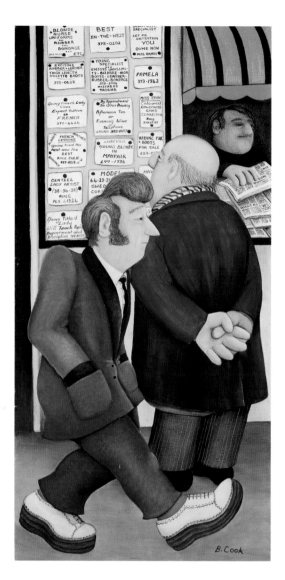

Teddy Boy

John saw this Teddy Boy walking down Charing Cross Road, very proud of his appearance, and pointed him out to me. On the way back to the hotel we stopped at the tobacco kiosk nearby to read the cards – plenty of French lessons as usual – and to find out if any good ones had been added, and we decided to copy them all down. This took rather a long time; when we had finished we turned round to find that a small crowd had gathered behind us, and we scuttled off furtively.

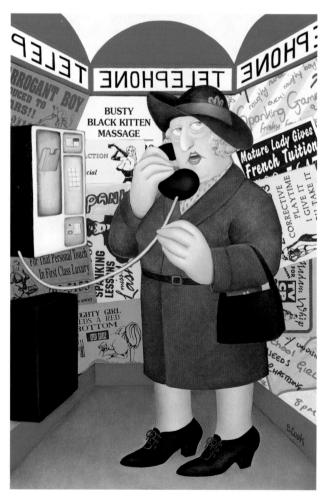

Telephone

Here are some more of those cards, a present from a friend who collects them from London telephone boxes and regularly sends them to me. Some of them are illustrated and others written out by hand. What full days (and nights) these girls must have – writing out and placing the messages, rushing back home again to receive any calls and then possibly having to strap themselves into a restricting little black leather number ready for action. The lady on the phone is not ringing for any of these, she's just chatting to a friend. I used one of the old red telephone boxes on the Hoe as a model for this painting.

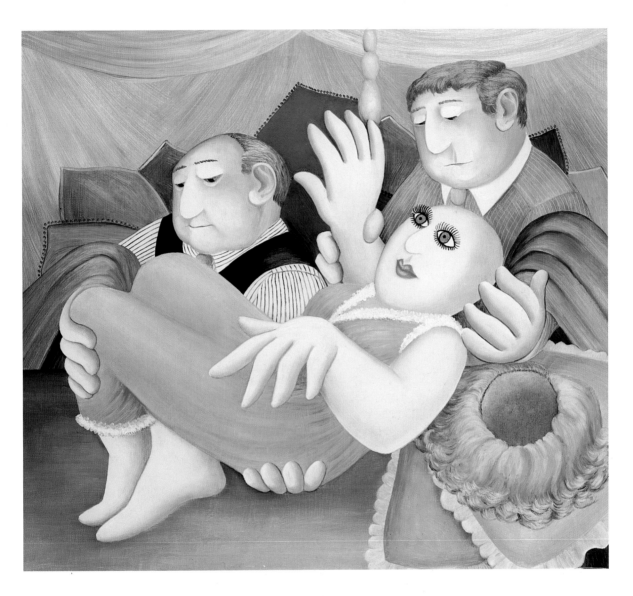

The Bald Lady

This sight was revealed when the lift doors in a large store opened wide for a few seconds and closed again after leaving the scene imprinted on my mind for ever more. Even now I can clearly see these two men struggling to arrange the mannequin on a large, luxurious, four-poster bed. As her wig dropped off onto the pillow I knew instantly that this would be my opportunity to paint a bald lady.

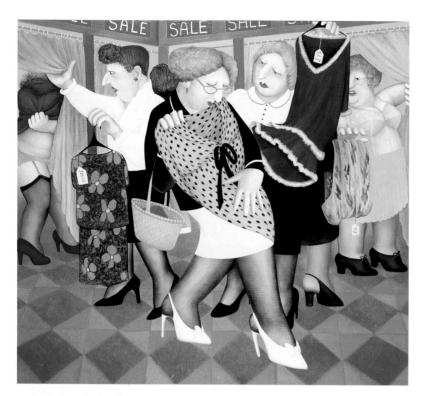

The Sales

A stay in London means a look in the shops, and the sales will always tempt me in to find a bargain. Many are the grave mistakes I've made in getting one: discovering this, in the privacy of the hotel bedroom, there is then the problem of finding an extra suitcase. The method I now use is to attend the sales, touch and try on to my heart's content, then put it all back on the hangers and march smartly out of the shop. This is most satisfying (and economical).

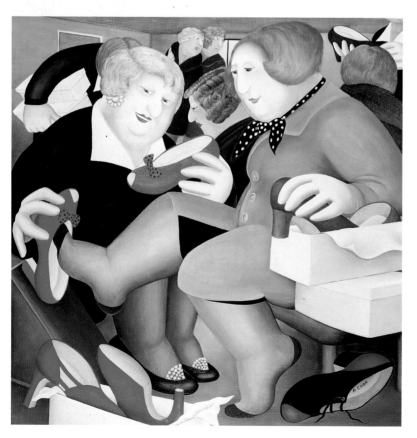

Shoe Shop

Shoes also receive minute attention from me, and I'm very interested in the changing styles. I was delighted at the recent return of the three-inch platform soles that were in vogue a few years ago. This style has now come round three times in my lifetime, the first being more than fifty years ago when I wore a pair to my wedding. Now I'm afraid they might be a bit lofty for a great-grandmother, and my jumbo-sized plimsolls enable me to criss-cross continents in the utmost comfort.

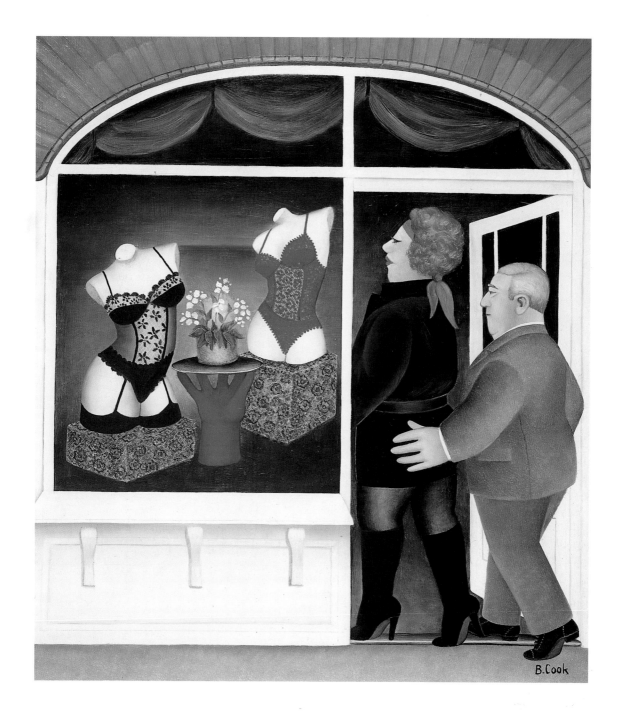

Lingerie Shop

I gazed in here as we passed it on our way to the Portal Gallery, and took such a fancy to the underwear I decided to paint it. Whilst discussing this with a friend, I learned that portly little gentlemen often escort their lady friends into the shop to buy them something nice. I expect they need portly little gentlemen to do the purchasing as it all looked lovely but very expensive.

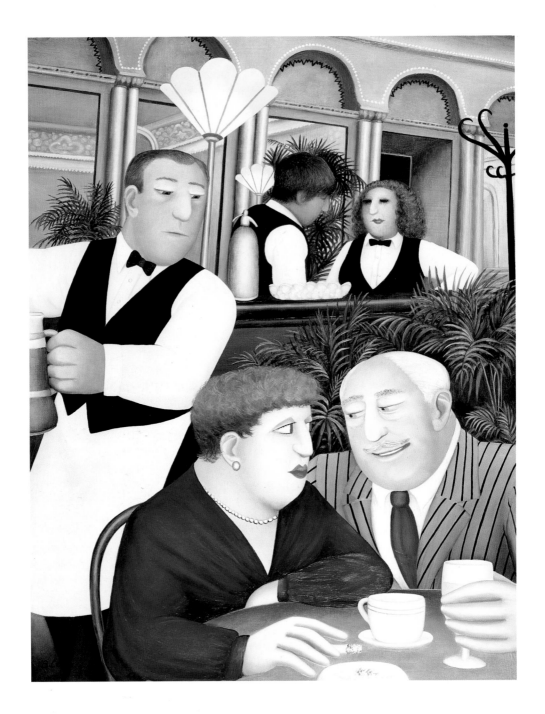

The Criterion

Just a stagger away, after an exhausting bout of shopping, is this cool and pleasant bar
and restaurant in Piccadilly Circus. Although I'm really only interested in the figures in
my paintings, and always draw these first, I have tried here to show part of the lovely
art-nouveau decorations. The fluff of greenery round the man's head disguises the fact
that I had some difficulty with the bar.

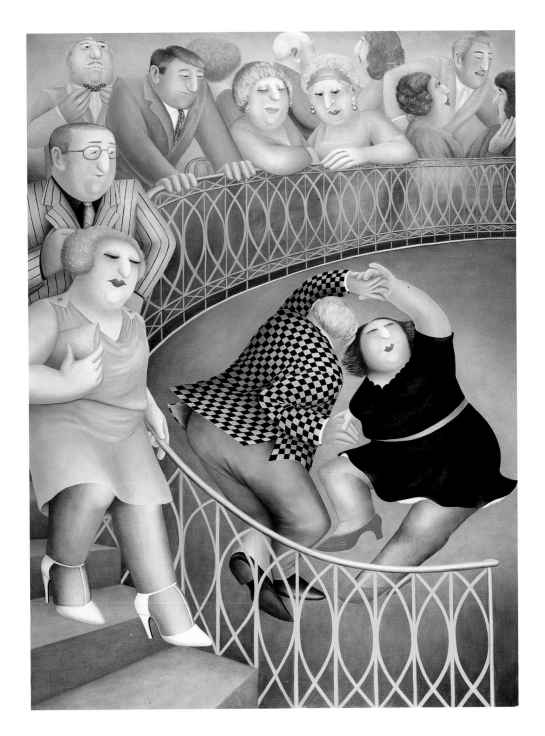

Café de Paris

Some very energetic dancing indeed goes on at teatime in the Café de Paris, just a short walk from the Criterion. I have always enjoyed tea-dances – I admire the expertise and love the pretty dresses. This is the second tea-dancing picture I have painted and here I was fortunate in having a balcony and stairs to pack with people. Where I was unfortunate is that it was made of wrought iron.

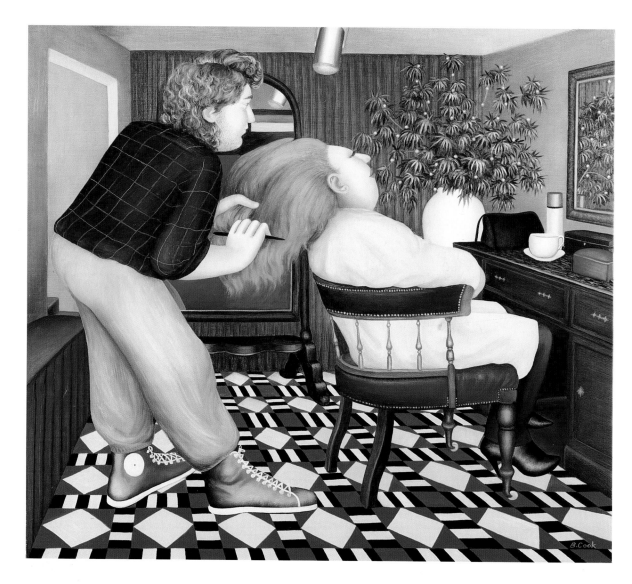

Sweeney's

This is Denny, the friend who used to do my hair when we lived in Looe, in Cornwall. After a while he moved to a smart salon in Beauchamp Place, and was wearing these attractive boots when we called to see him. These and the décor of the salon made up my mind to paint a picture. To complete it I've given him a customer with a great mass of ginger hair, much favoured by me.

Harrods

Just round the corner from Sweeney's we passed this enterprising man. He'd set up his cassette player, put out his hat, and was doing a nifty tap-dance outside an entrance to Harrods. Very good it was, and rewarding too, judging by the size of his collection. I knew the ladies would need stylish outfits in Knightsbridge and so borrowed an ensemble from Princess Diana for one of them.

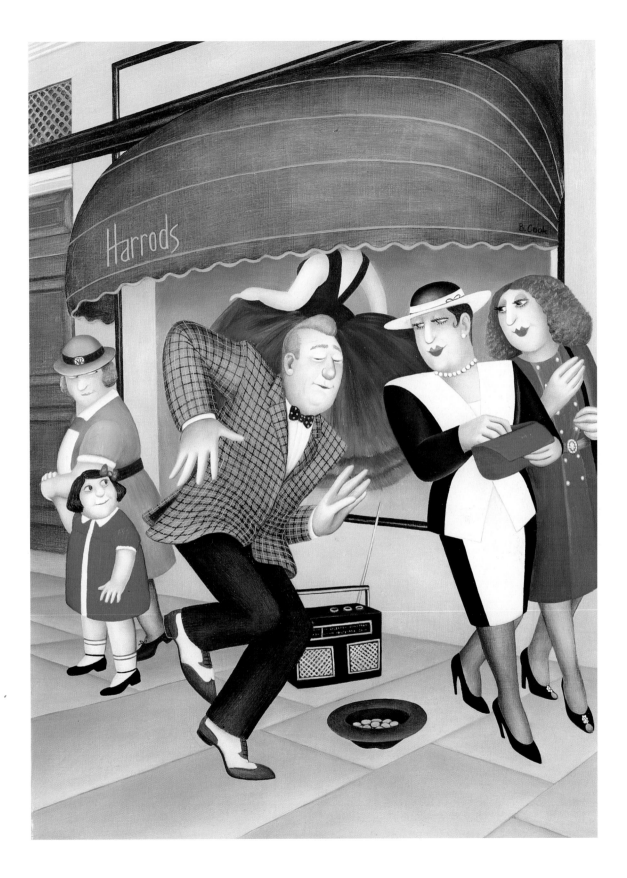

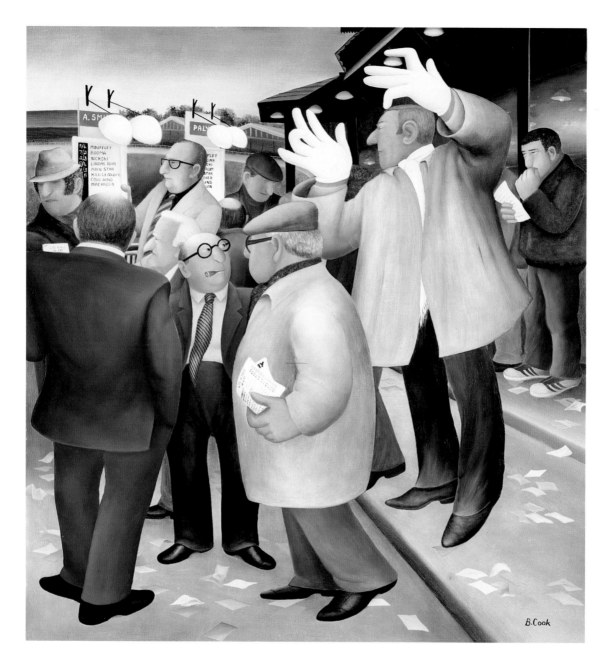

Tic-Tac Man

One of our days out finished with a trip to Harringay Stadium, and in the picture things are hotting up for the next race. The tic-tac man is passing the odds (if that is the right expression) further on down the line. I had just made a bet so I hope I put his fingers in the right position. I think I did, for a beautiful white dog called Leave Me Out won for me. If only I had been able to paint the dog herself! Despite many attempts I was quite unable to manage a picture of the dogs lined up together and, after the final failure, painted my winnings instead.

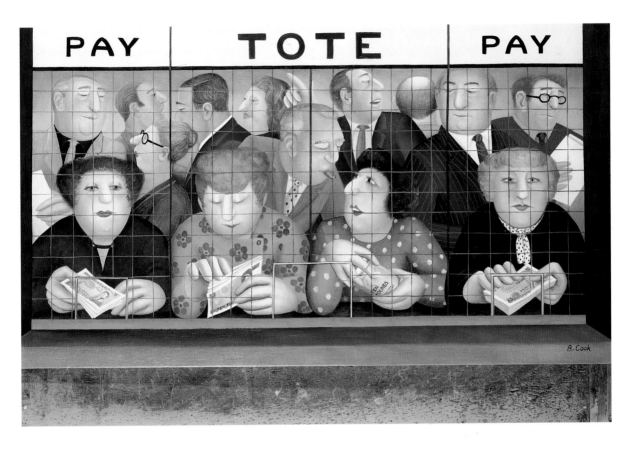

The Tote

And here are the winnings – well in fact they were £6.20, but I've increased this to what I really hoped would be pushed towards me through the grille of the tote, a nice fat wad of notes. There was a great deal of activity going on behind the wire mesh, things were humming indeed, and after carefully counting my small fortune I turned aside to do a little drawing.

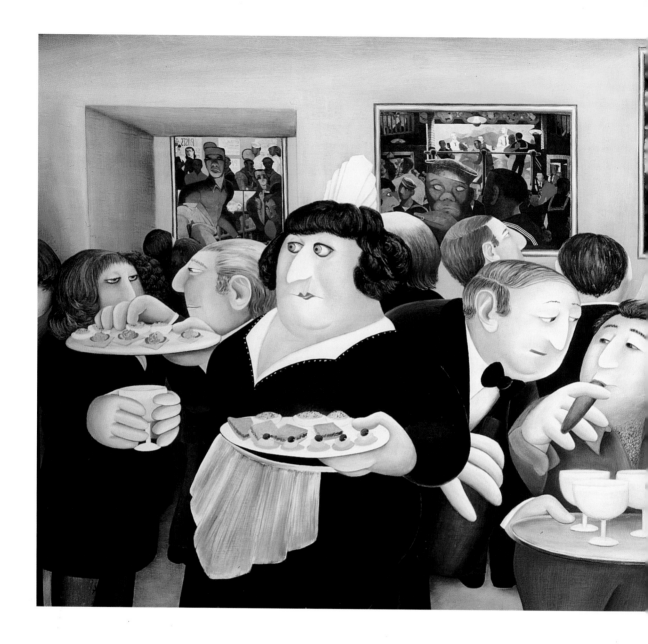

Private View

Edward Burra's paintings give me intense pleasure and we were very glad to be invited to this private view at the Lefevre Gallery. When I tried to record the occasion in a painting I found, as usual, that it was much more difficult than I had thought. Just as I was about to abandon it, inspiration arrived in the form of a letter from the friend who had invited us to the exhibition: her description of some of the people who arrived after we had left gave me just the incentive I needed to finish it. I cut some pictures from the catalogue to use as his paintings on the walls and hope that some of their lustre will rub off on mine.

The Corselette

This is what I hope to see one day at a private view, but no such luck so far. It seems that the only way for a scene like this to materialise is for me to attend a party dressed in the dainty garment myself. For some years I've kept a small advertisement showing me how to control my bulges with a glistening, gleaming corselette. This fascinated me so much that after failing to find a place for it in any of the other paintings, I suddenly decided it was worthy of one to itself – on a large scale too. I have not quite managed to capture all the shine and radiance but I feel I deserve A for Effort.

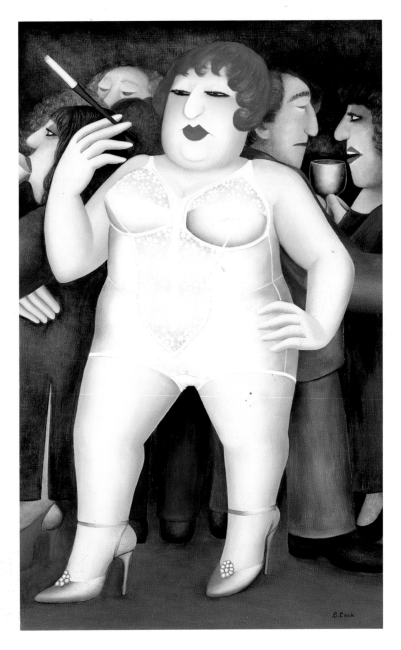

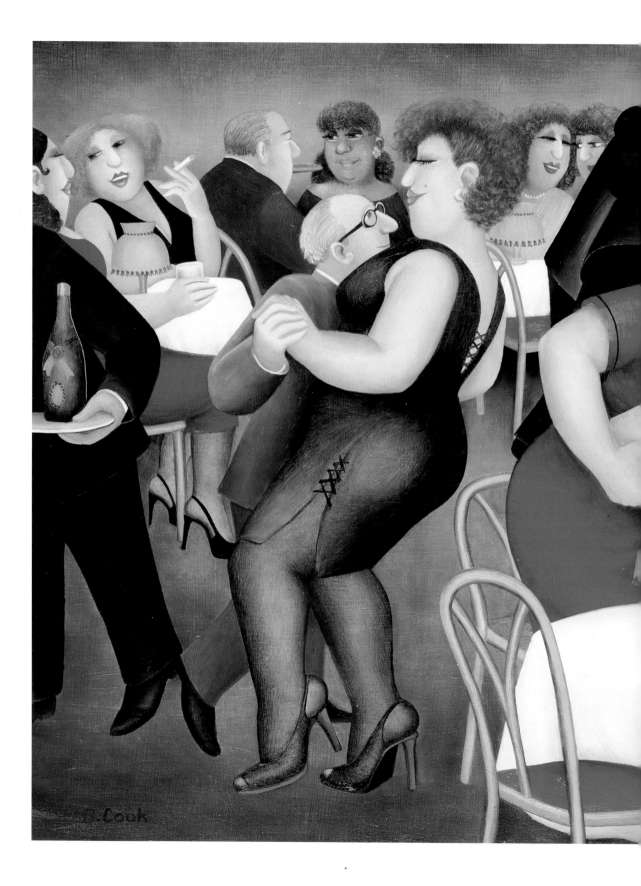

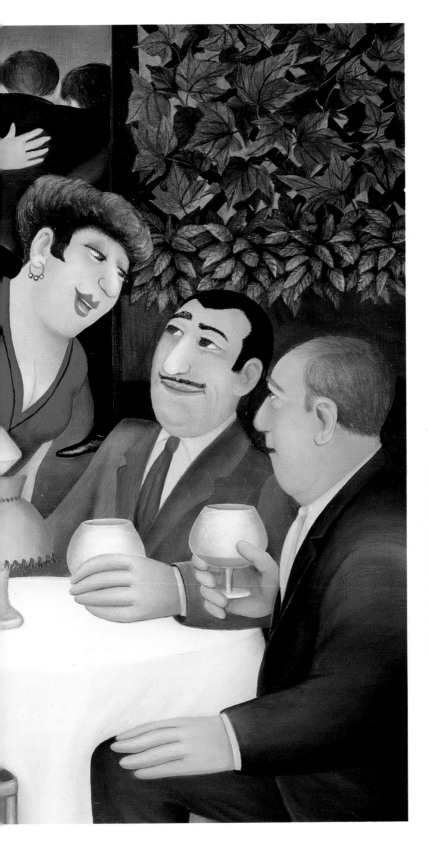

The Manipulators

I was asked to paint this for
the cover of a book called *The
Manipulators*, by Winston
Fletcher. I liked it a lot – it had
plenty of scenes for me to choose
from. I decided that this episode
in a nightclub would be the best.
The man sitting next to the girl in
mauve is my best effort at a Clark
Gable lookalike. A large photo
from a film book was propped in
front of me as I drew him. I think
I've got the eyebrows at least.

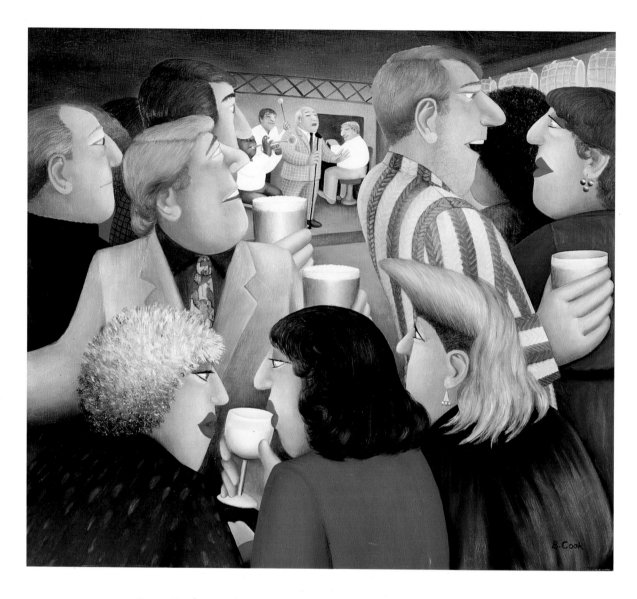

Jazz Pub

Arriving at Bertorelli's one evening for dinner and finding it closed, we turned into a nearby pub to discuss the next move. This didn't come until three hours later, though, as a jazz band was in full swing, and made even more enjoyable by an elderly vocalist. I can't remember having dinner at all that night, I only remember the band and the crowded pub. After I had managed to draw it all I couldn't resist adding the punk hairstyle that I'd seen recently – known as the 'Swordfish', my granddaughter told me.

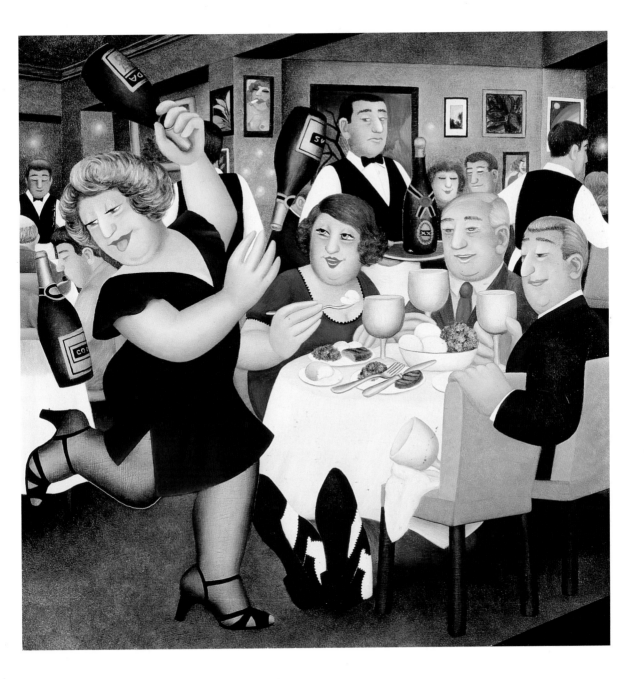

Dining Out

This picture was painted for the Portal Gallery's Christmas show, on the theme of 'Eat, Drink and Be Merry' – which is exactly what is happening here. One of the revellers has overdone it rather and is lying under the table, but the others are still in full swing and enjoying the impromptu juggling exhibition. I too would enjoy seeing something like this but have not been so fortunate. I have, however, seen a pair of two-tone shoes emerging from beneath a table as the owner snored away the evening.

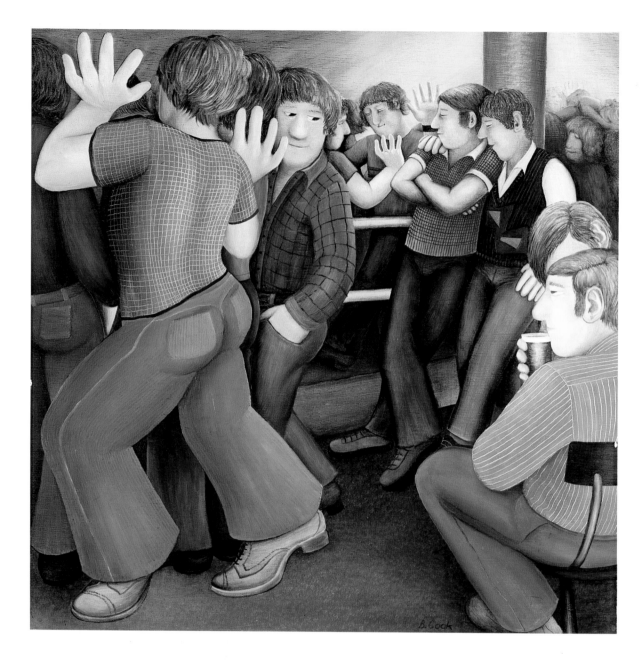

Bangs Disco

I felt I had taken a step forward with this picture, in managing to paint most of it in one colour – blue. We went to this disco at a time when everyone was wearing jeans. I found it very exciting, with little bursts of dancing round the tables as well as on the floor, and I was so eager to try and paint this I drew it as soon as we got back home again from London.

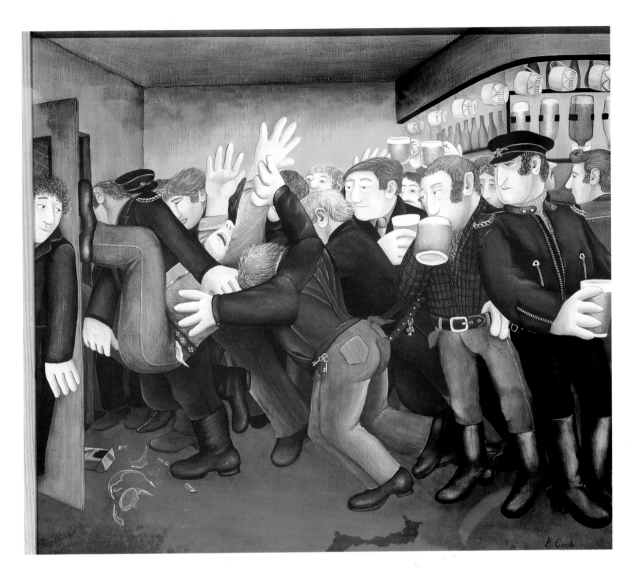

Leather Bar

I am the one in the front leaning forward, pushing him out of the door.... That is not strictly true, but he *is* wearing my jacket, purchased the day after we had visited this bar in London. I hoped it wouldn't have a similar effect on me. I noticed that as first one body and then another was pushed through the doors everyone swayed towards them, me included, and I have tried to show this. Oh how difficult it is painting spilled beer! For some time I sat in front of the picture and painted nothing, then I tried throwing paint on to make a splash. After that fiasco I poured cold tea onto a red tray, broke a milk bottle beside it, had a drink of beer and painted what I saw. I hope you can see it too.

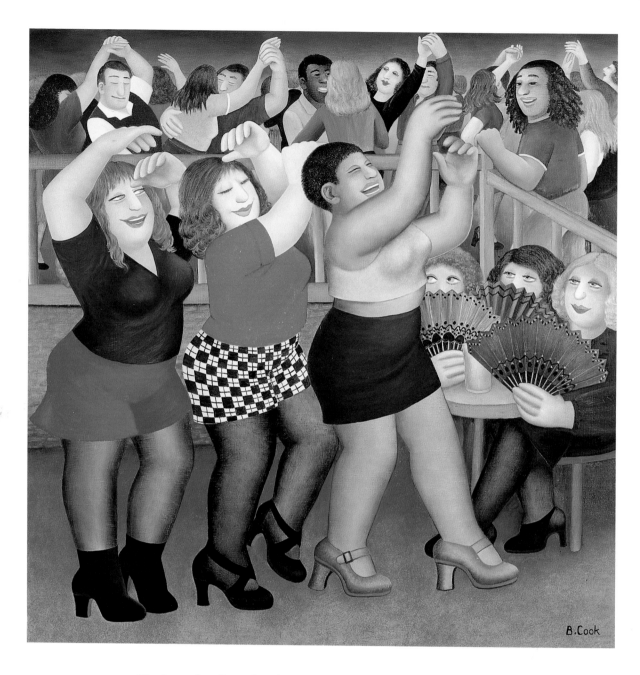

Doing the Lambada

We had been to the theatre in London and as we came out we were met by our South American nieces, who asked if we would like to go to a local salsa club. Would we! We hastened round to get a good seat, and the girls explained that earlier on everyone had had a lesson on how to do it and now they were putting it all into practice. And how they danced. John said he enjoyed it much more than the show we'd seen. The atmosphere was lovely. Some of the girls used fans to cool off after particularly energetic performances.

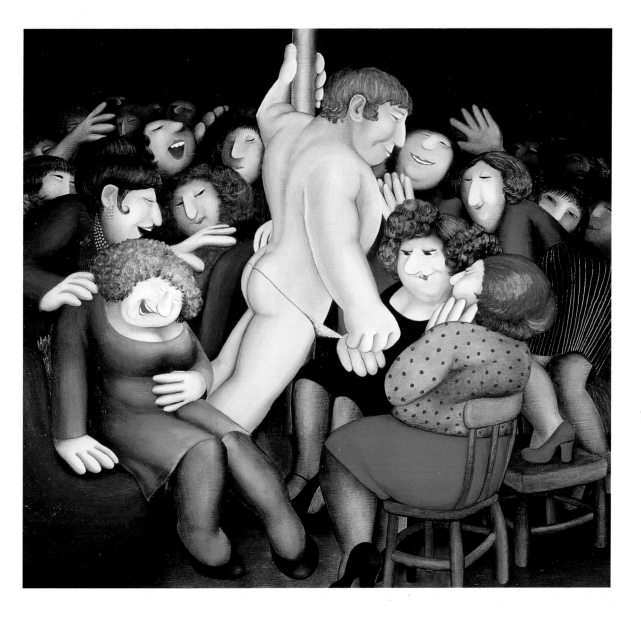

Ivor Dickie

I doubted whether I would be able to get a painting from this event, much as I wanted to. After some time thinking about it I decided to try and draw the audience, handsome women dressed in their finery and out to enjoy themselves, and gradually the picture formed. He had a very fine figure and liked lots of clapping and loud cries of 'get 'em off' to get him going, which I supplied. I'm rather pleased with the expression on the face of the lady in black – *exactly* right I feel – and I tried to get in all the hands extended towards him, which to me was very noticeable.

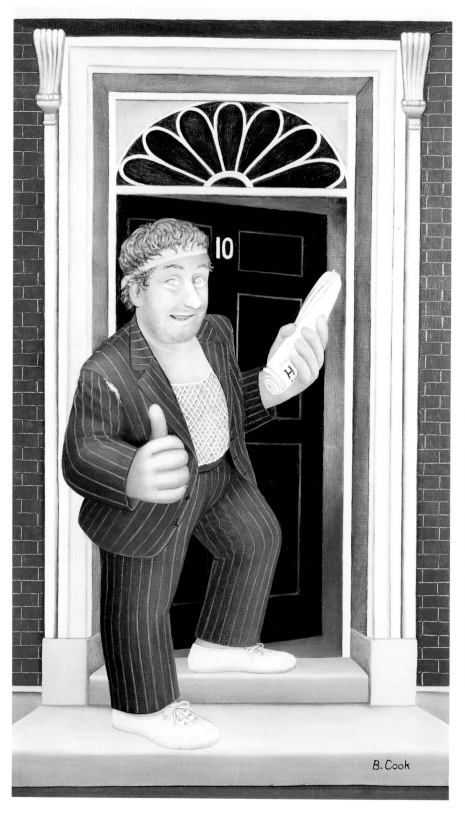

Rab C. Nesbitt

Here is one of my favourite TV characters. He and his companions have kept me amused week in and week out; I just wish I could understand more of what he says – I don't like missing any of it. As he is so talk-ative and opinionated I though he might have some political advice that could be useful to a prime minister, so here he is going into No. 10 Downing Street.

B. Cook

Round Britain

The paintings in this section are the result of various visits here and there around our native land – to Glasgow and Liverpool, Blackpool and Cornwall, with a few stop-offs in cafés in between, for much-needed refreshment. Then there are a number of pictures of Bristol, which we moved to two years ago, and which has proved a great source of pleasure – and paintings.

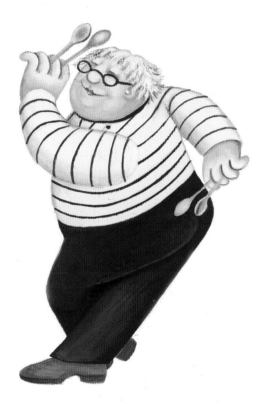

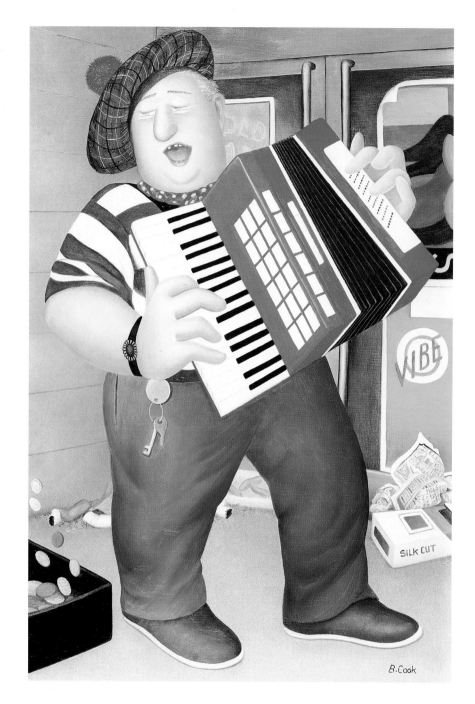

Accordion Player

The first three pictures in this section were painted after a visit to Glasgow, such a lively and go-ahead city. I quite thought I'd be surrounded by bonnie Scotsmen dressed in kilts, which I'm sure was the case when I went there in my youth, many years ago. Now they have made way for everyday wear, although a taxi-driver told me he had worn one for his wedding. So I was more than grateful to find this man wearing at least a plaid bonnet as he stood in a doorway to play his accordion. I've tried to make it as large and Scottish as possible.

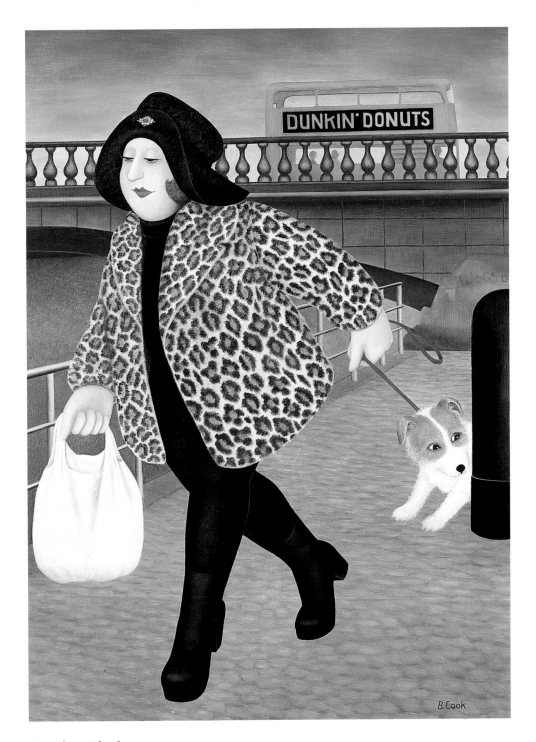

By the Clyde

I especially like a city beside a river, or the sea. It didn't take us long to find the Clyde and when I saw a little dog running along beside it I wished ours was with us to do the same. The red bus on the bridge, with Dunkin' Donuts on the side, against a dark grey sky, was the start of this painting. The girl's outfit I had seen at the railway station earlier and I liked it so much I used it here.

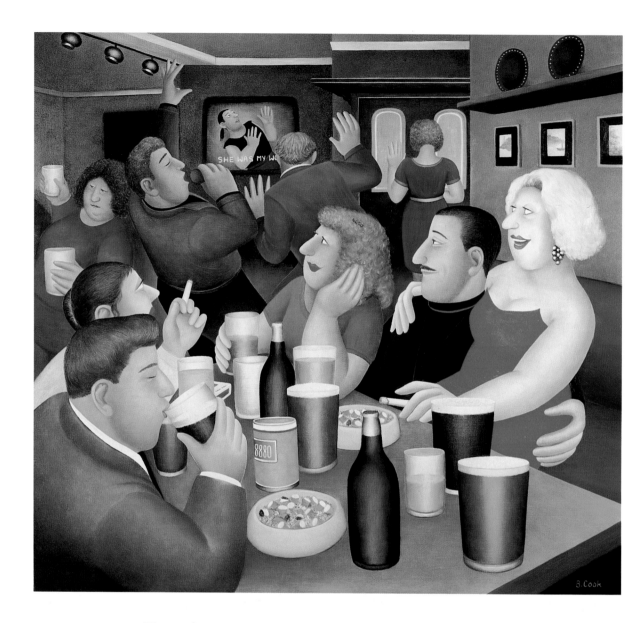

Karaoke

We were taken to this pub by friends and I thoroughly enjoyed my first experience of karaoke in action. We went upstairs to a large room with a bar at one end and the karaoke machine at the other, with chairs and tables in long lines down the centre. Leaflets were distributed throughout, listing all the available songs, and we had to tick which ones we'd like to perform. I say we, but a million pounds would not have persuaded me to get up and take the microphone. Others felt differently; there was an eager queue to take the stage and I was surprised to find how very good most of them were. I don't know whether this is peculiar to Glasgow or if I'd find such good voices elsewhere, for I've never seen it again.

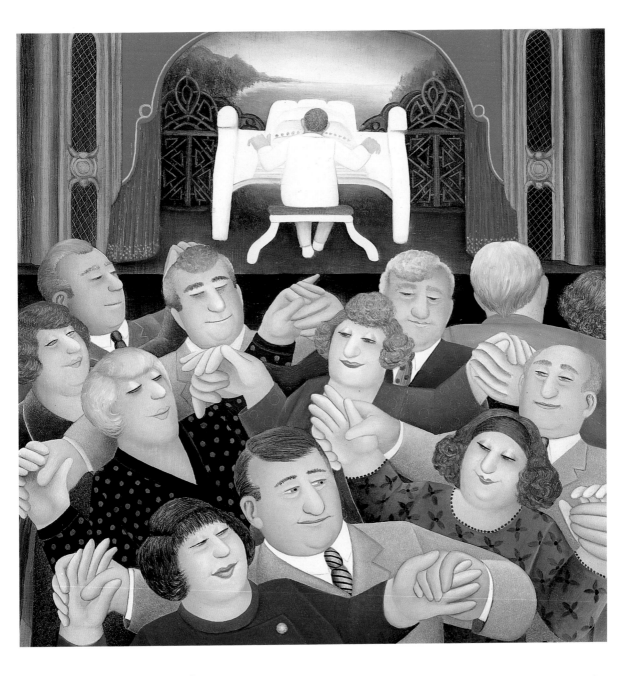

Doing the Saunter

I particularly liked this magnificent ballroom in Blackpool, and the organist dressed in white. The saunter was my favourite dance when we went there a few years ago, the ladies guided by the men from behind. The organist occasionally looked over his shoulder as he played to make sure the dancers were all enjoying themselves. I loved Blackpool with its lights and piers, and as the people arrived in their charabancs they were all smiling, ready for fun.

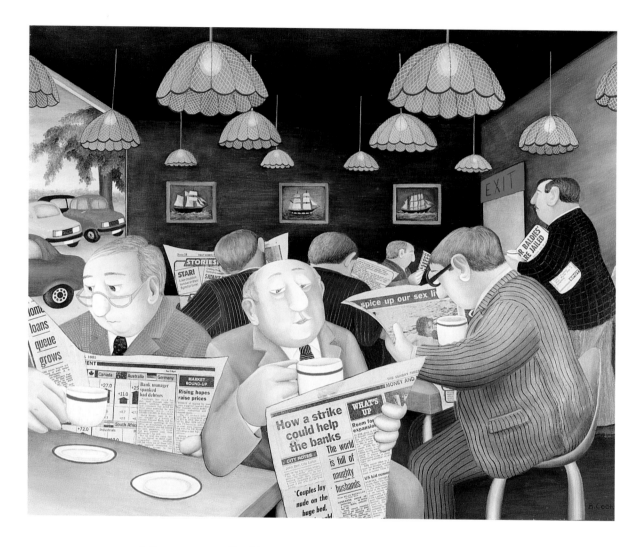

Motorway Café

I like motorway cafés, especially since the food has improved so enormously. Have you tried the fried bread recently? I can recommend it. It must have been mid-morning that we called at this one, when businessmen and travellers pause for coffee and a look at the papers. The decorations have since been changed in here, and the large basketwork lampshades (the original reason for the painting) have sadly disappeared.

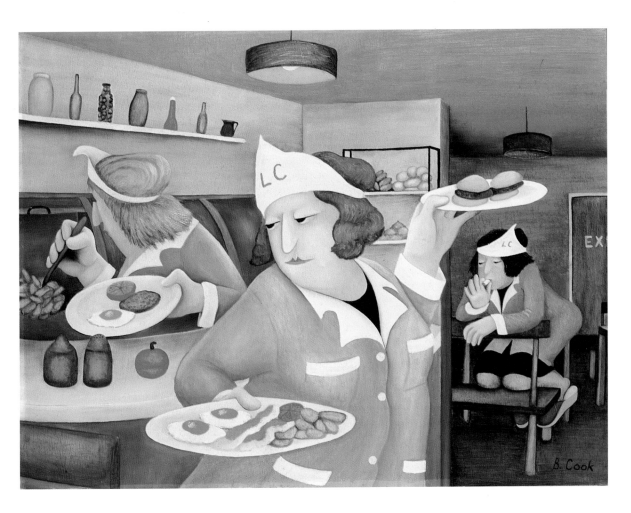

Little Chef

Another frequent port of call on our journeys is the Little Chef. On this occasion I became aware of the small hunched figure in the dark corner when I was waiting for my waffle with ice cream, cream and chocolate sauce to arrive, and realised she'd had a *very* hard day. I like to think I so often paint food because of the colours, but could it be greed?

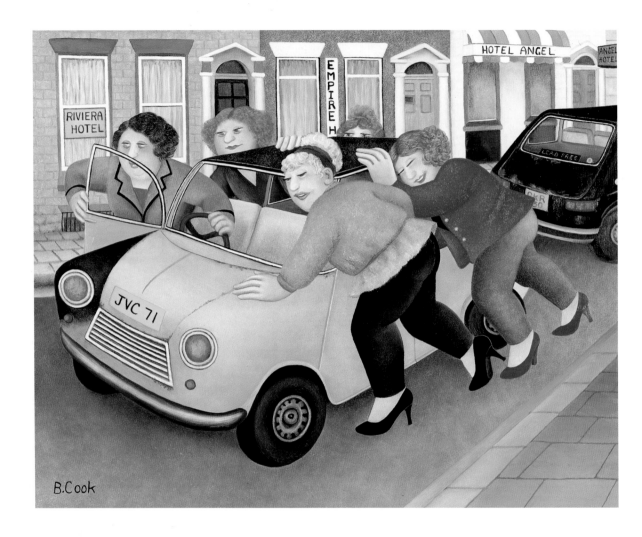

A Good Little Runner

A few years ago Joe told me he had seen from his window a number of young men running and pushing a very small car down the road. I was reminded of this one day when I came across a photo I'd taken in Liverpool of a row of small guesthouses in a back street. To complete the picture, the perfect motor car was regularly parked near our house, a rusty little banger just about to fall to pieces, and this became the star of the painting – pushed down the road by women instead of men.

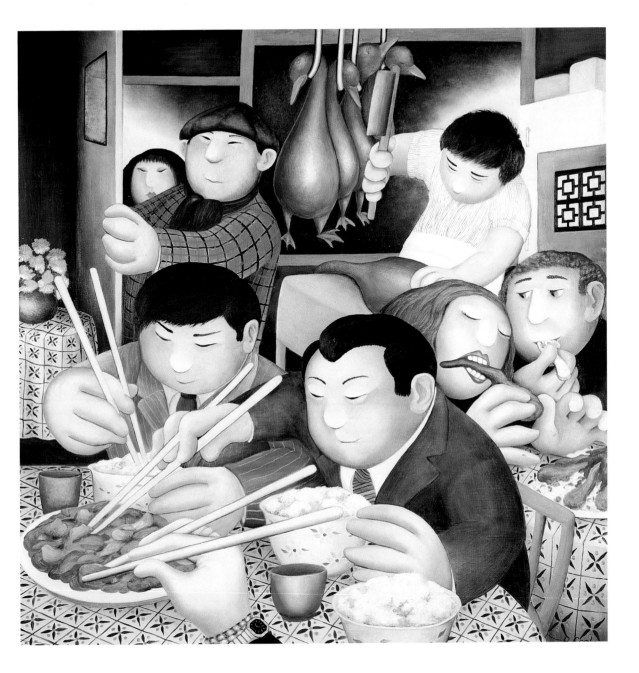

Chinese Restaurant

We always enjoy visiting Liverpool, not just for the splendid art galleries, but also for the public houses and Chinese restaurants where we spend a good deal of our time. I clearly remembered the ducks hanging in a line, the chopper flashing down and the oilcloth on the tables, but strained my brain considerably in recalling and assembling all the other details. *My* hand is the one at the front, manipulating the chopsticks with great skill to pick up one grain of rice at a time; unfortunately this is not quite fast enough: the food is so delicious that in reality I use a spoon and fork.

Saturday Evening

I don't often see people dancing in the pubs now and wonder if there must be some new regulation forbidding it; this is sad, for I used to thoroughly enjoy it. I would rather like to get up and play the spoons at a certain stage in the evening and sometimes think I will practise, in case I'm ever invited (or allowed) to.

This painting and the next were originally designed to be printed round large beer cans, and with a little imagination you will see just what the man on the far left of the picture is intending to do.

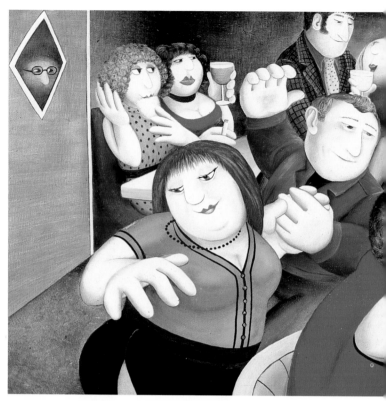

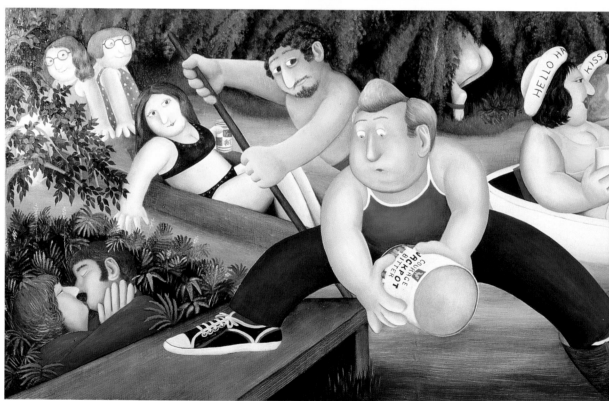

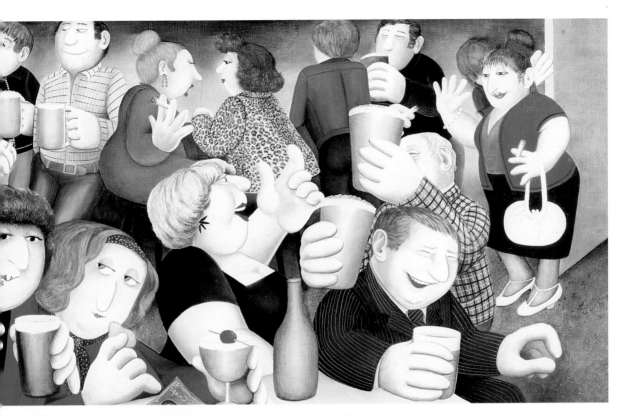

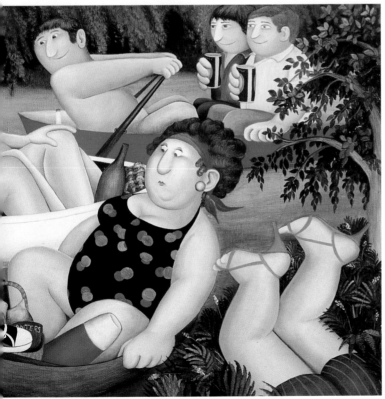

Sunday Afternoon

Another brewery picture. John
suggested this subject, for we lived
near the Thames in our youth, and
great pleasure it gave me to try and
bring it back again. On looking at it
now I realise that everything going on
here is based on our various activities
during that time, including falling into
the river, a misfortune which befell us
on our wedding day.

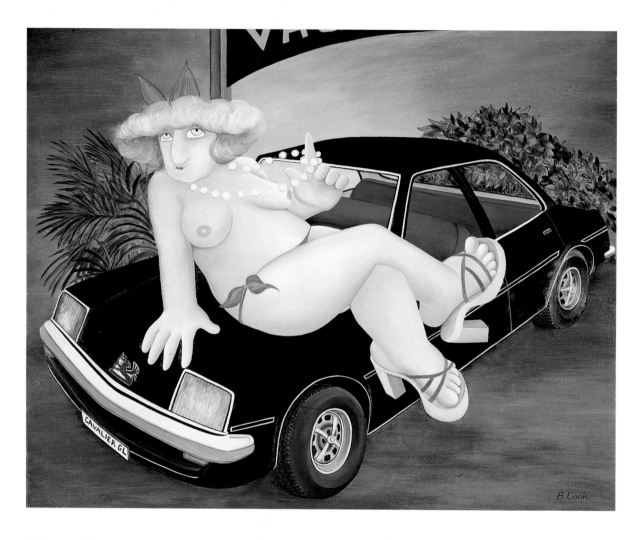

Motor Show

Although John has taken me to motor shows on two or three occasions, I have never been lucky enough to go when the topless girls are there. I like painting both flesh and motor cars, and so decided to do my own version. I never learned to drive but would really love to have a customised car, a Rolls Royce for preference.

Beer Garden

This is painted on canvas, a rather secondhand one as I'd had to remove several unsuccessful attempts at another subject before deciding she might fit. We had been sitting in a beer garden one Sunday morning when she hove into view, surrounded by children, and then sat gazing into space – possibly recovering from a rough Saturday night. I drew her when we got home, but then forgot her until the bare canvas could be ignored no longer.

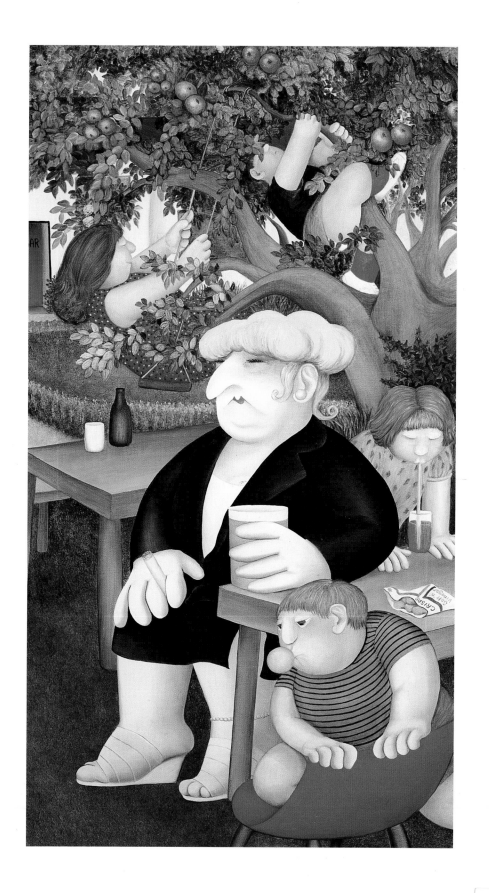

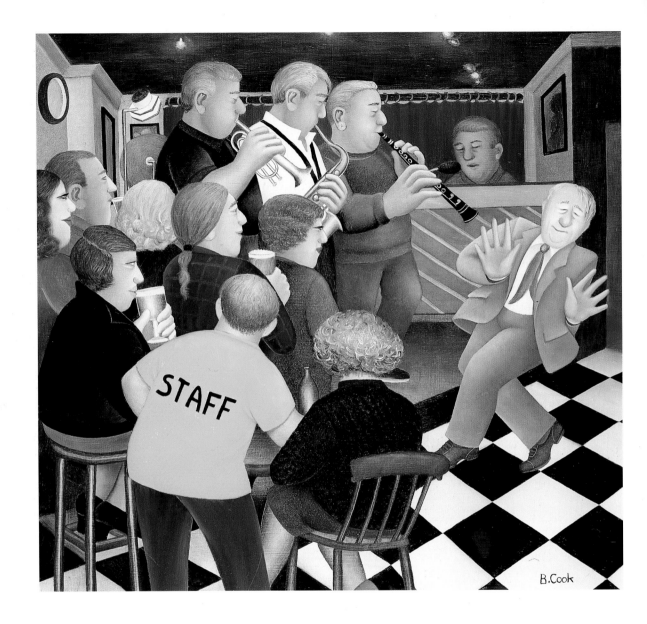

Jazz in the Winter

Our granddaughter and her family live in Bristol, and we moved here ourselves early in
1998. I knew how much I'd enjoy living in this exciting city, and I loved it from the start.
Nowadays Friday nights are generally spent in this pub, the Duke, where jazz is played
most days of the week. Here I've painted the little old man I saw dancing drunkenly there
one night. After he'd lurched into the bandstand once or twice one of the musicians calmly
stepped down, took him by the arm and guided the dancing figure out of the door, never a
beat missed. Another night the door opened and a boy came in, danced all the way to the
gents, and soon afterwards danced all the way back again. Best of all, he had bright red
hair, my favourite.

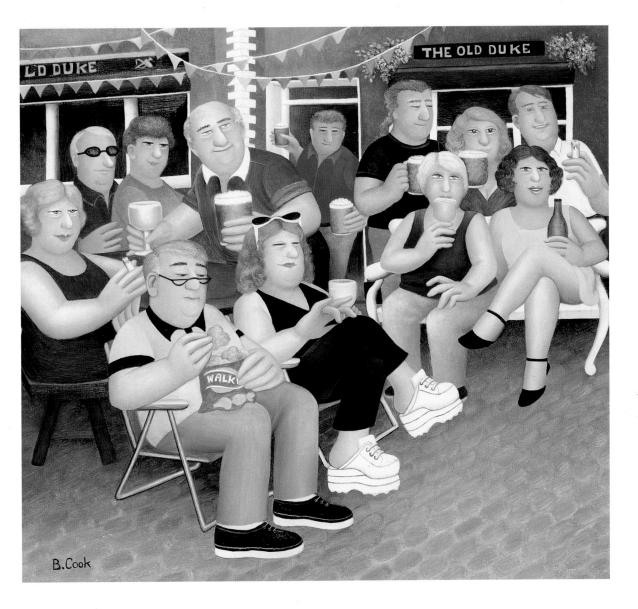

Jazz in the Summer

Summer Sundays often mean jazz in the streets or parks, and it's wonderful sitting outside the pub in the sunshine near the water, listening to the music. The bands play on a sort of stage and on this particular day it was so busy we had to sit behind it, facing the audience. As you can see they are all enjoying themselves, fingers tapping, drinks and crisps circulating.

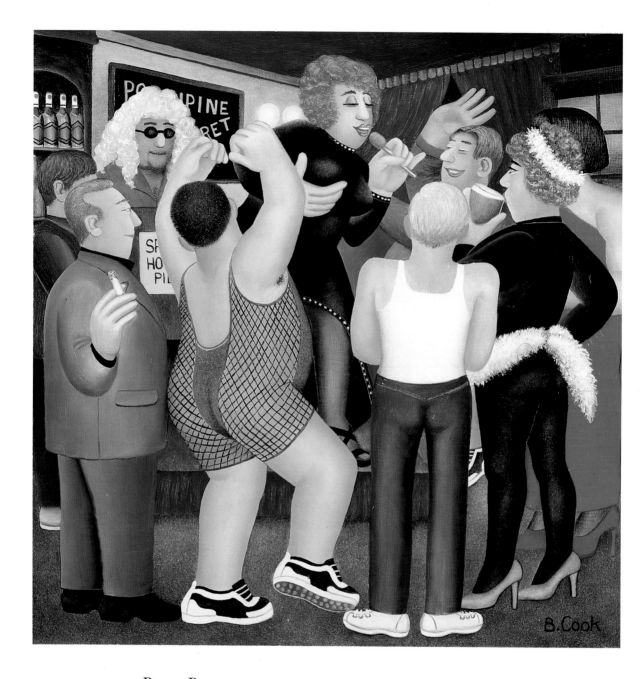

Party Boys

This party was in full swing as we entered the Porcupine one night. Most people were dressed to the nines and one was mostly undressed, in fishnet combinations. What fun the singer was – some were dancing to the music and others gathered round to applaud. I had seen the man in the blond wig on another occasion and he made us laugh so much I decided he should put in an appearance here as well.

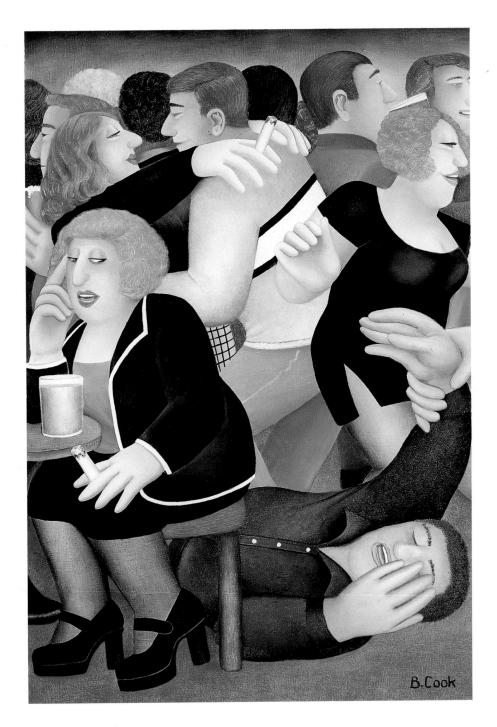

Friday Night

This is a busy picture, rather like our Friday nights. The body on the floor is unusual though – he'd flown through the air and landed at our feet without any warning. There had been slightly raised voices earlier, but nothing more. A large bouncer bustled over and dragged him off by one arm, and we all got back to our various activities. We saw him later going off with a bruised face. What he'd been doing to earn it we shall never know.

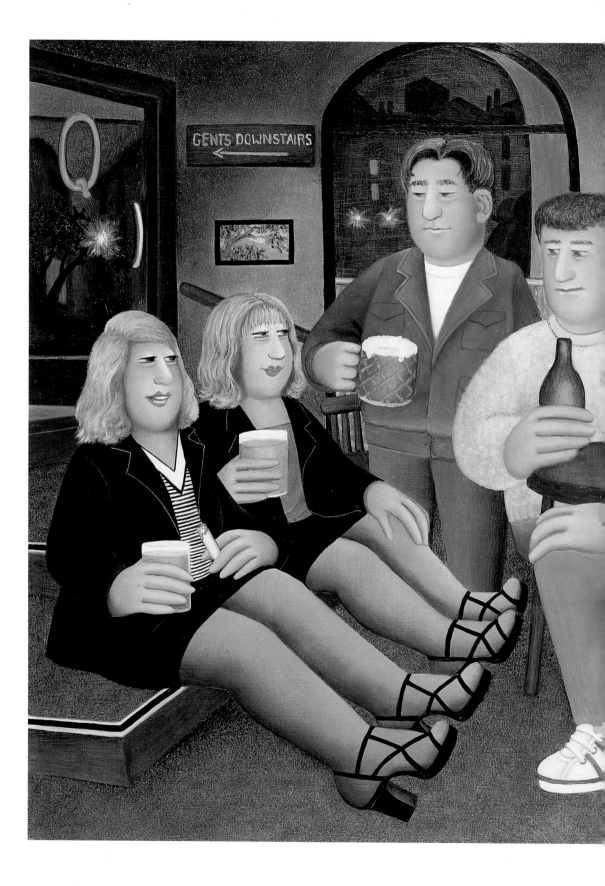

B. Cook

Strappy Shoes

This is the Quadrant in Clifton Village, where we often call in for a drink at the weekend on our way to the city centre. On this particular night some of the many students who live round us were in here having a drink. There weren't enough chairs, so two of the girls sat on a nearby step, legs outstretched in front, and it was then I noticed their identical strappy shoes, perfectly placed for a drawing. The man standing has a very popular hairstyle – a centre parting with hair springing out on either side.

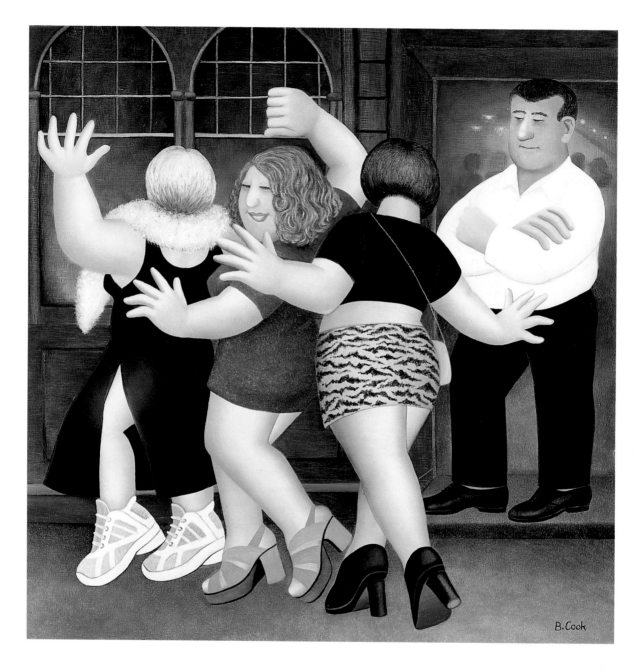

End of Term

Leaving the city centre one evening we were followed by a group of girls excitedly talking and laughing together. As they passed they called out 'End of term, end of term!', and waved. Here they are, watched by a bouncer in the doorway of the Porcupine, one of our regular ports of call.

The Elephant

There are some beautiful buildings in Bristol, new ones as well as old, and they are a source of great pleasure to me when we are out and about. The elephant emerging from the wall on this one is a favourite of mine, and I decided to use the building as a background for a couple I'd seen in a shopping centre. As they passed we realised they both had black eyes, and were looking rather grim about it. As I was drawing this picture the figures got larger and larger and the building smaller and smaller, but I still kept a good view of the elephant. He looks disapproving, doesn't he?

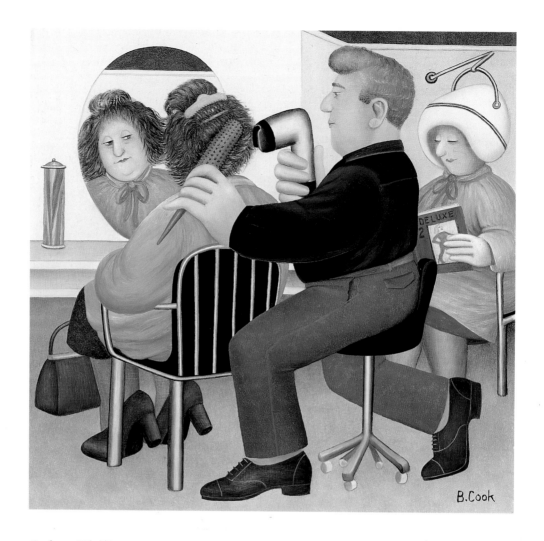

Salon Philip

This is a small area of the salon where I have my hair done. Over the years I've painted all the salons I've been with, as the hairdressing itself fascinates me. In this case, though, it was Mr Philip's chair that caught my eye. As he attended to the hair on each side in turn he swivelled the chair round rapidly with his feet, gliding swiftly over the floor. How easy, I thought, and much better than standing all the time. By the way, I have never actually seen this bird's-nest hairstyle in his salon; it's my attempt at untidy hair in need of attention.

Shopping Mall

Here are some more strappy shoes, and a lot of happy shoppers. They are using the escalators whilst beneath them thousands more on various levels are milling about between the shops. At one time I thought I'd never be able to finish this painting because there were so many people to fit in. The man holding the parcel doesn't look well, does he? I'm not surprised – John said he felt ill several times when he was there. I think these shopping malls are for us ladies.

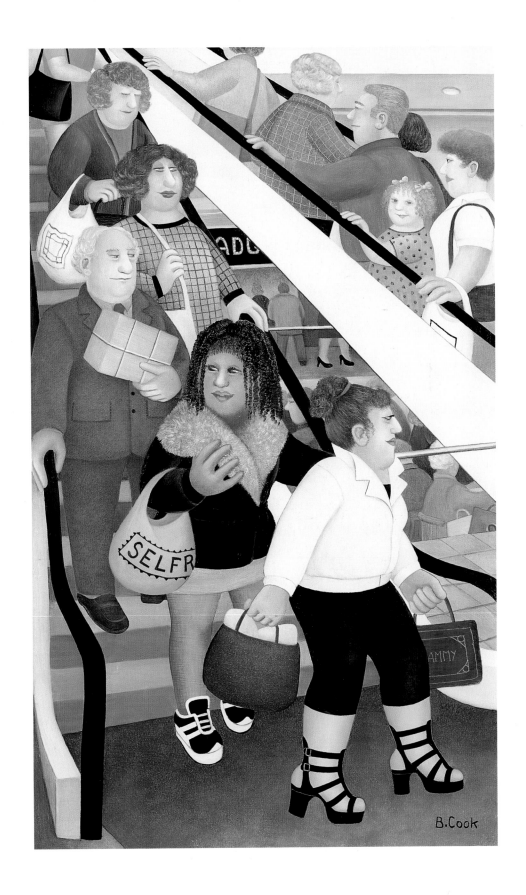

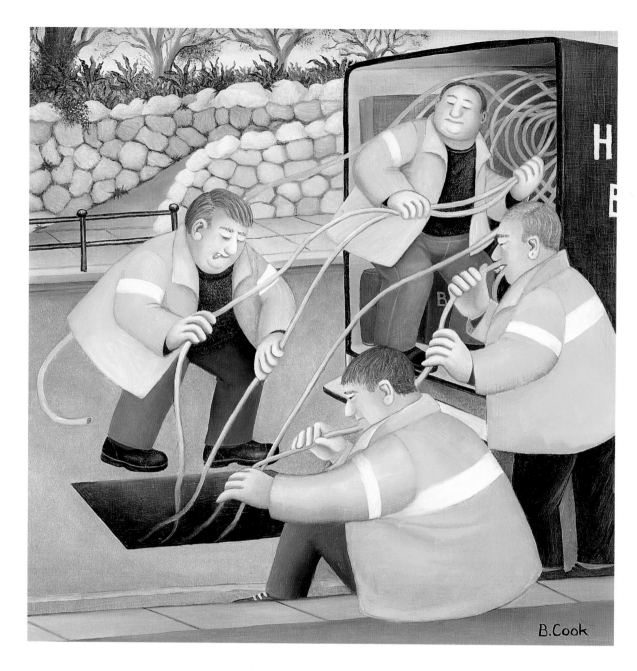

Dyno-Rod

Every day we walk into Clifton Village to get the newspaper, and one morning whilst crossing the road I came across this little scene. Intrigued by all the pipes, I asked one of the men if he was Dyno-Rod. No, he's dynamite, another swiftly answered. There and then the picture formed in my mind. I always call it Dyno-Rod, but John tells me it is more likely to be telephone wires they are dealing with.

America

We have been to America many times now, once flying out there on Concorde and twice returning home on the QE2 – which gave me a taste for the high life! I like the Americans, and we met many kindly and cheerful people in the course of our exciting travels across the States by train.

Jackson Square

This is one of the results of a much-looked-forward-to visit to New Orleans, when I very bravely flew all the way to America for the first time. Fortunately I managed to persuade myself to sit quietly in my seat, drinking, and not run amok in the gangway, or I would never have had the chance to see this lovely place. Jazz bands play in the public gardens as well as in most of the bars, and this is what we saw on our way through Jackson Square to sit by the Mississippi and watch the riverboats go by.

Audubon Park

We saw this man nattily attired in white from head to toe swinging down Bourbon Street. After some unsuccessful attempts to paint him as he was, I decided to move him onto a park bench in the zoo at Audubon Park, where we had lunch with the squirrels and watched the toucans. It was so hot I could easily have slept the afternoon away (and several did), but the squirrels diligently collected, stored and ate scraps of food without pausing. I treated myself to a Snoball but rather wished I hadn't.

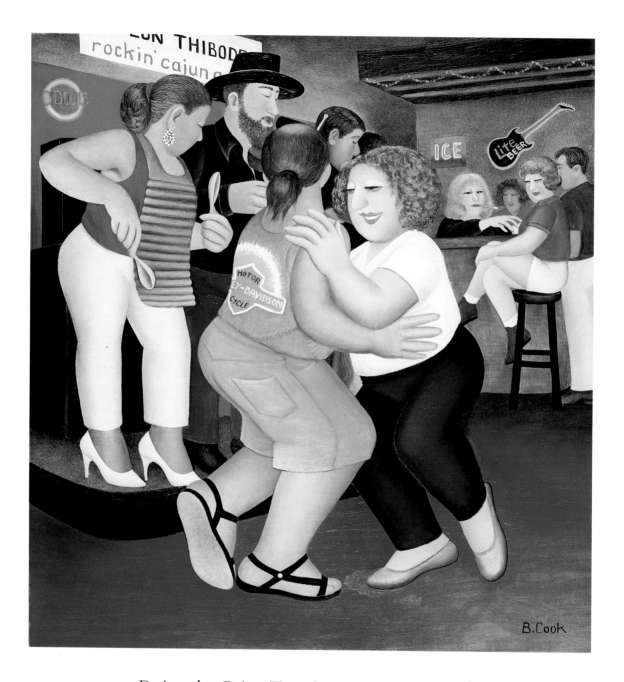

Doing the Cajun Two-Step

We were watching this couple in a bar in New Orleans, performing expertly to the band which had attracted us inside. During an interval we asked the name of the dance and were told it was the Cajun two-step, which seemed an ideal title for a painting. I like Cajun music very much – I'm particularly partial to the spoons – and another big attraction of this bar was the long happy hour when two drinks could be had for the price of one. All this made for a most satisfactory evening's entertainment.

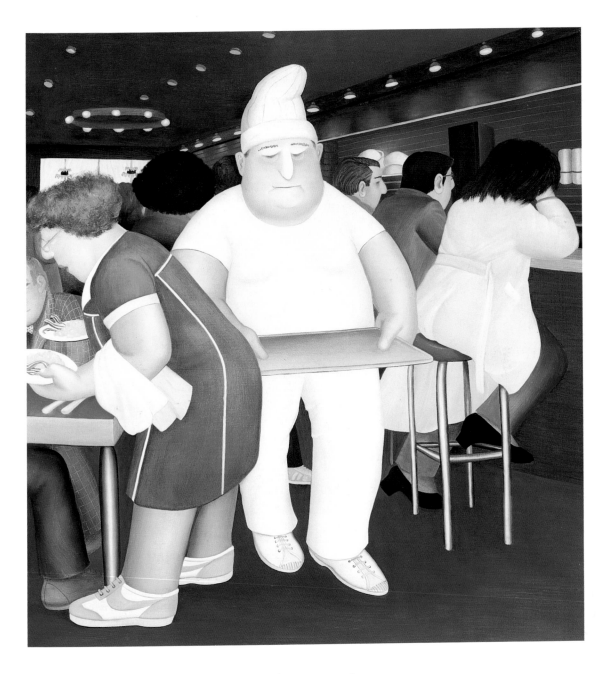

Breakfast at the Royalton Hotel

Here we are in New York, with scrambled eggs and bacon coming up in the hotel café. The waitress chewed gum and called me honey, just as I'd seen on the films, and the breakfasts were delicious. Bran muffins were *my* downfall and I see from the chef's empty tray that he's just delivered new supplies and is going back for more. I hope.

The Park Bench

On the days which promised to be very hot we'd go up into the park to sit for an hour or two, sometimes feeding the squirrels. Until, that is, I heard one little girl warn another that she'd catch both fleas and rabies from them, when they were hastily abandoned by me. This one, and the very handsome park bench, were down by the lake but I brought them up here so I could show some skyscrapers in the distance, and this is my one and only attempt to paint them. I am really only interested in painting figures so have to be very strict and not allow myself to do them until I have painted the background.

Lunch in the Gardens

Fortunately there are lots of shady places to sit between bouts of bargain hunting. I think these four were probably from an office nearby, enjoying their lunch in the fresh air. Not exactly gourmet, but very pleasant and much appreciated by the pigeons.

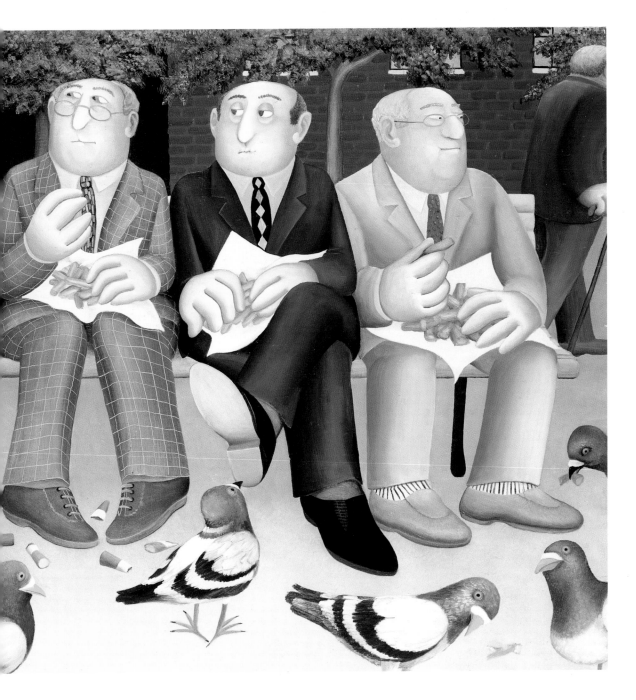

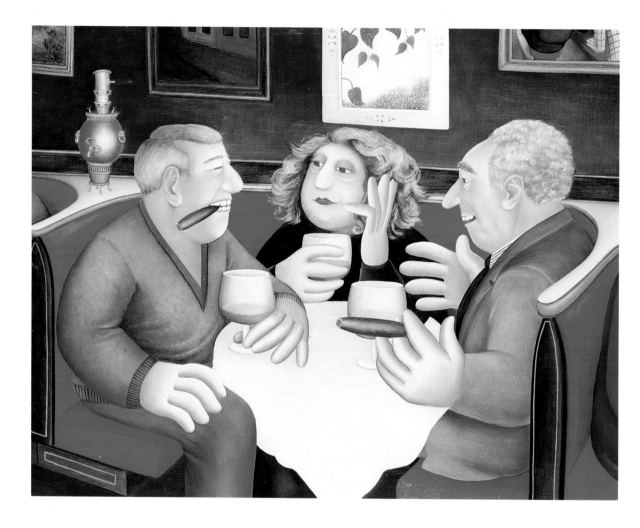

Russian Tea Room

One day we had lunch here. When I had finished looking at all the lovely paintings I settled down to eating and to observing all the busy activity around us. I learned that a lot of people have favourite seats, some being especially desirable. Here is the one I have chosen for mine, with some intellectuals enjoying brandy and cigars. I don't very often paint teeth and perhaps in this picture you can see why.

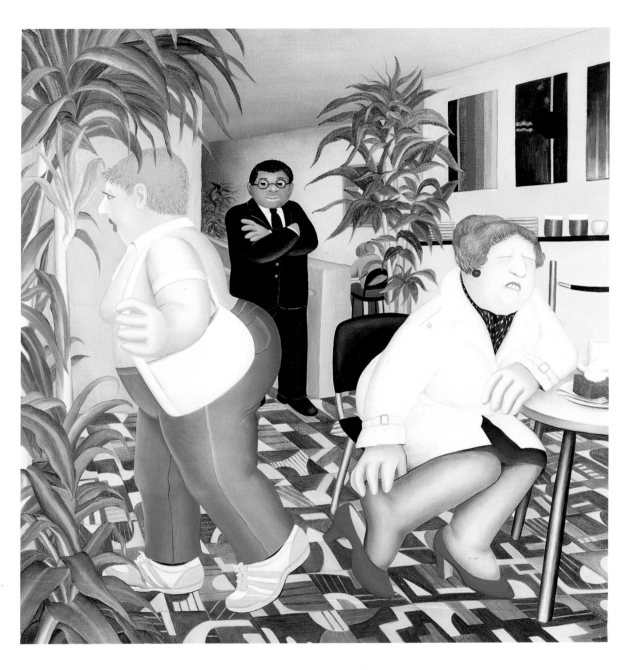

The Museum of Modern Art

A short pause in the museum café, for a massage of the aching feet and a chocolate brownie. The other lady hurries off for a further session of art appreciation whilst the porter gazes calmly, having seen it all before. I hope you notice the abstract paintings on the wall; I felt I had been rather successful with these – not to mention the rather startling floor – and wondered whether I should go in for them in a big way.

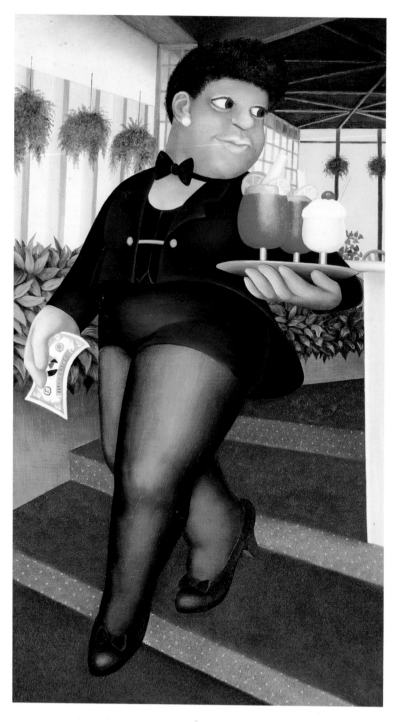

Cocktails for Three

We left New York in a Greyhound Bus and some two-and-a-half hours later arrived at a large hotel in Atlantic City, where we were each handed ten dollars in quarters. Retiring to the bar to discuss the investment of this unexpected bonus we found a very attractive waitress coming down the stairs with a tray of cocktails. I now think they could not possibly have been as lurid as I have painted them, despite all the careful notes I made. This isn't where my ten dollars went, though: I lost it all on...

Slot Terrace No. 4

As I made my ten dollars last for two days I don't think I need ever worry about becoming a compulsive gambler. A greater worry was that I might miss something going on in that exciting atmosphere, with lights flashing, bells ringing and the crash of tokens cascading out of the machines. Crowning it all, for me, was the lift with the transparent wall which revealed floor upon floor of slot machines as we swiftly descended. What I couldn't remember was how the lift worked, or landed, and so that I could quickly get on with painting all the hands and arms working the machines, I shrouded these little details in darkness and a tasteful display of greenery.

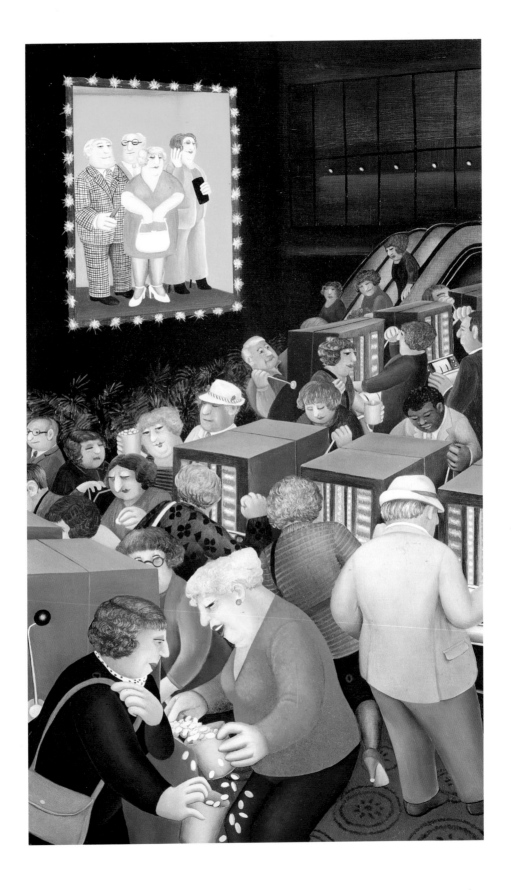

Woman with Cigar

Some people played two machines, and this little lady also smoked a cigar to help her concentration. These were just in front of a bar, and a waitress told us the machines seemed to pay out more when close to bars or restaurants. I think this could be true but we hadn't time to test it for we were off to catch the bus. I wished I had one of the cigarette boxes (or lighters) in the shape of a slot machine that two men were examining as they laughed, drank and discussed their winnings on the way back to New York.

Bus Ride

There was lots of laughter and discussion of husbands from these three as they travelled on the bus with us to Chinatown. I guessed from their pretty clothes that they were going out to enjoy themselves, and their legs swung out in rhythm as the bus raced over the bumps in the road and hurtled around corners. I would like to have shown just this, but despite every effort on my part, only one pair of legs is swinging.

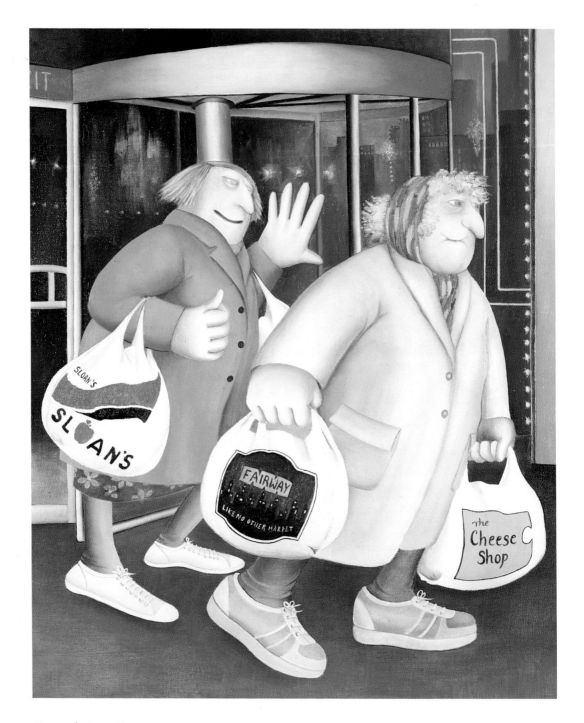

Revolving Door

This started out as an enormous picture of my most favourite café, the Automat. The harder I worked at it the more it became reduced, and in the end I was left only with the revolving door – and the two bag ladies coming through it of course. They had a little heckling session about tokens (for the automat) with a short-tempered assistant in a kiosk, after which they lurched off cackling together to get a cup of coffee.

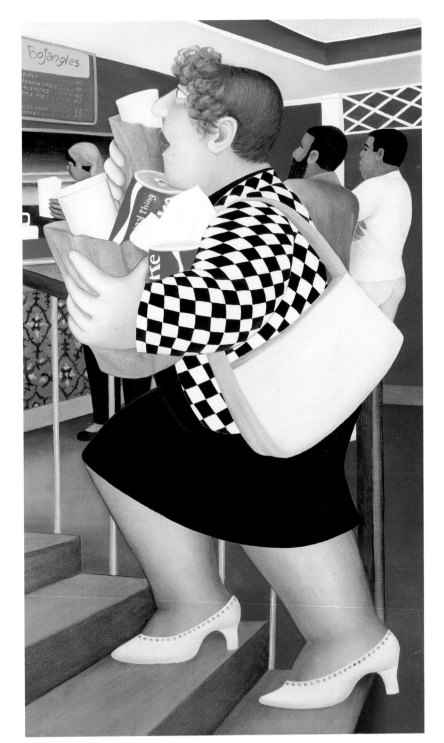

'To Go'

Sausages, biscuits and gravy in this case, and I hope she enjoys it as much as I did. This was a Sunday, and we found that some restaurants were closed and there were queues outside others, so we staggered up to the hotel bedroom with our arms full of brown paper bags from Bojangles.

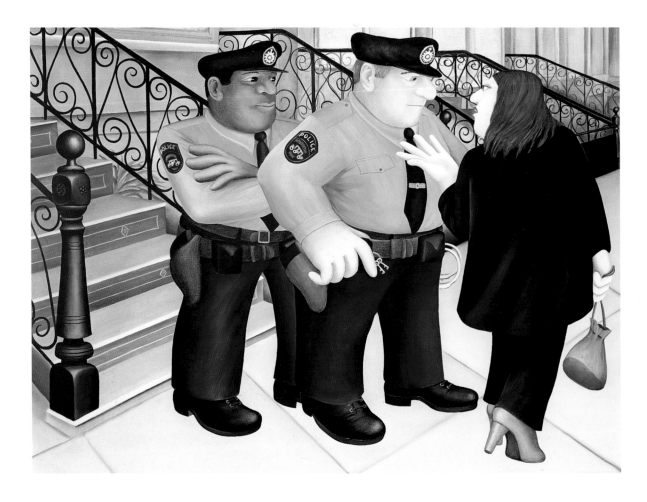

White with Rage

We had intended to go to Coney Island on the day I saw this, but a thick mist made us decide to go instead to Christopher Street with friends. As we sat at a table outside a café, innocently enjoying a cup of tea, a filthy row blew up behind us. She was refusing to pay her bill and the police arrived to sort it out. White with rage, she flung the money on the ground and flounced off.

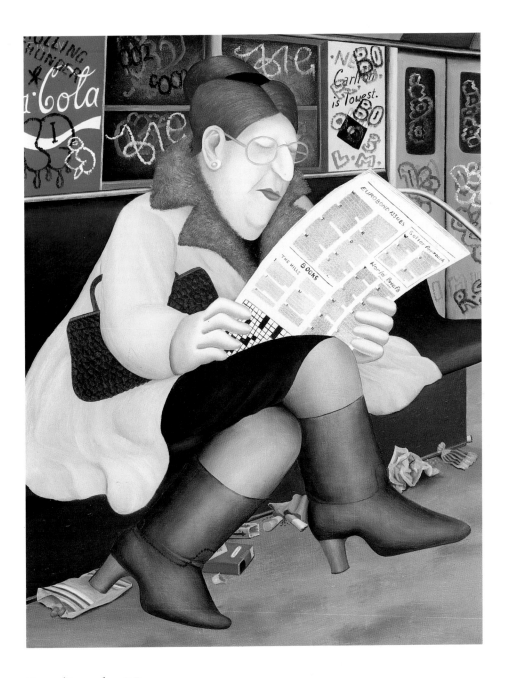

Reading the Newspaper

One day we finally achieved our trip to Coney Island. We took the subway, and found ourselves surrounded by these exotic decorations. This interested me immensely for we had travelled on others with none at all, and until now I had only seen subway graffiti on television. Sitting near us was this striking businesswoman, reading placidly through the journey regardless of stops, starts and even a youth waving a cup and demanding money. We all ignored him and he departed for a more fruitful carriage.

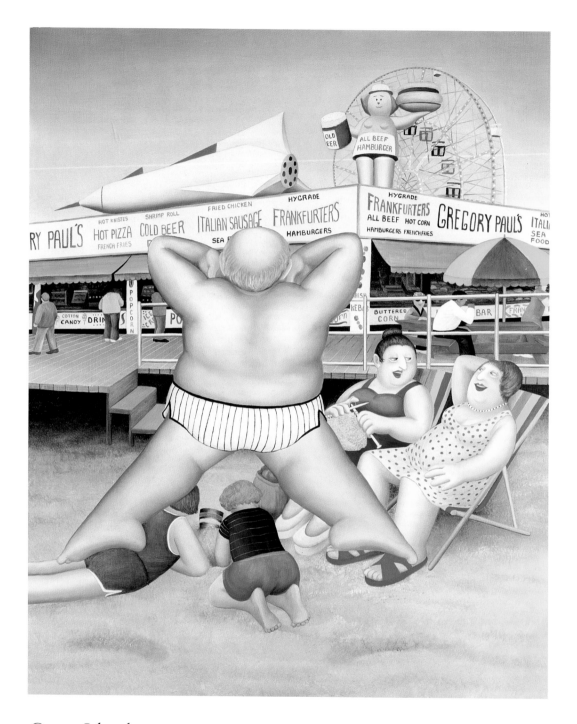

Coney Island

It was a lovely sunny day at Coney Island, which was almost deserted since the season had not yet started. We bought a plastic Mickey Mouse and Miss Piggy, then some lunch, and sat on a seat on the boardwalk. There was only one family on the miles and miles of beach and whilst the rest of them sat in the sunshine Father exercised, running on the spot, jumping and leaping continuously. I craftily painted in two footprints, to show he is jumping and not just hanging about in mid-air.

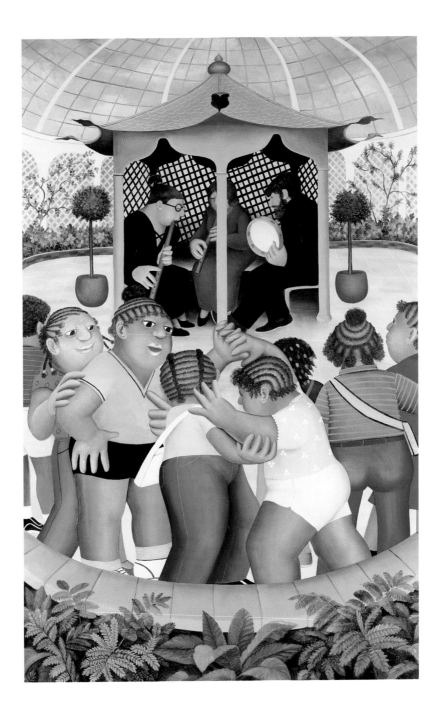

Botanical Gardens

We caught a train and, getting off too early, had a long walk through the Bronx until we were joined by a regular visitor to the gardens who showed us the way. He told us he went there every day, to sit and listen to his radio. Large groups of children were arriving in yellow school buses, and we all went round admiring the sights and views together. Well, not all of us were admiring the sights and views – some were fighting and arguing. I had noticed these little girls on a subway, and thought it would be a good opportunity for me to show their attractive, intricately-woven hairstyles.

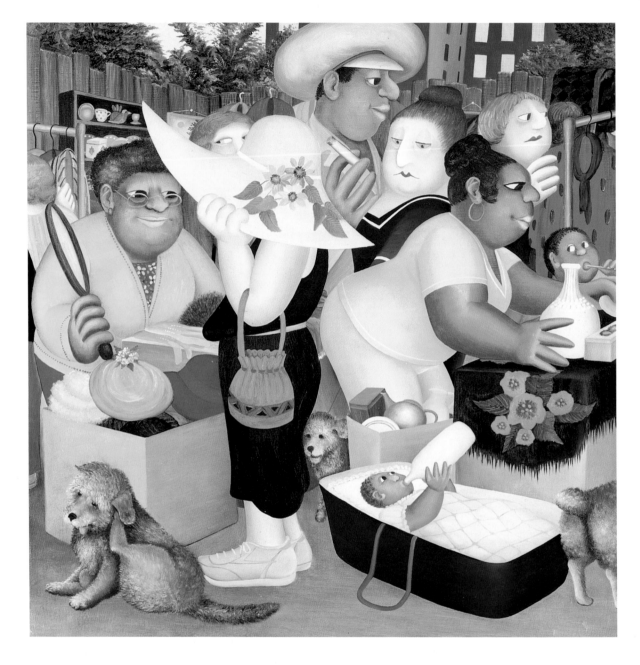

Street Market

Time flies by in the street markets near Canal Street, so does money. Most of the treasures we had to leave behind on the stalls, I'm sorry to say. There were lots of little lookalike dogs, part poodle, part Pekingese and part terrier. Now this combination is not easy to depict, as I found when I came to paint them, and the more paint I added the messier they became. The man in the big hat was very tall and good-looking. He was outside the station when I saw him, but I thought he'd just fit in here.

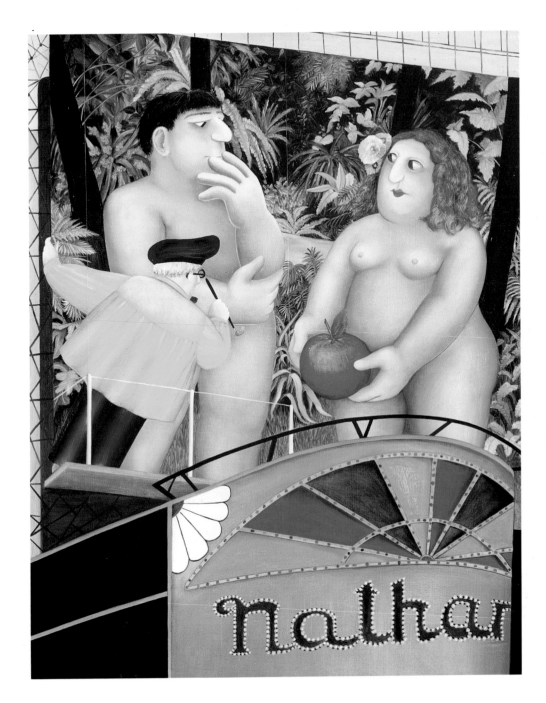

Nathans

I watched a little tiny man high up in the sky painting an advertisement on a huge hoarding over Nathans on Broadway one morning, and wondered what it felt like to be up there. I decided that I too would paint a hoarding for New York and here it is, with me painting it. I don't know why I chose Adam and Eve, but the background is from a photograph taken inside the conservatory at the Botanical Gardens. Adam looks rather doubtful, could it be at the size of the apple? The hardest work here was in making the strategic placement of arms, mine and Eve's, so I didn't have to get too personal.

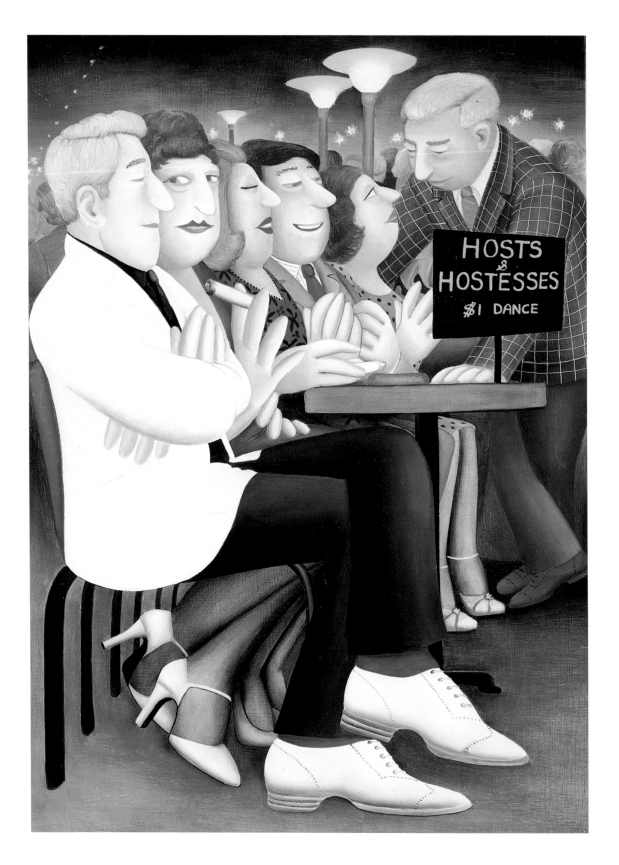

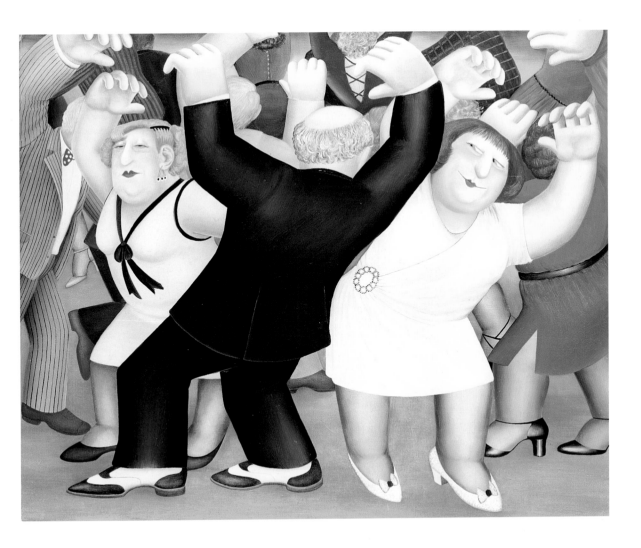

Rumba

During the rumba all the arms seemed to be flung upwards at the same time, which was very appealing to me for a lot of my paintings are arranged round the hands. I wondered whether it was because most of the dancers had had lessons, so that their steps followed the same perfect pattern. I loved Roseland, all the decorations and the happy atmosphere.

Hosts and Hostesses

I'm fascinated by shoes, and as we walked into Roseland I found a large showcase full of them. Some were enormous, bigger even than mine. This was reassuring, and we went on into the ballroom and sat near the dance floor. I soon realised that the large table next to ours was for the hosts and hostesses, who charged a dollar a dance. I watched some of them dance every dance and worried about those not quite so popular. Sometimes they all sat down together and chatted, and this is what I chose for a picture, making a careful arrangement of legs and feet.

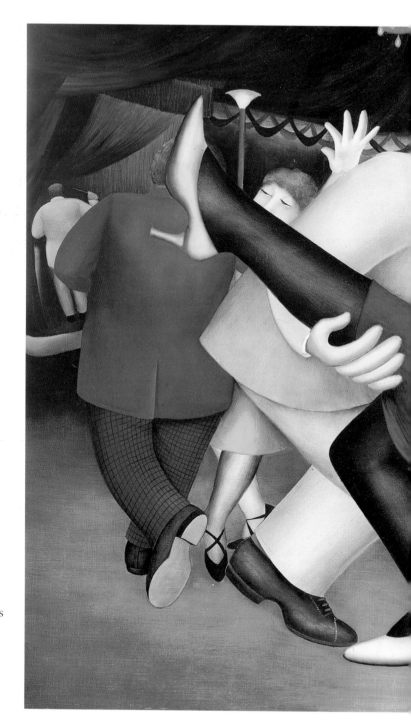

Tango

I love dancing of all sorts, not doing it, just watching. These two came to my notice because of the tremendous effort it was for him to raise her again once she'd reached the floor. This became quite worrying – needlessly I think, for they did it many, many times and she was very petite. The man in the bomber jacket was much in demand as a partner and although he had some difficulty with the platform soles he twirled and side-stepped round the floor for every dance.

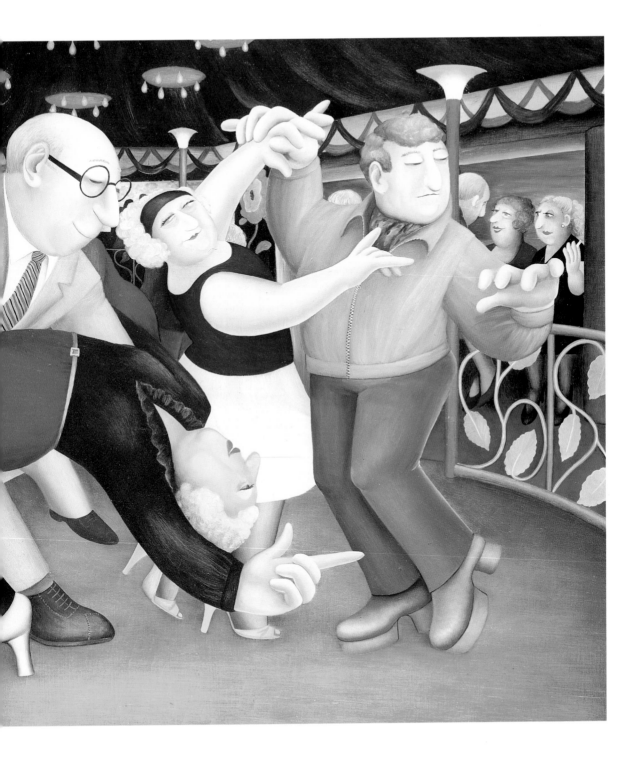

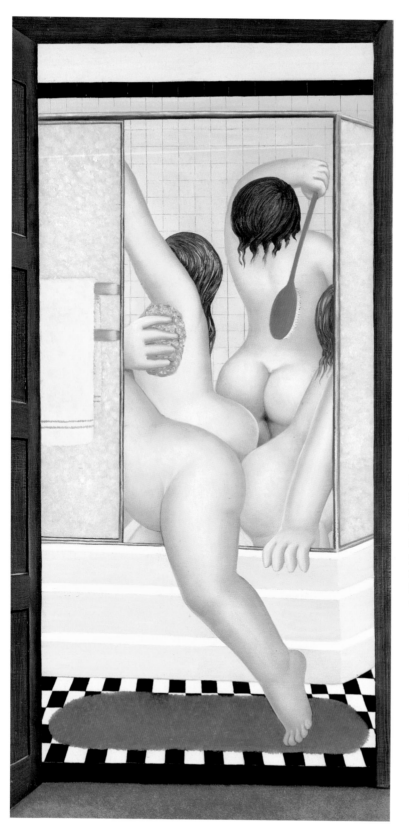

A Bathroom

We had a most comfortable hotel bedroom, very large, and I took a great fancy to the bathroom. I drew this one afternoon whilst lying on the bed and this is what I could see through the doorway. Well, perhaps there *weren't* four girls in there enjoying a shower together, but the picture was dreadfully dull without them.

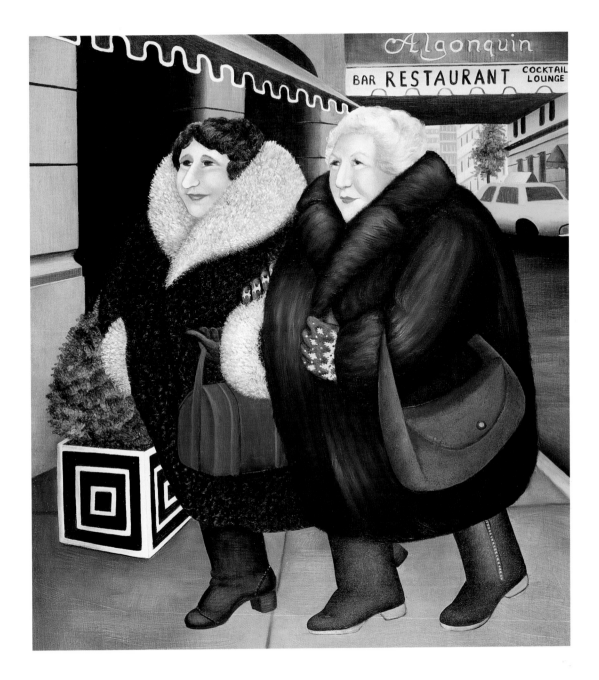

Bar and Barbara

The Algonquin was opposite our hotel on 44th Street and each time we passed it I mingled with the people going in and out, hoping to hear some witty conversation. Expectations rose further when we were invited to tea there one afternoon by a journalist acquaintance, but after finding that we were not sitting at a big round table – only a small square one – all our attention was directed to the sandwiches and cakes. I was discussing this with these two friends, who were talking about their forthcoming trip to New York, and I grew more and more excited as they described the fur coats they'd be wearing and the parts of Manhattan they would be visiting. So much so that I transposed them to this location, one in Persian lamb and one in sable, before they had even left these shores.

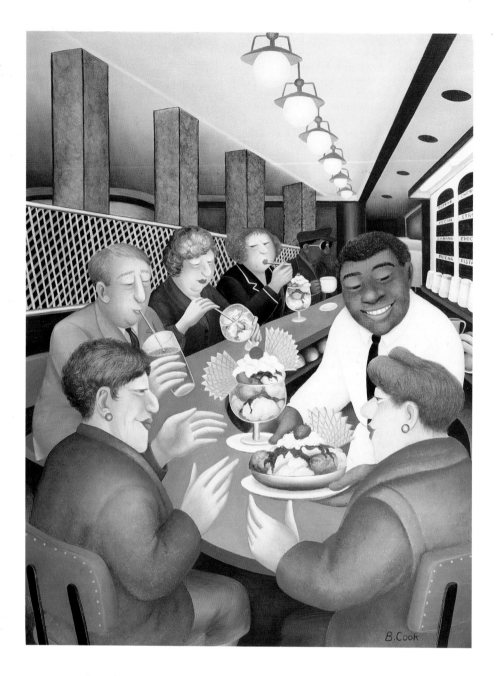

Howard Johnson Café

This café was close to our hotel and was visited often by us when we discovered, indignantly, what it would cost to have a snack sent up by room service. I very much liked the interior design, and the pattern the light fittings and columns made, so for once I took pains with the background. Breakfast was what we were usually after but I saw these ice cream sundaes in full colour on the menus and I sampled one myself before leaving New York. It must be a terrible task for anyone trying to stay slim there: the portions offered are enormous and I rarely left a table without carrying a full doggy-bag away.

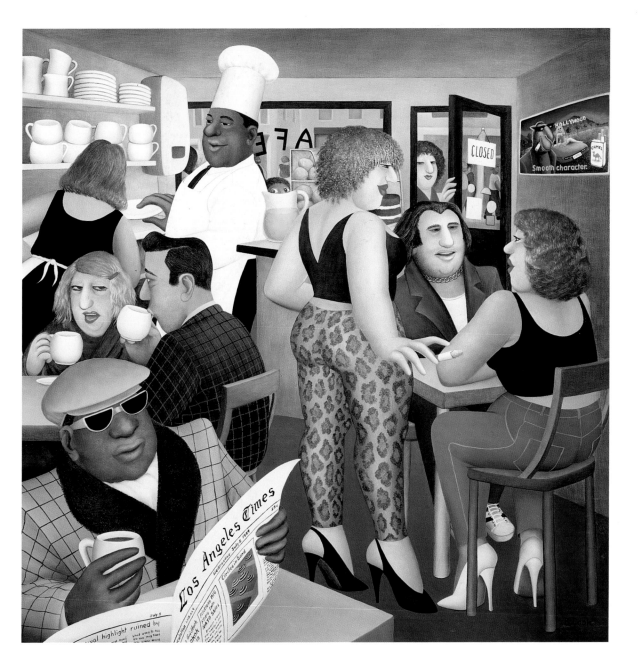

Hollywood Café

Here I am in Hollywood! Where you can't see me, at the back of the café. The only addition I've made to the scene is the advertisement for Camel cigarettes on the wall, which was a huge and very striking poster that I saw on hoardings all over Hollywood. After a visit to Forest Lawns (hoping to find Rudolph Valentino's grave), a bus took us back to Sunset Boulevard and we turned into this café. The chef was enormous and dressed in spotless white. I don't think his clientèle were glamorous enough to be ex-film stars: in fact the man sitting with two girls looked rather menacing, and as we drank our coffee we speculated on what sort of business he was about. Monkey, I expect.

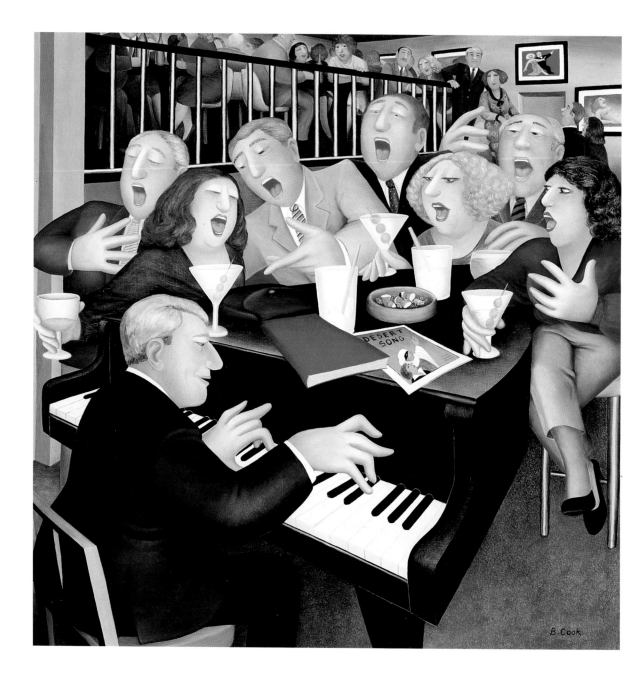

Big Olives or Little Olives

This sing-song took place in a very nice restaurant in Philadelphia where, after wining and dining, a group of friends gathered round the piano to perform songs from the shows. What a lovely evening: everyone enjoyed the unexpected entertainment and I found the enthusiasm of the singers very exciting. Back home with pencil poised, I quickly discovered that it would need a very careful arrangement indeed for me to be able to show both the singers' faces and the pianist's, as well as his hands at the keys. A further difficulty I had was in painting the cocktails – vodka martinis made with the utmost care for our friend Norman, who likes a cold glass, lots of vodka and a little olive. Norman always enquired about the size of the olive when ordering his drink and this led to the name of the picture.

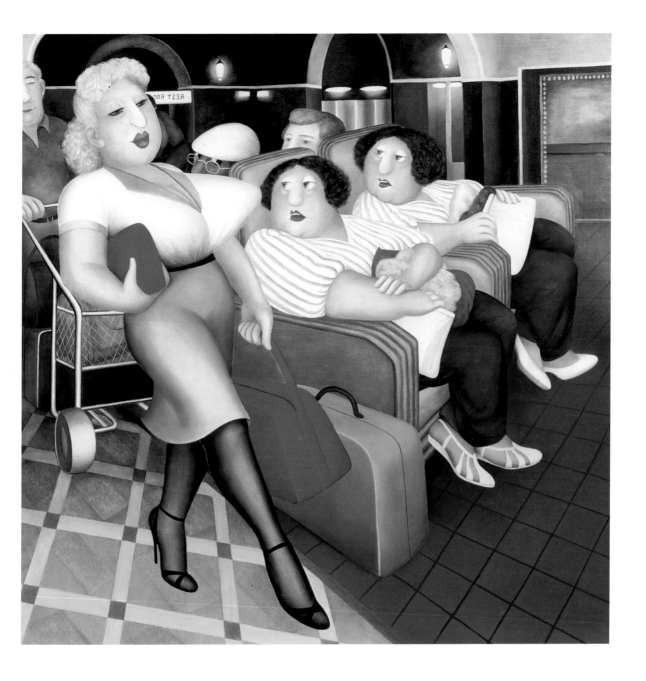

Twins

Pictured here is a combination of people and places I have seen on various trips across America. The background is Los Angeles' art deco railway station, much admired by me when we had a stopover there between trains. Twins fascinate me and I had seen these two watching an outdoor performance on a pier in San Francisco. They fitted nicely in the pair of seats. I had drawn the lady with the outstanding figure on our first visit to the States, when a long wait at Miami Airport was enlivened considerably by her arrival. Believe me, I have not been able to do her justice, and a ripple of excitement went through the waiting room as she entered. I've painted her as I last saw her, proudly striding towards her boy-friend, waiting to meet her in New Orleans.

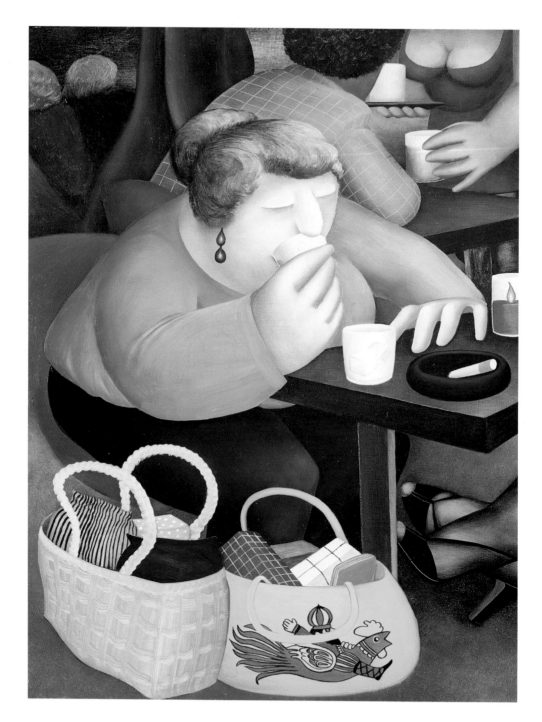

Rye Over Rocks

We often went into Grand Central Station in New York, visiting all the bars in turn, and one evening, before dining on oysters there, I saw this lady waiting to catch a train. She ordered rye over rocks (twice) which must have been greatly needed after a day's shopping. We were served by a pretty waitress in very skimpy clothing, and most of her is squeezed in at the top of the picture. Do you notice the expert rendering of the 'rocks'? I had one myself after painting them.

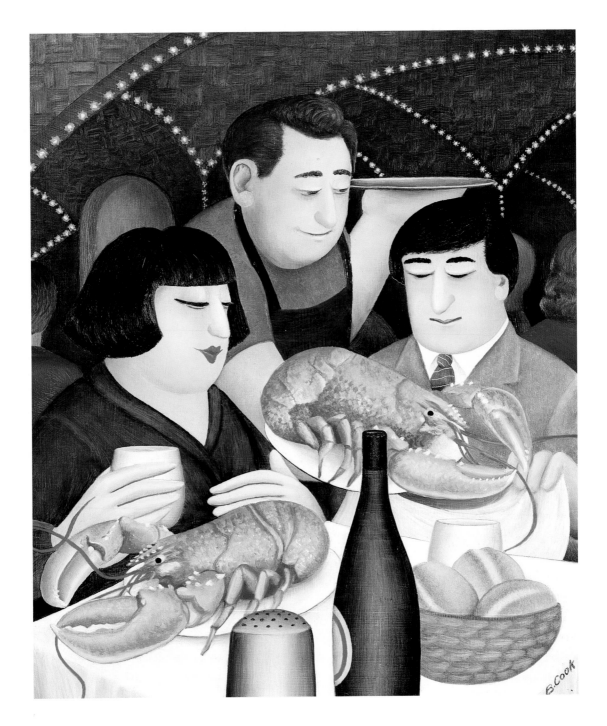

The Lobsters

Here is another scene from Grand Central Station, this time in the wonderful Oyster Bar. This couple from Japan were sitting at the table next to ours. Despite their size – both were small and elegant – they had enormous appetites and these lobsters were just one part of their dinner. I myself had merely a monster bowl of clam chowder, which was decidedly filling, so I watched the various courses arrive at their table with great interest. When I came to paint the picture I used one lobster as a model, turning him round to get the two views. Then we ate him. He was *delicious*.

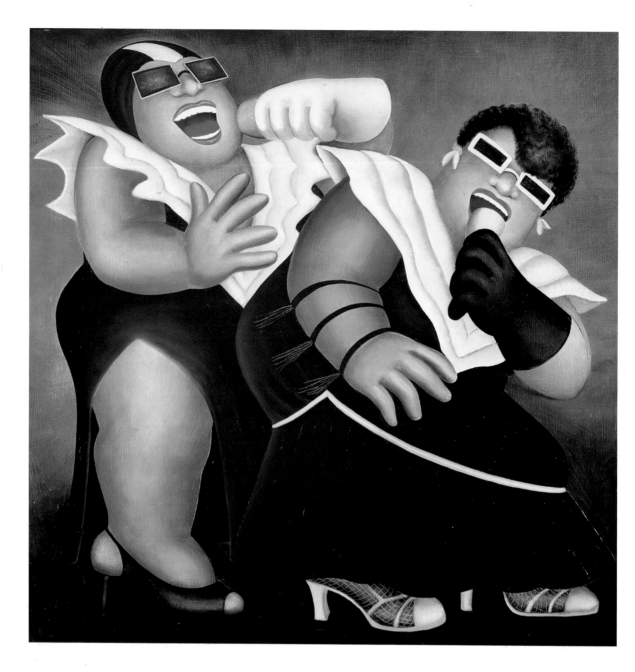

De Cocoa and Hot Chocolate

We nearly always had a rest in the hotel in the afternoons and watched television whilst getting ready to go out for the evening. Judge Wapner giving his verdicts on the court cases became mesmerising, and I particularly liked an advertisement for removing hair which showed three pairs of women's legs with a man's hand sliding up and down the smooth, silky, unshaven leg of each – no stubble! These two singers appeared in one programme, performing in a night club in Harlem. They were so gorgeous I drew them as they were singing 'I Love the Boys', rushing to get in all the details of their clothes.

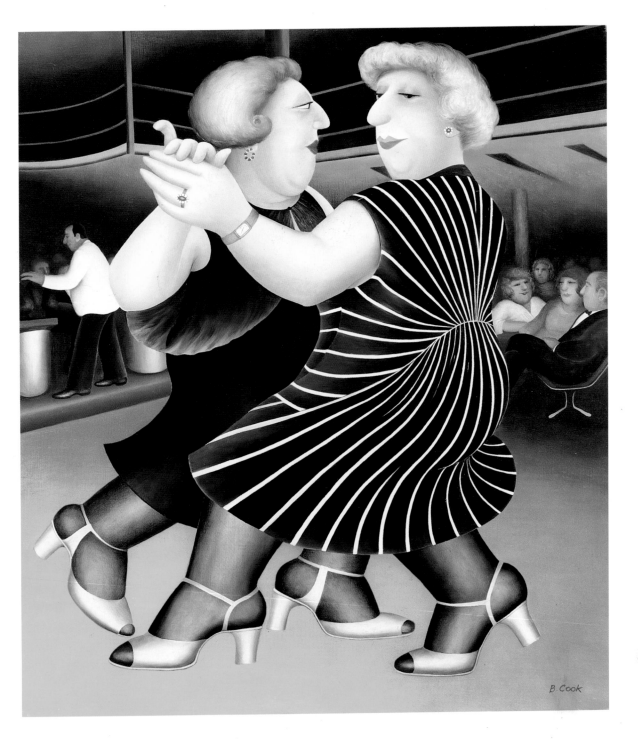

Dancing on the QE2

Homeward bound. Every night is dancing night on the QE2 and all the pretty dresses are out. These I thought were particularly handsome. After I had painted the dresses I became rather excited as they appeared to be moving about in the picture, then I realised it was my eyes that were dancing – from painting all those stripes.

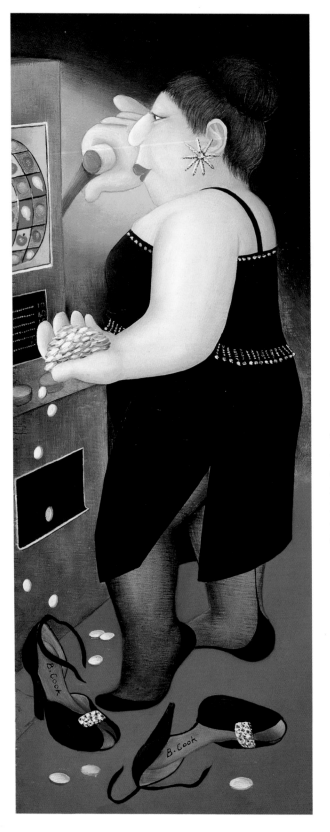

Jackpot

We were travelling back home on the QE2 and this lady in the casino told me that if I wanted to win the jackpot I must take my shoes off. She had removed hers and was having great good fortune. Of all the American paintings, this is the one I decided to keep for myself as a memento of all the exciting things we saw, so John made a special frame to match the dress and the shoes.

Globetrotting

When I look at these paintings I'm surprised to find how many places we've visited. I was too frightened to fly in the early days so we criss-crossed the continent by boat and train. Now I can go further afield but, having discovered cruising, might just take the lazy way out and let the ships transport me to the various ports in the utmost comfort.

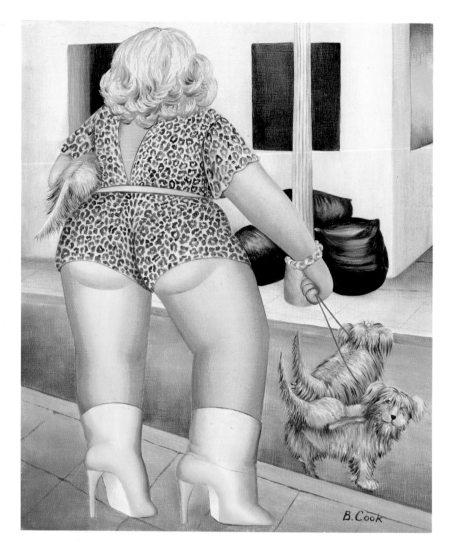

Lady of Marseilles

I painted this picture after a visit to Marseilles. It is an exciting place, dangerous too, and we were warned about which streets never to enter. I don't need warning twice, so we left those streets well alone and sat safely on the quayside in the evenings, content to watch activities on the magnificent yachts and the bustle around the small pavement cafés. This girl, dressed in a minute leopardskin outfit and sporting a golden tan, busied herself going here and there, pausing for a chat or drink, and occasionally disappearing into a dark alley. Her final appearance was from a nearby doorway with three small dogs eager for exercise, crossing the road in front of us as we walked back to the hotel; she left me with this last view of her.

Restaurant Chartier

We spent a few days in Paris some years ago and this is the students' restaurant we queued up to get into almost every night. How I loved it all, the atmosphere, marble tables, brass fittings, even the noise. I discovered, as usual, that none of this is easy to paint and in the end concentrated on the waiters' uniforms and the quantity of plates carried on their arms. I'm particularly proud of the bald head in the front.

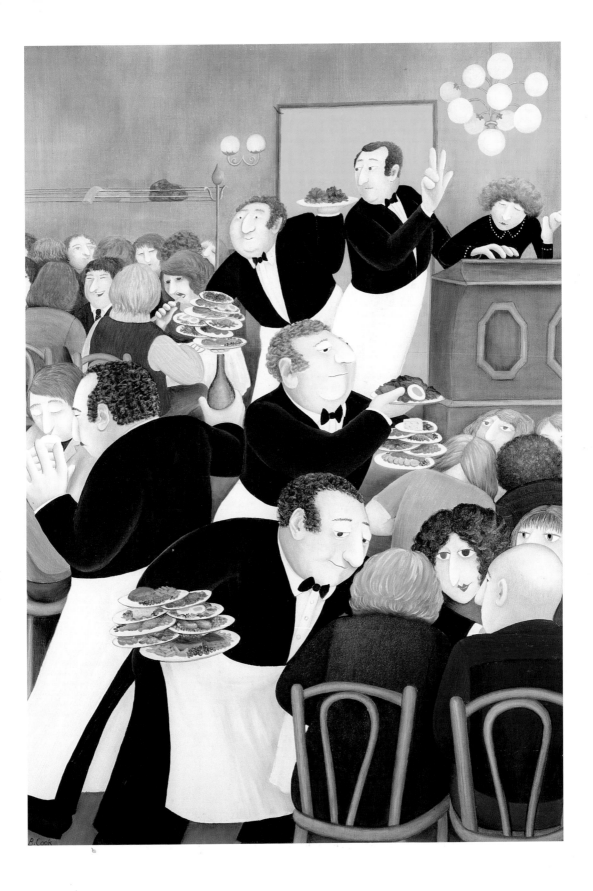

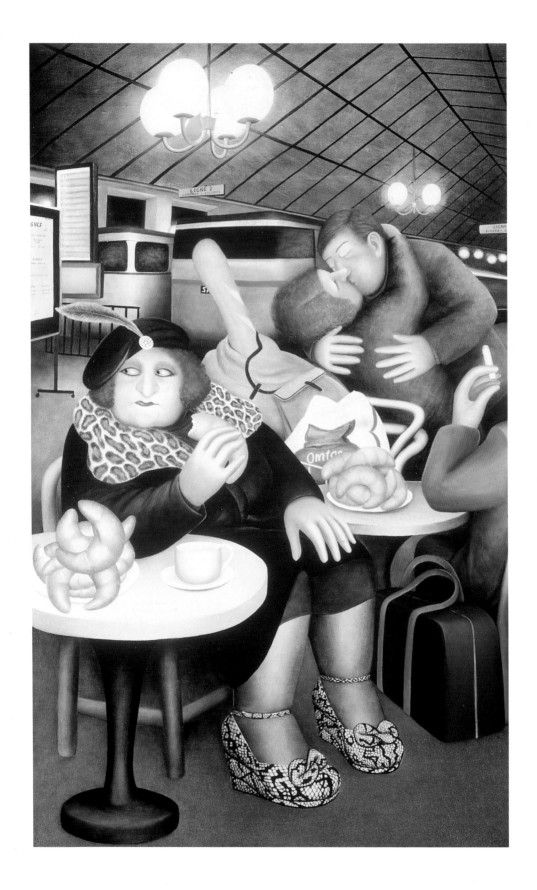

'Ullo Chéri

Some nights during our stay in Paris we'd slowly weave our way (from café table to café table) up to Place Pigalle to join the sightseers, and generally ended the evening opposite these two. The fetching get-up of the one in shorts appealed not only to me but to many others judging from the number of times she disappeared and reappeared on her corner.

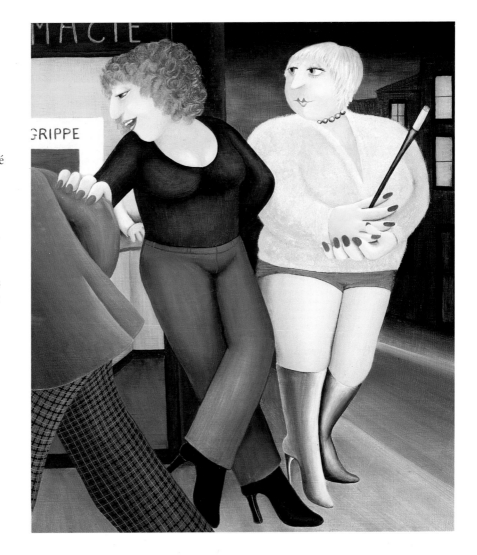

Gare du Nord

I had bought a pair of shoes from a flea-market in Plymouth and they were so attractive I knew I would not rest until I had painted them. On visits to Paris I've seen quite a few middle-aged and old ladies wearing rather eccentric clothes so I thought this would be a good place to show them off. We had arrived at the Gare du Nord early in the morning while travelling from Milan and I saw the young couple kissing as we sat down for coffee. The customer at the next table was the owner of the loaf of bread in the knapsack, but the croissants were all painted from one I bought at home and turned round and round to show the different views. I had to do a lot of drawings before I came up with someone suitable for the shoes and I finally decided that this one would be satisfactory, and rather French.

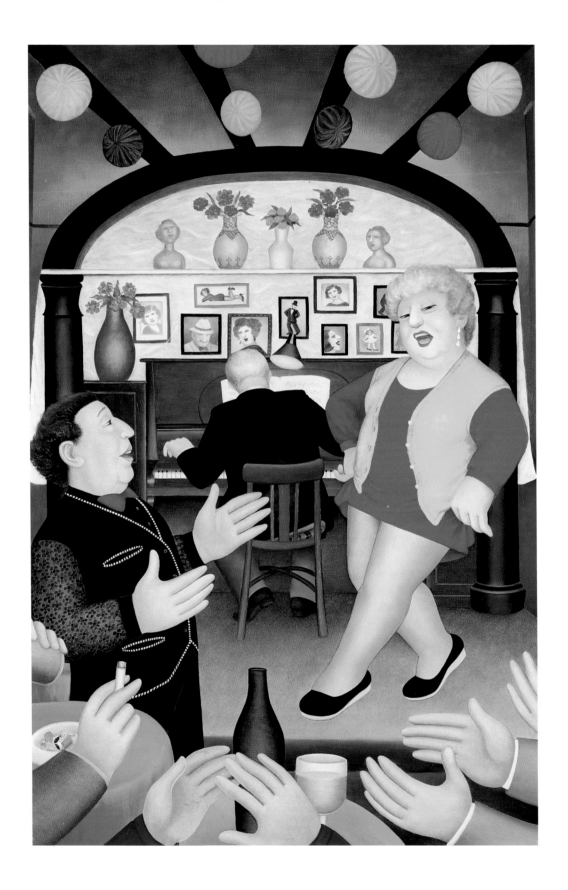

La Paloma Dancehall

We had to join a large queue outside the Paloma Dancehall in Barcelona waiting for the doors to open, so popular are the two daily sessions here. They are held in a lovely old hall with decorated ceiling, balconies and boxes, the dancers rushing for the seats round the floor and the onlookers climbing the stairs to the balcony. The paso doble was the favourite dance and very well performed it was too, with nicely rounded hips swaying seductively to the music. The man at the bottom left was greatly in demand as a partner and could take his pick amongst the ladies. All of these had beautifully arranged coiffures of every colour except white: no self-respecting middle-aged Barcelonese lady allows a grey hair to appear, I understand. I would have liked the picture to consist entirely of swaying hips but I soon found that I would need a few heads as well, and arms, which meant hands, too – something I always like painting.

Bodega Bohemia

(opposite page)

We were led to this little music hall through some dark alleys just off the Ramblas in Barcelona. It gives employment to ex-music-hall stars who have had to retire but still enjoy performing. The man on the left is the Master of Ceremonies, encouraging the applause for the lady just finishing her song. This was in Spanish so I missed the saucy bits, though they were thoroughly appreciated by the rest of the audience. All the restaurants, cafés, bars and clubs in Barcelona only come to life at about eleven o'clock at night. So it was bedtime at five for me after a day of sightseeing, and up again at twelve for a night of frivolity.

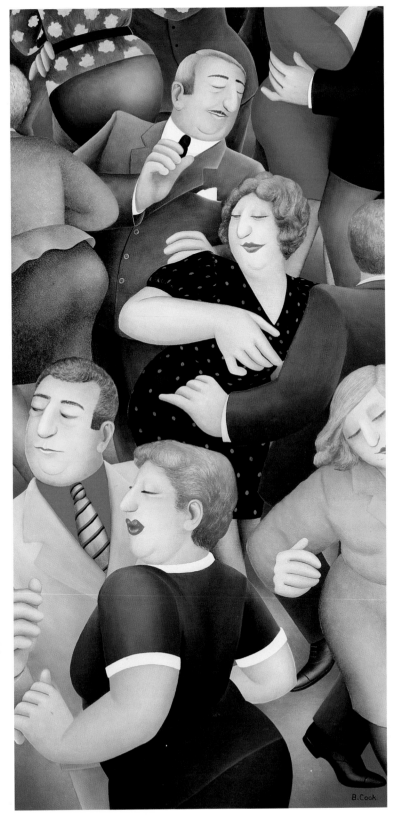

B.Cook

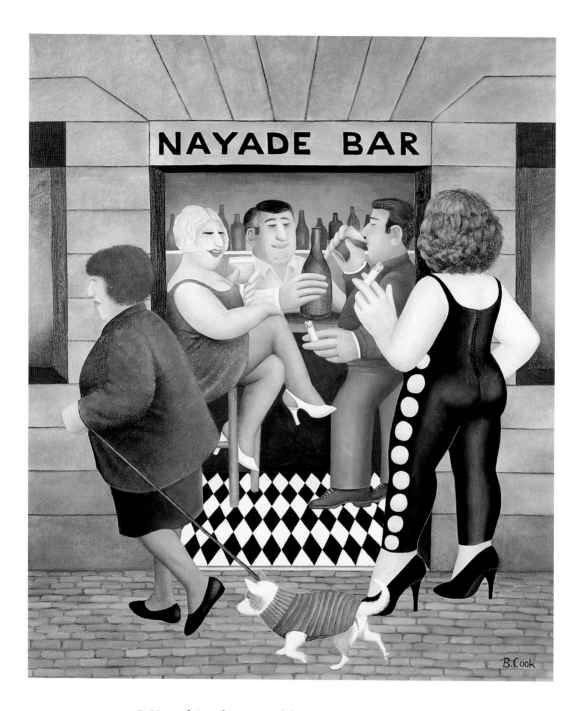

Miguel in the Ramblas

This is Miguel, dressed so smartly in his hand-knitted blue and red striped jumper. He was quite old and trotting along behind his mistress, and she called him by name as he paused by a lamp-post. I chose this little bar as a background for him because I was so taken by the girl, in her amazing outfit, standing outside. I'm puzzled as to how she got it on and off – it can't have been easy (or warm either). There are lots of little bars like this in the side streets off the Ramblas in Barcelona, a wonderful place to visit.

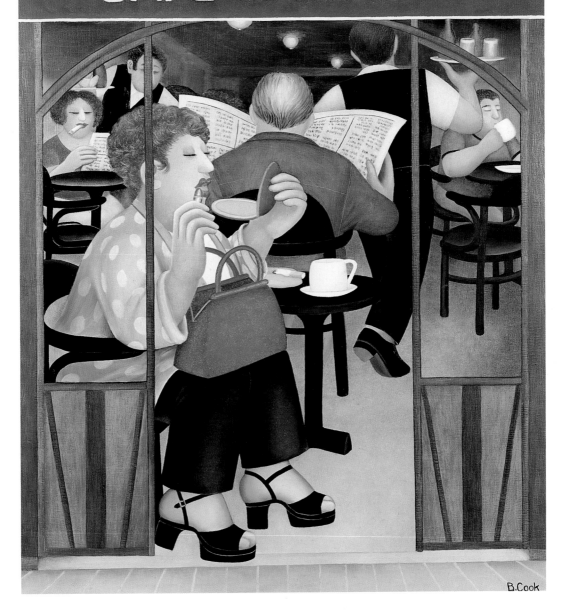

Café de l'Opéra

Our hotel in the Ramblas was close to this café, where we stopped every morning for coffee or – in my case – hot thick chocolate with *churros* (doughnut sticks) for dunking. As I sat enjoying this healthy snack in there one day I noticed my neighbour, contentedly smoking and reading the newspaper. Eventually she finished up her coffee and prepared to leave, finally applying a glistening new layer of lipstick. And here she is, sitting by the door now so I could paint both her and the café from the outside.

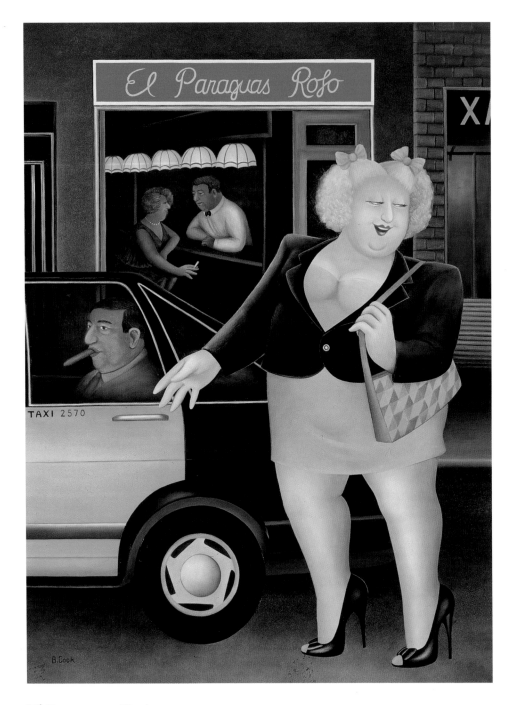

El Paraguas Rojo

Here is a rather famous prostitute. I first saw her on television in England, and then recognised her standing near our hotel in Barcelona, in front of a little bar we often used to pass at night. I say pass because it was so ill-lit that we were dubious about what we might find were we to venture inside. We have been to Barcelona several times and loved every moment there, for I am especially fond of cities beside the sea. This is a large painting (of a large girl) and each time I do one of this size I vow it will be the last: there are so many loud oaths and curses as I heave them on and off the easel.

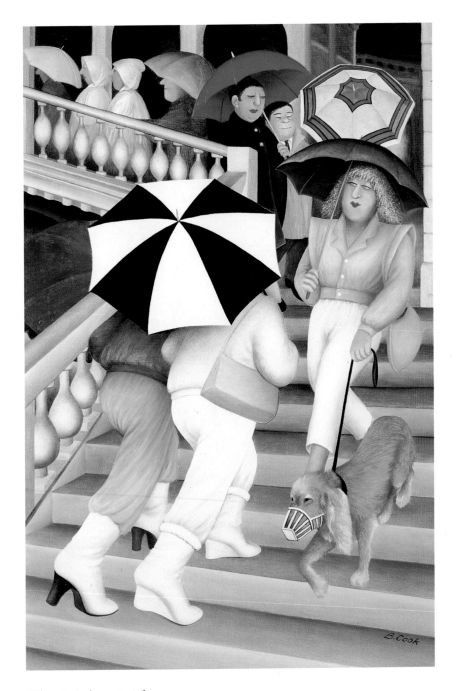

The Rialto Bridge

This scene is one I watched as we sat drinking coffee whilst waiting for the rain to stop on a sightseeing holiday in Venice. We are good tourists and like walking, so we followed the instructions in our very good guidebook and learned many, many things about the buildings and artists. Each new revelation, and gasp of amazement, would be followed by welcome refreshment in a nearby café, and in one of these I had the most gorgeous ice cream I've ever tasted. Dogs are very popular in Venice, most of them wearing plastic muzzles as a safeguard against rabies. This was approved of by me, being highly nervous of all the health hazards I imagine to be lying in wait for me on foreign shores.

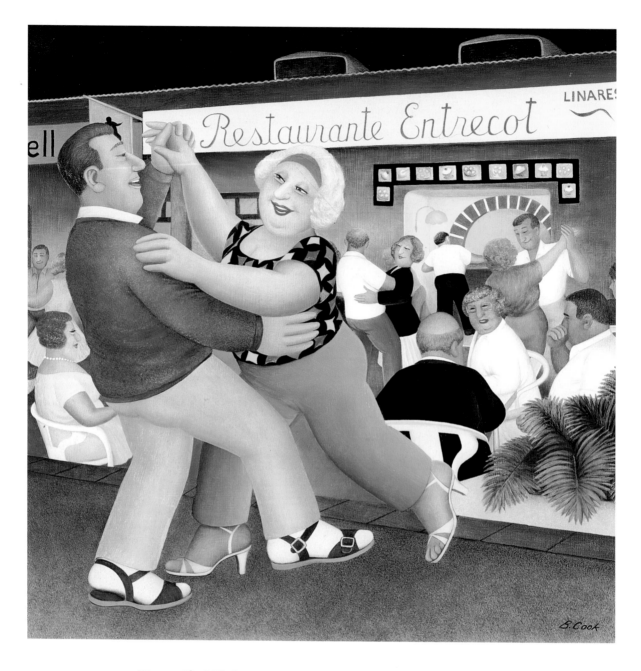

Tenerife Nights

We have been to Tenerife twice now, in the middle of our rather dreary English winters. And what absolutely lovely sunny weather they have there. These suntanned bodies were having a good time in one of the many little bars near the hotel. The bars are large, open patios a few steps below pavement level and each has someone singing and playing the organ, or music from a juke-box, so that people can have a drink and a dance. Passers-by saunter along the pavement, enjoying the music and activities. The couple here stopped for a little dance before going on to whatever they had arranged for the evening.

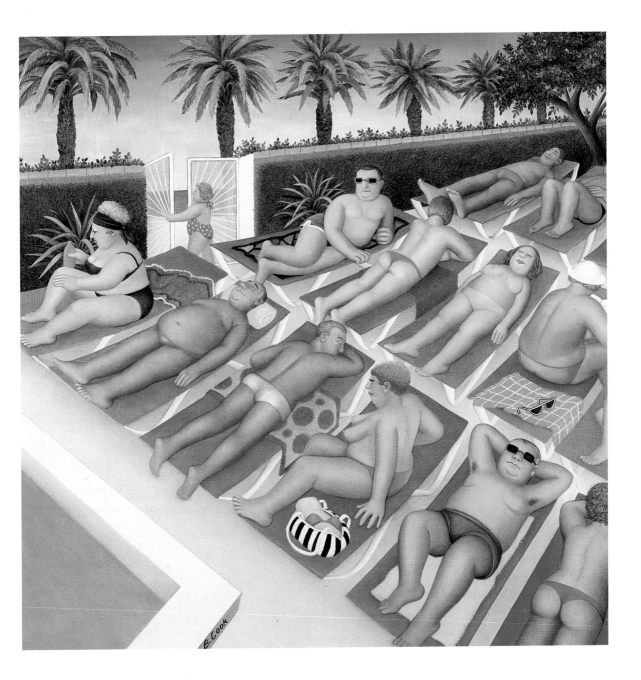

Tenerife Days

During the day it was much too hot for me to stay in the sun, so I was amazed to find these people still lying on their sunbeds when we got back to the hotel in the late afternoons. The beds were booked with a towel first thing in the morning, and then the ritual of tanning took up the rest of the day. Each part of the body would be turned to the sun's rays at regular intervals, some going deep mahogany, some golden and others scarlet. To get these variations in the painting I spent about two days working on each figure.

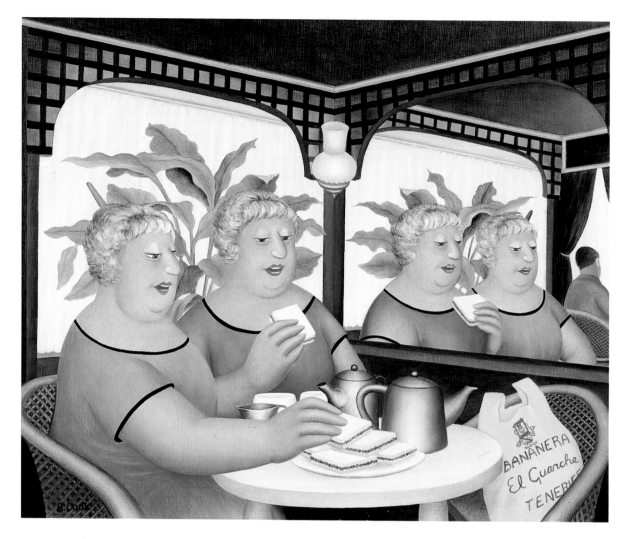

Reflections

This is a café at the top, rather more sedate end of Tenerife. Up here the scenery is greener and more lush, the climate cooler and much wetter. We had hired a car to travel around the island and stopped here for a drink. I noticed a pair of middle-aged twins having afternoon tea quietly together – better still, they were beside a large mirror. I have always liked twins, and here they were twice over – I could hardly wait to start the painting. Oh, what a task I had set myself – I not only had to paint two identical faces but two more in reverse! If I ever come across triplets by a mirror, I shall resolutely look away.

Tango in Bar Sur

Some years ago we decided to go to Buenos Aires especially to see the tango, the most exciting and seductive of dances. As we were having a drink in a bar on the night of our arrrival this couple got up from seats at the back, the piano and accordion players took their positions, and they all gave an absolutely stunning display. For two weeks we spent every evening and sometimes afternoons as well watching and listening to the tango, which is not just dancing but songs and music as well. It is the dance, though, that excites me most of all.

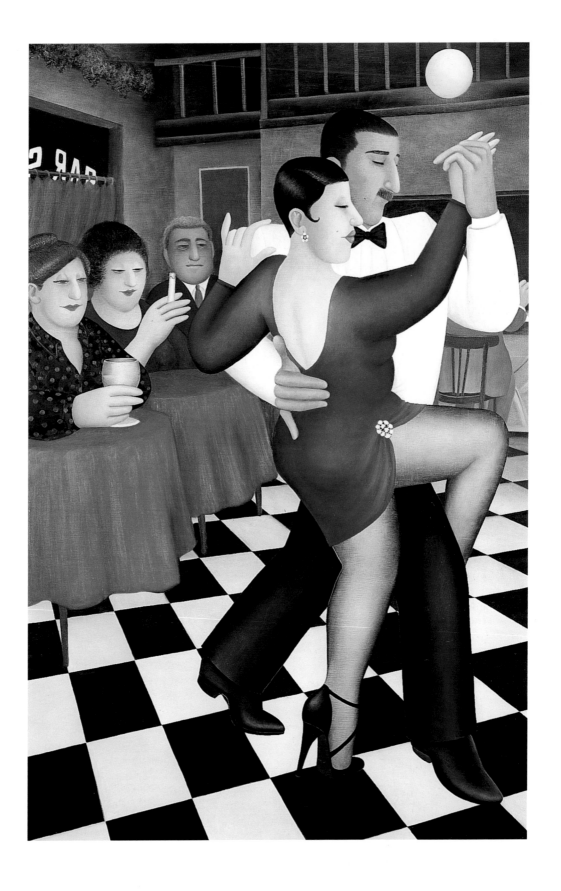

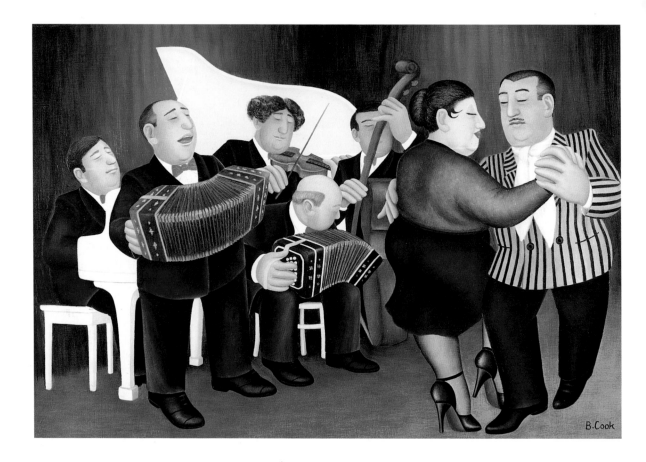

Tango Band

Tango bands can be very exciting, and I was so carried away with an afternoon show in the Municipal Theatre that I eagerly purchased one of the tapes on sale in the foyer as we left. This I did by sign-language – the audience and staff were entirely local and Spanish-speaking – which was a mistake. The tape turned out not to be the exciting rhythm of musicians at the peak of their performance, but a girl's heart-rending songs about Buenos Aires. Both the music and dance are treated very seriously indeed, as you can see from the faces in the picture.

Tango Bar

Black and white floor tiles are popular in the bars here, and this is a little one we were taken to by a guide. It was empty, but a man magically appeared with an accordion while the manager busily poured us drinks. He then took up a microphone and sang a few songs from a book, finishing off by dancing with a little old lady who had arrived in the door-way. All this frenzied activity a few feet away from us had made me nervous, but just as I started to shake with laughter many more customers arrived, including these two dancers, and everything settled down.

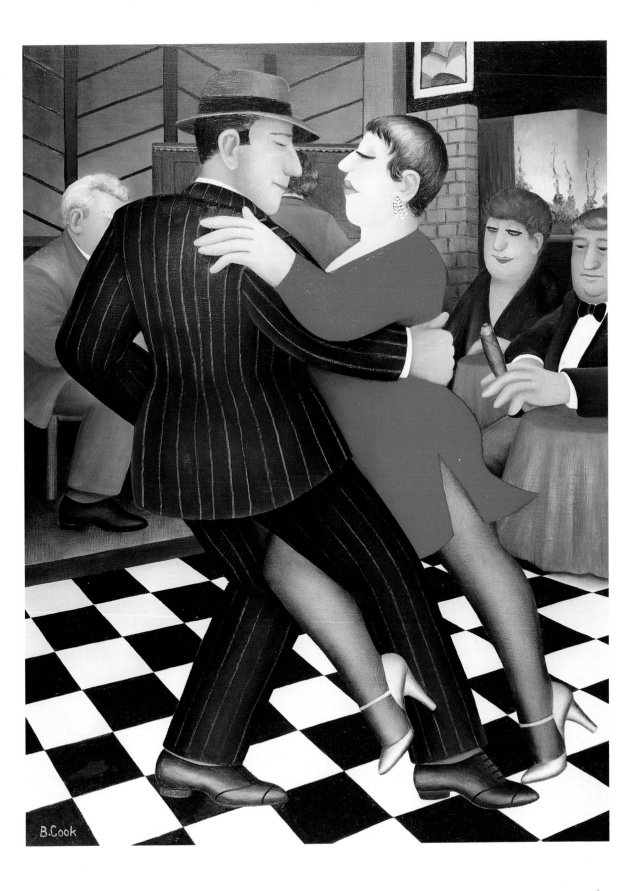

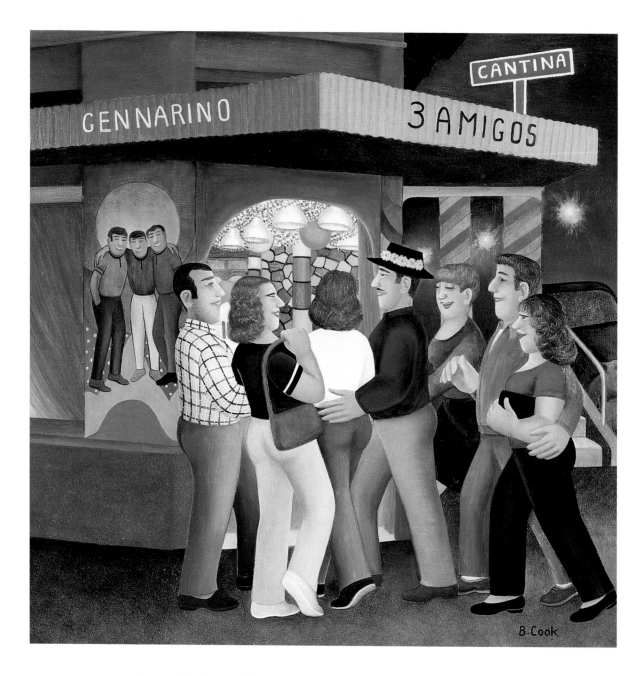

Tres Amigos Cantina

We left the tango bar and Aldo the guide took us to a district called La Boca, which is down by the docks and considered rather dangerous after dark. Around there are the cantinas, song and dance halls for young and old, full of bright lights and loud music. There they eat and dance, have parties and – as on the night we were there – celebrate weddings. In the picture a wedding party is just going into the cantina, and the bridegroom is wearing the customary big hat. The outside of the building was actually much shabbier than I have shown, with lots of peeling paint on corrugated iron, but the inside was a riot of balloons, festoons, tinsel and lights. The people were very friendly and pleased that we enjoyed it all.

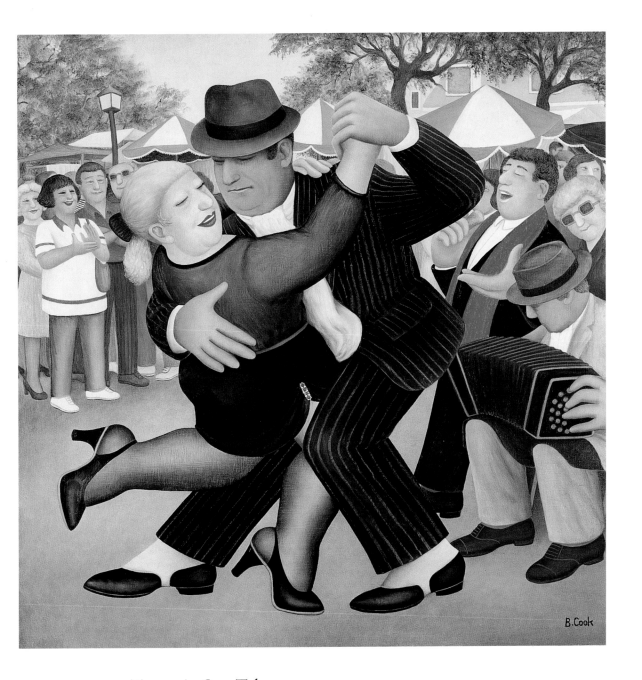

Tango in San Telmo

Tango never stops in Buenos Aires and whilst we were examining the stalls at the outdoor antiques market held on Sundays in San Telmo Square a little band assembled. It consisted of an accordion player and a guitarist, joined by a singer with his microphone and these two dancers. This drew a large standing audience as well as those seated at the café tables enjoying a drink in the sunshine. Here the man wears the uniform most often worn for this dance, a chalk-stripe suit with a white silk scarf, and a felt trilby on swept-back hair, glistening with grease like patent leather.

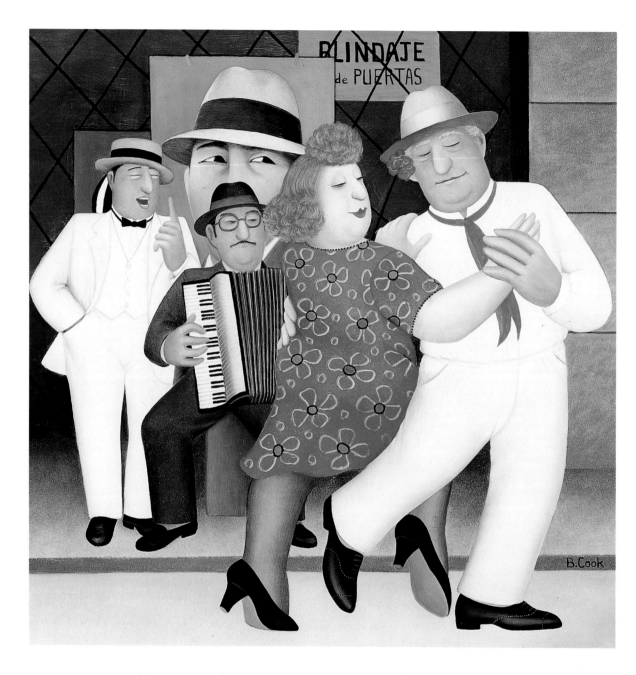

Tango Busking

The streets in San Telmo were full of pavement cafés, and in front of nearly every one a group of tango experts performed for the general entertainment. We found these four in a side street just as we were leaving, so we stopped to have a last look.

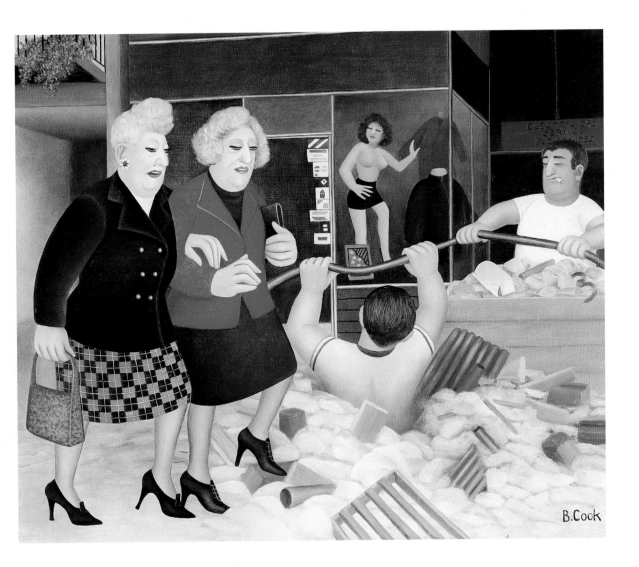

Pavement in Buenos Aires

A lot of the older ladies I saw shopping were very elegant, beautifully dressed and coif-feured. They often went about in pairs, sometimes threes, with arms linked, which is when I began to notice them. And perhaps the pavement you see here is the reason they are linked together – for support and not just friendship. Many of the pavements were in this state, often with a variety of pipes emerging from the hole, and sometimes workmen too. Occasionally an old carpet would be thrown over the rubble, making it easier to climb. I watched these two men, busy with their hole, from a café on the opposite side of the street.

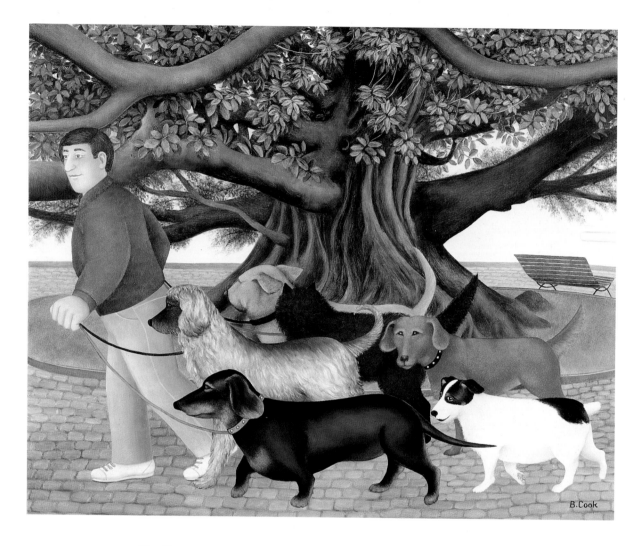

Walkies in Buenos Aires

Here is a cluster of more nimble feet, with no worries about tripping up, just eagerness to get to the park. The accommodation in the city is mostly in the form of apartments and as the dogs (and there are many) need exercising, the dog-walkers collect them in groups at regular intervals. They seem to be very well behaved. Here they are passing the oldest tree in Buenos Aires – so I was told. It is a magnificent and enormous tree situated in a district called La Recoleta, just outside the cemetery. I was fascinated by the tombs and mausoleums in there, for many of them are by famous artists, and it is all very well kept and cared for.

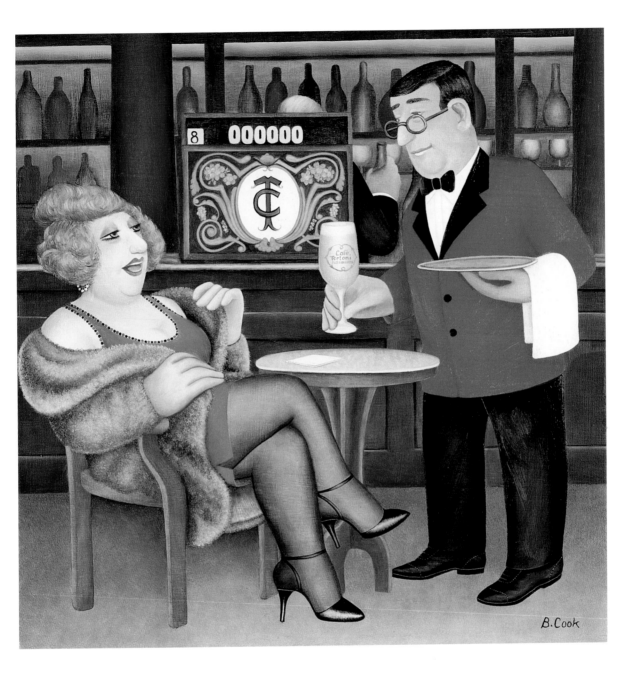

Café Tortini

This is a very old café and the customers are generally middle-aged couples and families, but on one of our visits we saw this lady, wearing a tiny green dress under a fur coat and having a laugh with the waiters. She is in front of a handsome cash till, decorated with a style of popular art we saw on many things all over Buenos Aires, and the reason I painted this picture. The waiter is holding the glass we later purchased from the café as a keepsake. I can strongly recommend the delicious hot chocolate served here and in all the other cafés.

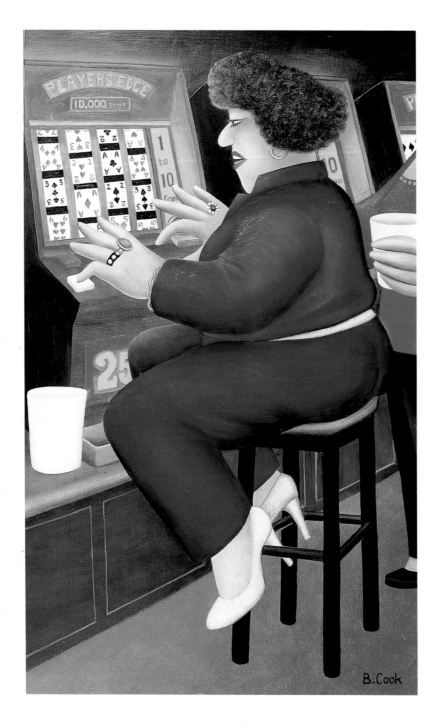

Now Nudge

The pleasures of cruising. 'Now Nudge' is the button her finger presses, and the cup waits for the fortune that will come gushing from the machine. There is always a gaming room on the cruise ships and I like to spend an hour or so playing the slot machines. Others like a lot more than this, and will guard their chosen machine with their very lives. Sometimes they play two together; I saw a woman doing just this and smoking a cigar at the same time. This lady was quite dedicated and did not leave her 'Player's Edge' for the whole time I was there.

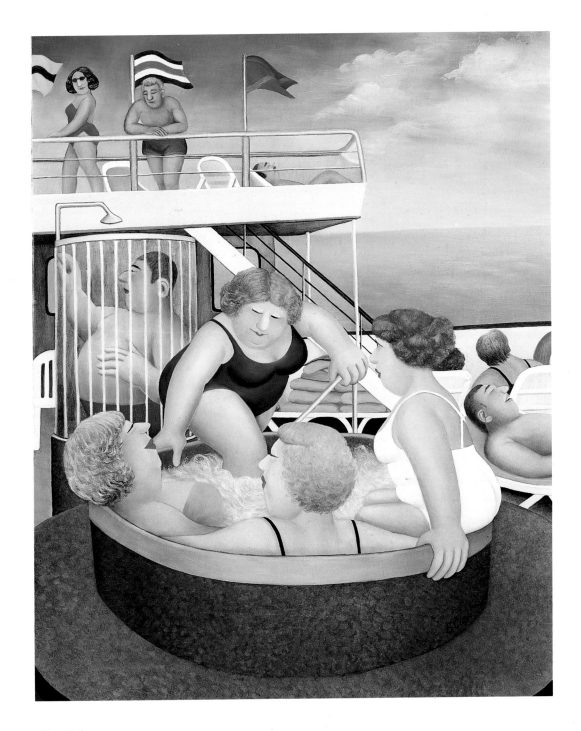

Cruising 1

Here we are at sea on a lovely sunny day. There is an extremely large man taking a shower – I was not at all sure he'd manage to fit into the stall, but he just made it. This was the first time we had been on a cruise and I thoroughly enjoyed it all, especially stopping every day at a different port. Mostly people sunbathed on this deck, but just in front of where I sat was the jacuzzi, which was very popular.

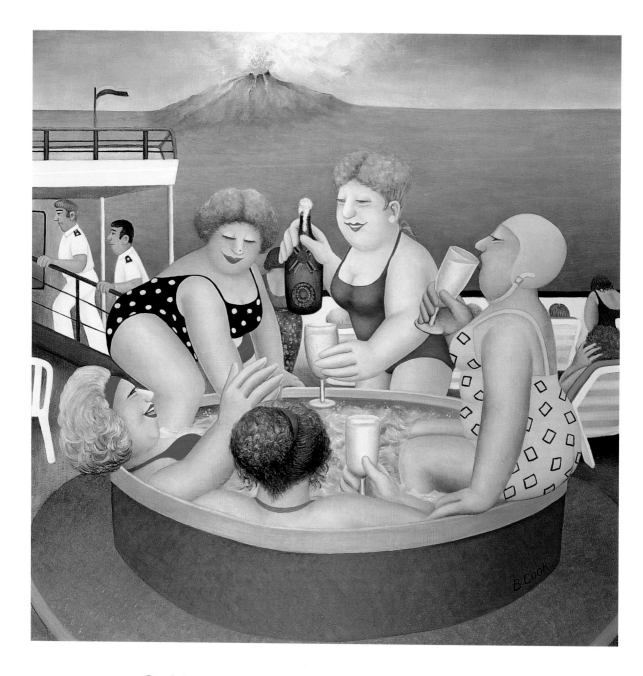

Cruising 2

Here is another picture of this cruise, with a slightly different background. One of the things I had hoped to see was a volcano in full eruption, cascades of lava and fire everywhere as shown in old prints of Naples. But I had to be satisfied with Vesuvius looking peaceful and quiet in the sunshine. So I gave my version a large fiery top, to show it was a volcano. Two of the ship's officers, glamorous in their uniforms, stroll past in the background, and this time the ladies share a nice bottle of champagne.

Homes and Gardens

Most of these pictures date from our time in Plymouth, and they include some of my very first efforts, when I was keen to try my hand at depicting everything around me, painting on odd bits of board scrounged by John from the timber yard. Our house was full of odd bits of junk which often found their way into the pictures, giving them rather an exotic air, don't you think. John is an enthusiastic gardener and I am rather fond of big green leaves, so these also make frequent appearances.

Ladies of the Watchtower

I don't often paint from sheer malice, but this was an exception. I grew to hate these two Jehovah's Witness campaigners who were always coming to the door and pestering me. After several reasonably polite requests to them not to call on me, I once again found them there – side by side, leaflets extended. Slamming the door I vowed, 'I'll get you!' – and I did!

Divine Visitation

We were just removing an enormous roast dinner from the oven one Sunday evening when the doorbell rang, and during the few seconds it took me to open the door, cry 'No thanks' and close it again this scene registered itself, indelibly. I guessed that they had had some practice in arranging their faces in just the right expression of friendliness and reassurance and took great care in trying to capture this.

Welcome

(previous page)

When I kept a boarding-house this is exactly how I felt when I opened the door to new guests, so I regard it as a self-portrait. I took enormous care over the see-through blouse and over the red hair, but had difficulty with the teeth – they turned out rather pointed. I think I was a good landlady – no restrictions, TV in all the rooms, cooked breakfast in bed. One of my visitors was a con-man and later went to prison, much to my amazement. I only realised he was less than perfect when he departed without paying for his accommodation.

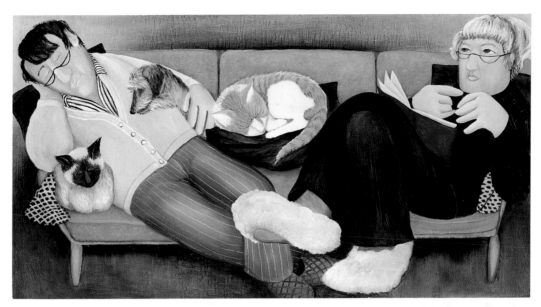

Watching Television

This often happens when we sit down to watch TV: John falls asleep and I read a book. Cedric and Lottie, the cats we had when I painted this, appear in quite a few of my pictures, Bonzo the dog not so often – he wasn't brightly-enough coloured!

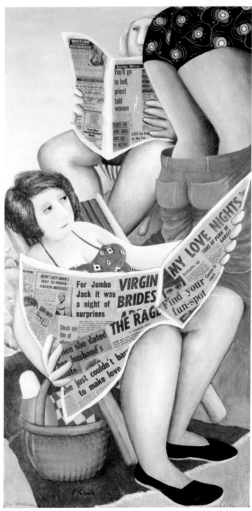

Reading Sunday Papers

Another favourite occupation. This picture started with the bottom and legs; after that, the golden opportunity for me to use some of the favourite headlines I'd accumulated. I like the appearance of newsprint against paint, and spent a couple of very happy hours fitting the papers together. They still make me laugh.

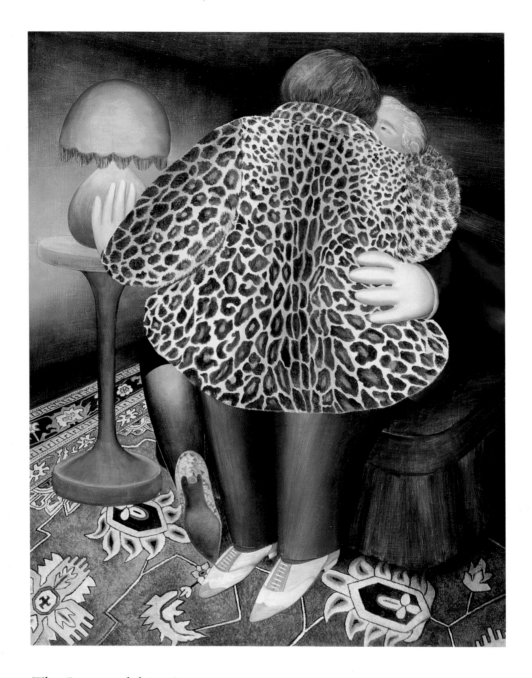

The Leopardskin Coat

The fur coat here came from a magazine but the lizard shoes I found in a charity shop.
The previous owner had feet half the size of mine so I just bring them out now and again
to use in paintings. I would like to be the owner of the two-tone shoes the man is wearing
but I have never been lucky enough to find a pair. There is a bold attempt at a carpet in
this picture, copied from the one that lay on the floor of my painting room until it finally
disintegrated under layers of oil paint, turpentine, cigarette ash and dog-bone remains.

Felix and Lottie

The sofa in the painting room also suffered from animal activities, in this instance Lottie (the dachshund) and her friend Felix, the cat with the large paws. There is a mock-leopard rug draped over the sofa, and I was very taken with the effect of their fur against the spots. And it isn't only fur that looks well on this rug...

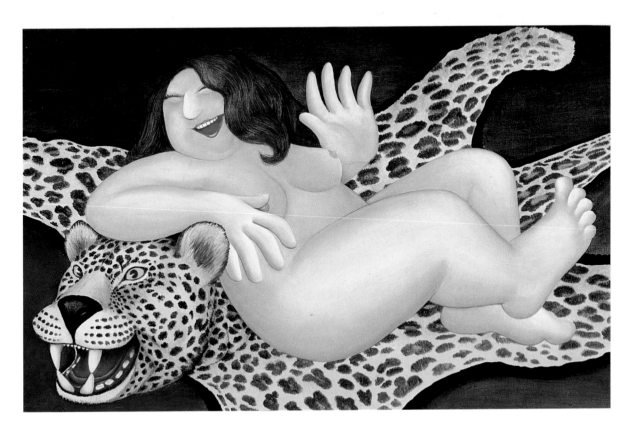

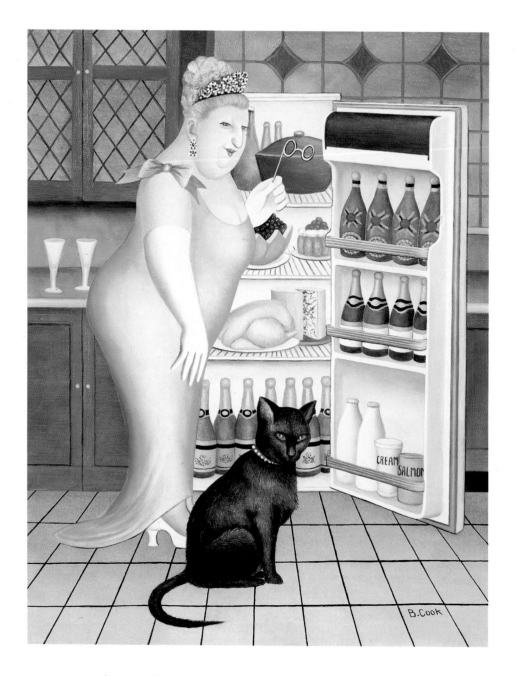

Percy at the Fridge

This picture, which belongs to my husband, John, shows his much-loved cat Percy and some of the food he deemed suitable for one of such aristocratic pedigree. I needed a kitchen background, so various parts of our own were used as a model, and the champagne bottles I copied from illustrations in magazines. In fact I keep pictures from magazines and newspapers of all sorts of things I think I may need for a painting. I'm sorry to say poor Percy is no longer with us in the flesh – only in spirit and on the sittingroom wall.

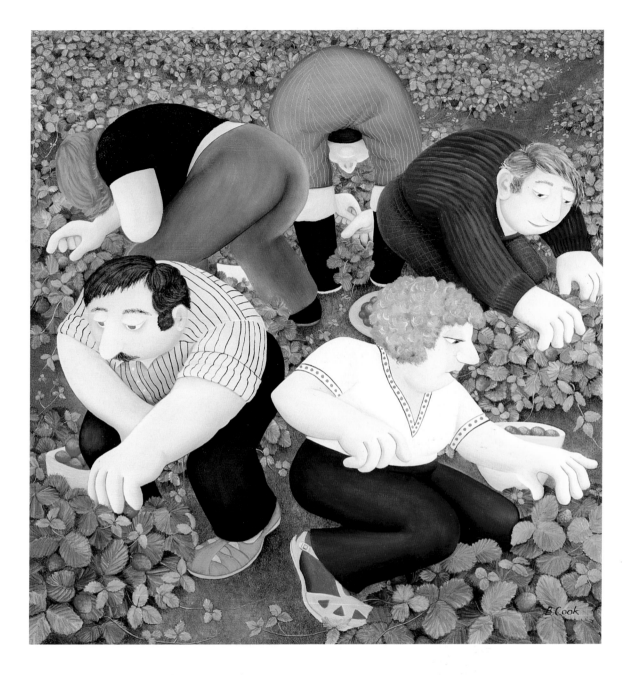

Strawberry Pickers

From champagne to strawberries. We took our granddaughter Alexa out to the strawberry fields one summer. She ate strawberries, John picked them, and I just stood about, unlike these people here. The plants were all painted from one I have in a pot at home, turned round to get different views of the leaves.

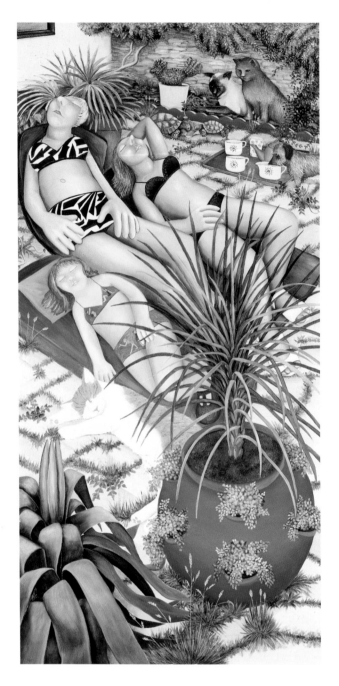

Sunbathing

I never did any housework on sunny days in summer, nor did Teresa, my daughter-in-law, or Alexa. Luckily we had a tiny patch of garden at the back of the house which caught the sun, so we lay there lazily all day with the animals. We dreaded that we might one day be liberated and have to go out to work instead.

The Lovers

This was a corner of our garden, my view in fact each time I slumped onto the sun-bathing mat, and a favourite spot of our cat Cedric's. After two unsuccessful attempts to get him placed in the centre of the foliage I gave it up and put in some lovers instead. One of them turned out to be George, who had just had his hair permed, and I liked it so much I gave them both the curls.

Red Hot Poker

(opposite page)

Look – no humans! Just Teddy the tortoise and Lottie peering through the undergrowth. I watched him desperately tugging away at a leaf one day, as did Lottie, who followed his movements (when he *did* move) with the greatest interest. He didn't succeed in shifting the red hot poker, or even in removing a leaf, so he staggered off to trample down the more convenient tomato plants.

Mum in Hammock

This is a Sunday afternoon in a garden in Reading many, many years ago. The pretty one in the sailor suit is *me* and the others are my sisters, Cynthia, Mary and Freda. Mary is eating her greatest treat – a large meringue – whilst the rest of us busily tease and provoke each other. We rarely spent more than a quarter of an hour together without an argument or fight and my mother, long accustomed to the sound of thuds, blows and shrill threats, takes a rest in the hammock. Just out of sight, in the garden next door, John would be aiming stones – and very accurate he was too.

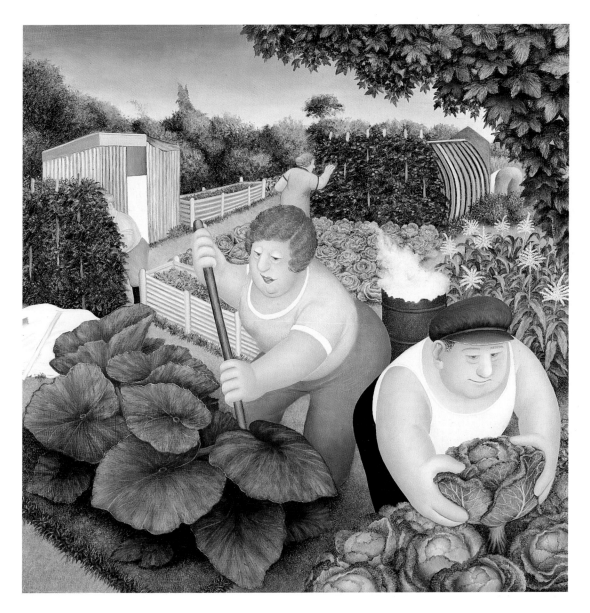

Attending the Plants

(opposite page)

And here we are, John and I, a hundred or so years later. John has progressed from stones to something I won't tell you about, except to say he got it off Dartmoor where the wild ponies are, and is busy preparing it for his tomatoes. This was painted on a piece of wardrobe our son had been dismantling in the garage, where this scene is taking place. The fact that we are hopeless gardeners does not deter us in the least: every year we plan, plant and pot up a new batch of failures.

Rhubarb

There's a nice big patch of corrosion here for me to paint, the corrugated iron shed on the allotments. Not that the rust alone attracted me, it was also the contented people I saw tending their plants each time I looked over the fence. And *what* fine plants they were growing – huge cabbages, lettuces, runner beans, well-protected soft fruit, even flowers. This was not an easy picture to compose. I was reluctant to leave any of the plants out but had to make room for a rusty shed and smoke-filled barrel, as well as make an attempt at perspective. All the cabbages were painted from a big one I bought in the market.

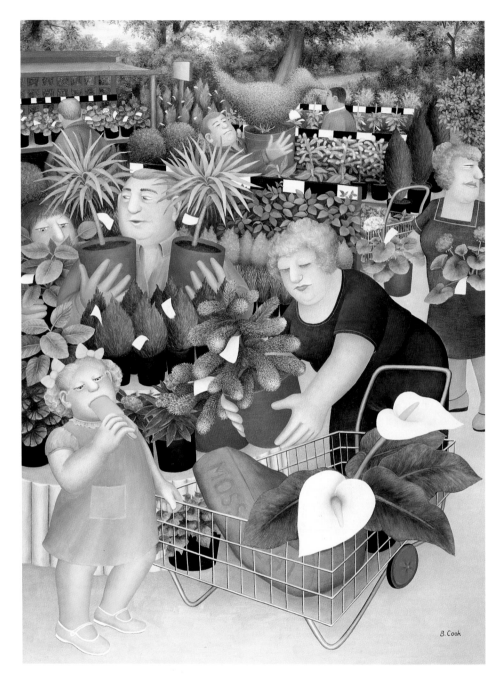

Garden Centre

I used several of the plants in our garden for this painting. I had been cultivating a large privet chicken for years (which later gave birth to half a dozen small ones, grown from cuttings) and the lily regularly made an appearance despite being cruelly cut back. There is something very soothing, and expensive, about a visit to the garden centre and it was a popular Sunday afternoon outing down our way. Half way through all these plants I asked myself if it was really necessary to paint each leaf separately. The answer was yes – because I have never been able to find a better way.

Sport and Recreation

● ●

I do so admire these energetic people, bowling, playing tennis
or football, cycling or dancing. There's lots of activity here
for I like painting movement, although not one for much of it
myself; watching tennis or wrestling on the television is easily
enough exercise for me. There are also some more sedentary
pursuits, playing cards and bingo, and nights at the ballet and
the opera, when the audience is sometimes more interesting
to me than the performance.

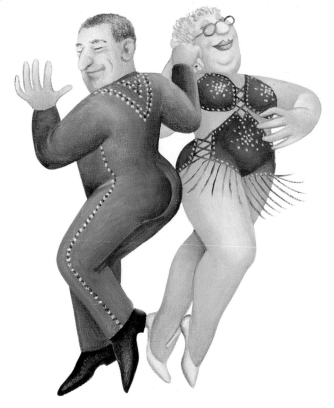

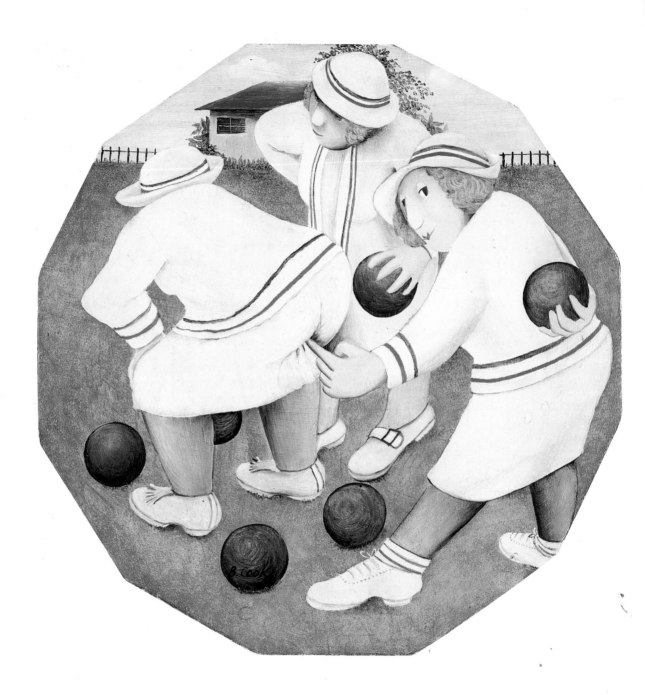

Sabotage

The main thing I'm after in my pictures is to get the design right. I painted this on a circular breadboard, so everything followed in circles, the arm and hand finally ending up like this. Have *you* ever been tempted? After the picture appeared in the *Sunday Times* someone wrote to me: 'I saw your paintings in the paper this morning and I laughed so much I fell out of bed.' It was nice of her, and many others, to write just to say how much pleasure the pictures had given.

Pretty Wood

Some of my paintings appear because of a phrase I like the sound of, and I still have a few hovering on the sidelines of my mind ready for a painting to be attached. 'Pretty Wood' caused this one: a term of admiration for a good ball bowled, they tell me. I'm not sure if it is possible for anyone to stand in this position but he has just rolled his bowl along the green, and the composition fitted the board I was using. The men in the teams I see are so good-looking that I once tried to persuade John to join so I could mingle with them. I learned last year that this painting had been stolen from its home in Canada – by a middle-aged lady perhaps.

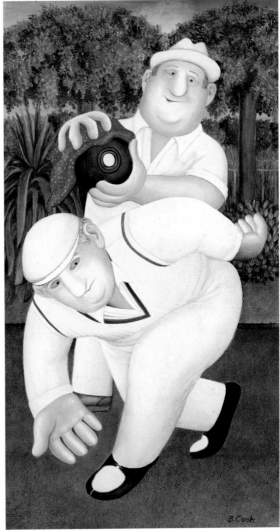

Bowling

Another view of bowls players, painted as the end-piece for the first book, *The Works*. After this I decided not to go too close to the bowling green whilst out walking the dogs on the Hoe. But I don't think the bowlers really minded.

Tennis

I was very tired indeed after arranging this strenuous game of tennis for a friend of ours, Tony. As soon as the picture was framed I realised I needed to find his opponent some real hair, and used an old hairpiece of Teresa's which fitted perfectly. So far I have not succeeded in keeping the hair curled and may have to perm it. Or shall I just go back to painting?

Ladies' Match

What a grand swipe at the ball this girl is about to take – if that is the right expression. It was the girl's leap in the air that started this painting off, but getting her partner placed to smash the ball back again (and still remain in the picture) was not so easy. She needn't worry about being in the right place, though, for although this is my third tennis picture none of the players so far has ever been limited by the markings on the court. I always like the start of the tennis season – it means summer is here, and as just watching a game leaves me as exhausted as the players themselves I can go home satisfied with all the healthy exercise I feel I've had.

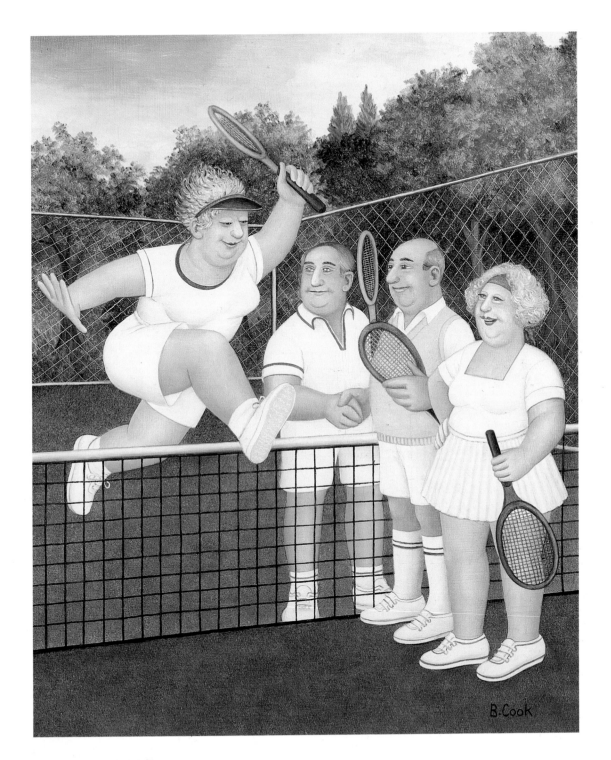

Mixed Doubles

An exultant winner leaps the net at the end of her match here. For some reason I thought that this was the usual way of celebrating a win, but I now recall that I have not actually seen it done. I had a teeny problem with the rackets. Although I copied the details faithfully from a tennis catalogue, I suspect that they are rather on the small side.

Footballers

I once saw a football picture which was mostly of the audience and very little of the players, and decided I would rather have one the other way round. I drew the figures in white from a match I saw on television, and as they had so clearly scored a goal I naturally gave them the colours of the local team – Argyle. I'm not sure what team the one in front belongs to but he is very, very dejected.

Footballers on the Downs

We are lucky to live near the Downs and go there
every afternoon with our little dog. There is every
possible activity going on: in high summer it's picnics,
kite flying, sunbathing and barbecues. In the football
season all the kits appear and hearty games are played
to loud shouts of encouragement. Here are some of
the players, their hair flying in the wind as they race
towards the ball for a powerful kick.

Six Thousand Women Running

And here are the 3645th, 6th and 7th just passing our
seat, under a shady tree in Central Park. It was quite
exhausting, watching them all running, and waiting
to give a cheer to the friend who had told us about it.
On a previous visit to the park we had found ourselves
near a little green dell, surrounded by trees, in which
several men were sunbathing. This was a most peace-
ful scene, quite silent, just watching eyes, and I
thought it would make a good background for the
race.

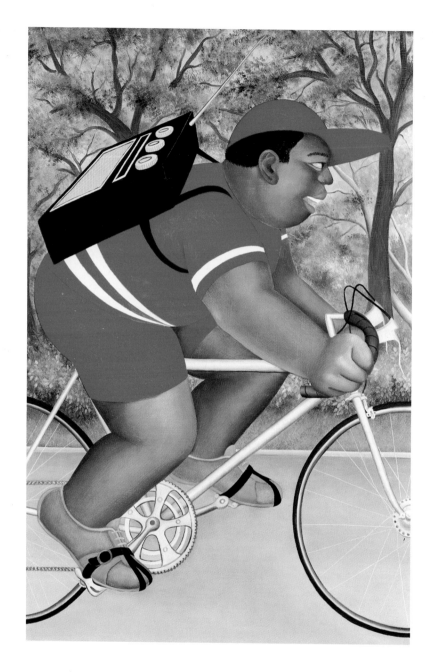

Bicyclist

If only it were *me* cycling and singing to the music, dressed in a snappy red outfit. Loud rock music announced his arrival and then I saw how attractive his clothes were. It took me some considerable time to draw the bicycle and I gave it up several times, but I liked him so much I persevered.

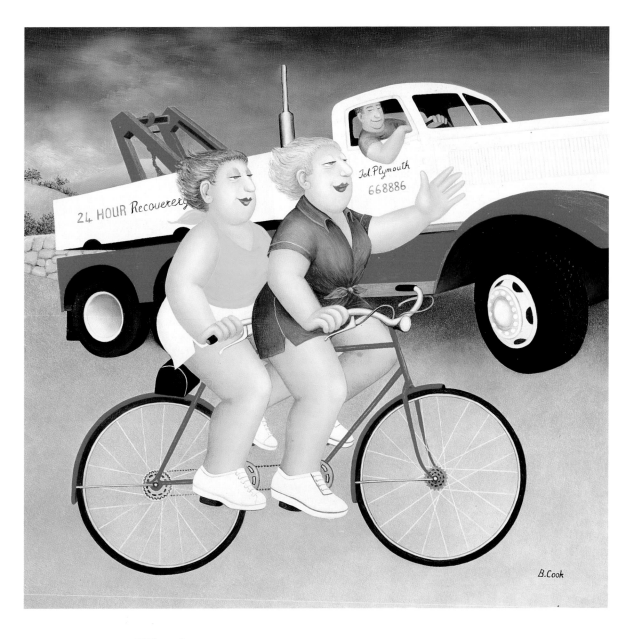

Wheels

I had thought about painting a tandem for some time but had been unable to work out the best way of doing it until I started to draw this lorry, and realised that one would fit in here and make a tasteful arrangement of wheels. As I haven't got a tandem, or a picture of one, a stretched bicycle seemed to be the answer. I thought I'd succeeded with this until I showed it to a cyclist! I now learn that there are also such things as tandem tricycles, on which the riders sit side by side, and I've every hope of capturing one of these in a painting one day. The lorry-driver here is not very good at spelling.

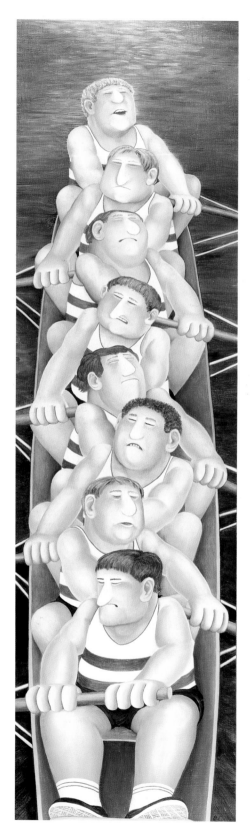

The British Eight

Here is the British eight, straining every muscle in their endeavour to win the race. This picture was inspired by a small newspaper cutting and as it was a sideways view I had the task of re-arranging them like this so I could better show the effort involved. The water was difficult but I think I've made rather a good job of it.

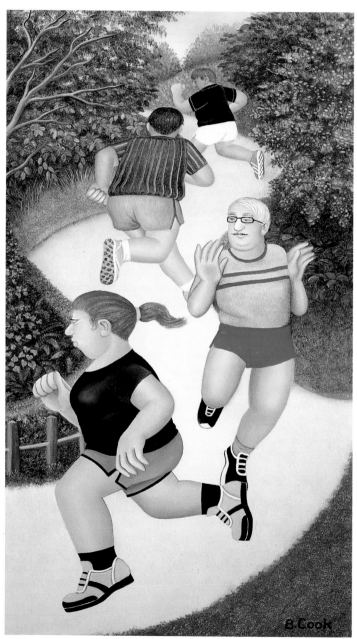

Playground Slide

I love the energy and movement at playgrounds, with all the children swinging, climbing and sliding. In this case it was the yellow slide that took my fancy – this is the only one I've seen in a playground and I liked it a lot.

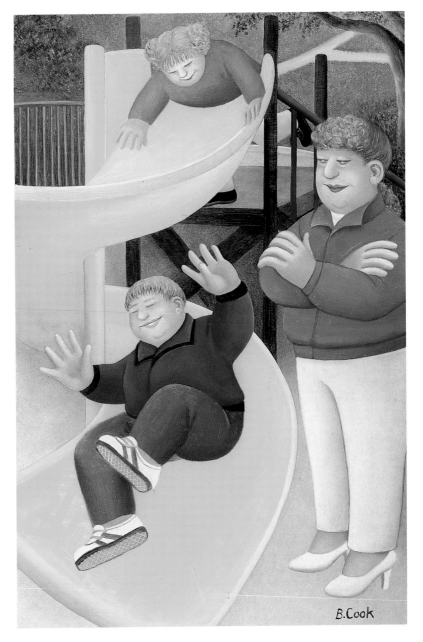

B.Cook

Morning Run

(opposite page)

These are some of the joggers we see in the mornings when out with the dog. This exercise isn't nearly so popular as it used to be a few years ago, and considering the hills there are in Bristol I'm surprised that anyone here takes it up at all. Some spring along lightly, but to others it's a real effort, and one man grunts in anguish with every leap he takes. I liked the piece of path they're on because of its curves, and photographed it to use as a background. Normally there would only be one runner on the path, but I like to get as many people as possible into my paintings.

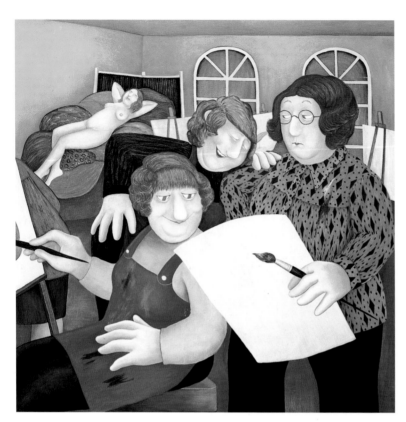

The Art Class

This is one side of a signboard for the Plymouth Arts Centre, and stems from the stories my mother used to tell us of her experiences of evening art classes she joined at a rather advanced age. They made her laugh so much I doubt whether she can have learned a great deal, but she enjoyed the few she attended. And this is how I feel some of the results might have been greeted.

Musicians

The other side of the signboard shows a serious trio enjoying some chamber music. I felt I really must get the instruments right in this case and borrowed a book from the library to assist me. It did take me some considerable time writing the music for them and I hope it is in keeping with the exquisite pleasure they are feeling.

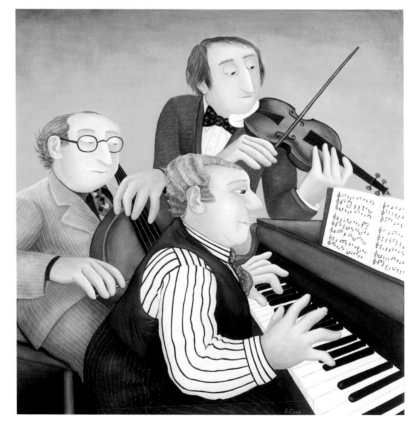

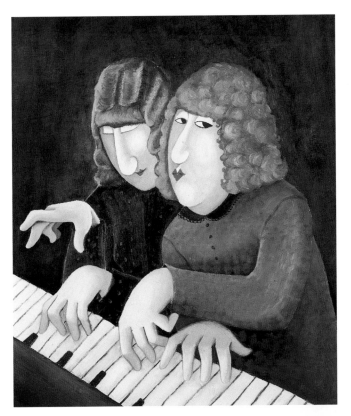

Pianistes

I'm not at all musical but love watching people play musical instruments. Crossed hands have always seemed to me the very height of expertise in a pianist, and for the first time I indulged my passion for ginger curls in this picture – painted many years ago.

Applause

Who mentioned bananas? I'm afraid I gave way completely to a fondness for large fat fingers in this painting – originally intended as a picture of James Galway. Gradually the hands got larger and James Galway smaller, and here he is receiving rapturous applause at a lovely concert he once gave in Plymouth.

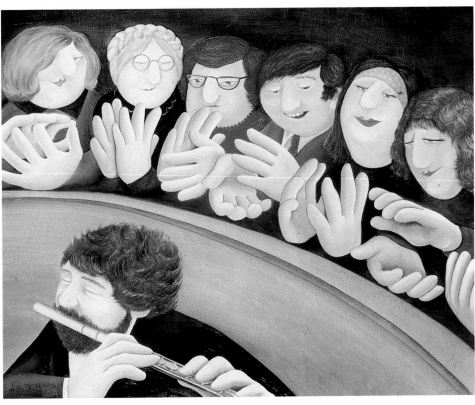

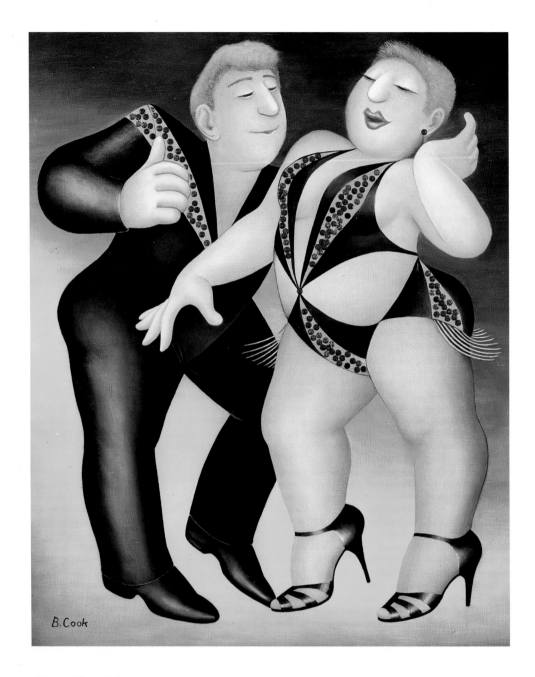

Cha Cha Cha

Some of the costumes in *Come Dancing* are so exotic that I am often tempted to reproduce them, and I decided that these ones should have stuck-on sequins for added lustre. Fringes on the dresses were fashionable again and I would have liked those in the picture to be more extravagant, but in my paintings I often have to make do with what appears instead of the sumptuous image I had hoped to capture. The popular hairstyle for this series was very short with a tiny tuft jutting out over the forehead and I rather wish I hadn't noticed this, as I laboured long to get the effect.

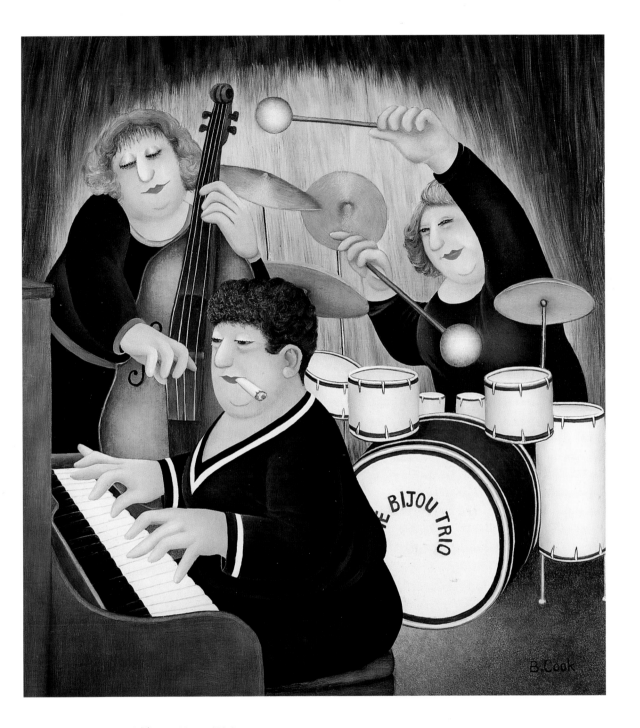

The Bijou Trio

One year the Portal Gallery in London decided on a musical theme for their Christmas show, and this was my contribution – three sturdy girls and their instruments. I like painting musicians: I often paint pianists, and I'm not too bad with the double bass either, but I now see that the drummer is having to perform on a rather tiny drumkit. She doesn't let this stand in the way of an enthusiastic rendering, though.

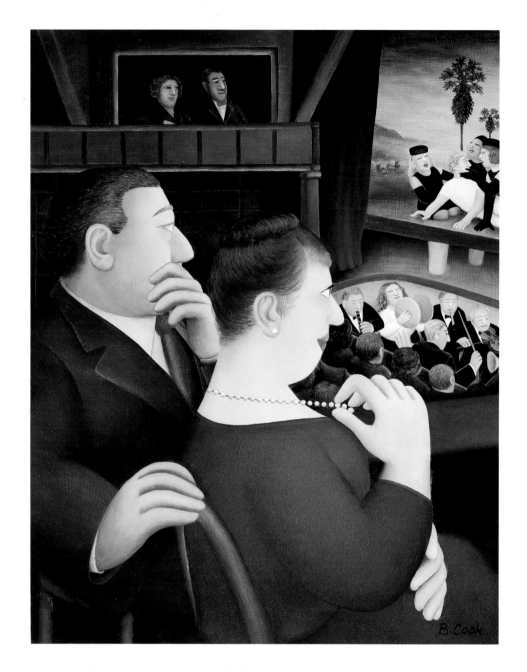

Magical Evening at Glyndebourne

This celebrates an evening at Glyndebourne, sitting in a box and watching *The Magic Flute*. There were certain difficulties to overcome here, one of them architecture. It took a long time to combine an audience, orchestra and performers without having a back view of heads as the centrepiece. In the end I rearranged the seating to enable me at least to show the profiles of the two main figures, absorbed in the wonderful performance. This was the second opera picture I painted, the first one being from a visit to Covent Garden to see *Madam Butterfly*; when I finished it I saw immediately that the members of the orchestra looked exactly like garden gnomes, and it has remained hidden from view ever since.

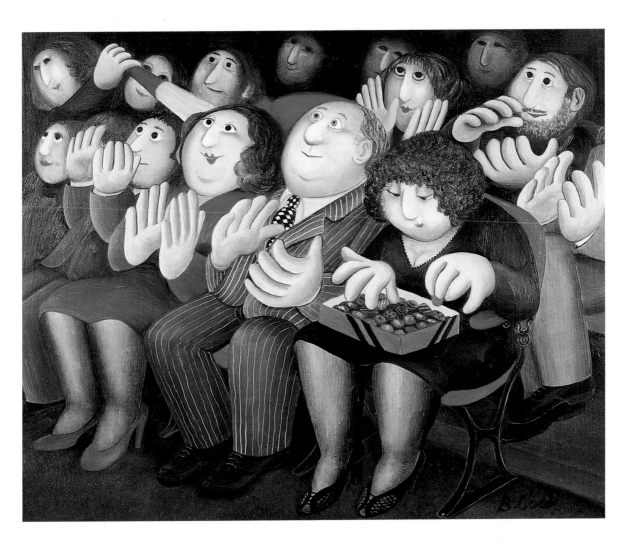

Balletomanes

I am very fond of ballet dancers, the men in particular as they sail through the air in the tightest of tights, and this is what I intended to paint here; but as you can see it turned out to be the audience. As I was trying to diet at the time, each of the chocolates is lovingly depicted, copied from one of the charts inserted in every box and saved by me for future reference. I am quite sure that this is not my last attempt at the ballet: when I do get a picture of the dancers *I* shall be the one dancing with Rudolf Nureyev.

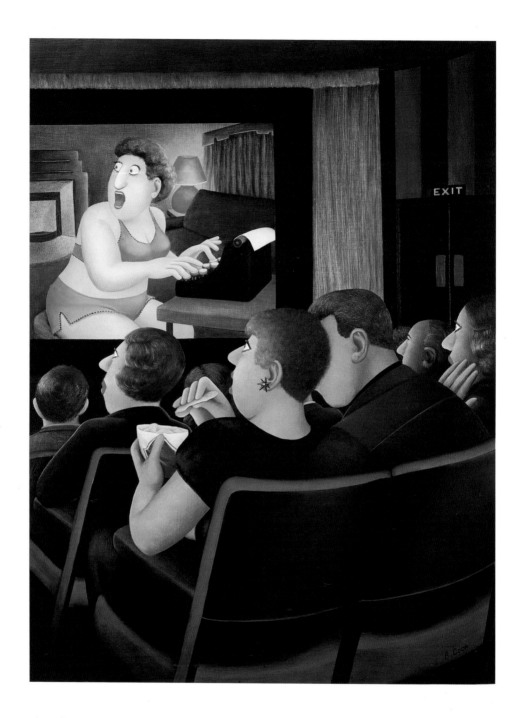

At the Cinema

When I was asked to do a poster for the British Film Institute I felt the best thing to paint would be some people engrossed in a jolly good film, and here my problems started. Some time elapsed before I could think of a scene sufficiently compelling to keep an audience spellbound. Then I remembered a story told to me years ago by a friend, a terrifying episode concerning a demand for a set of lists to be typed immediately, or severe punishment would result. The story certainly kept *me* spellbound, and with some minor adjustments it fitted the screen perfectly.

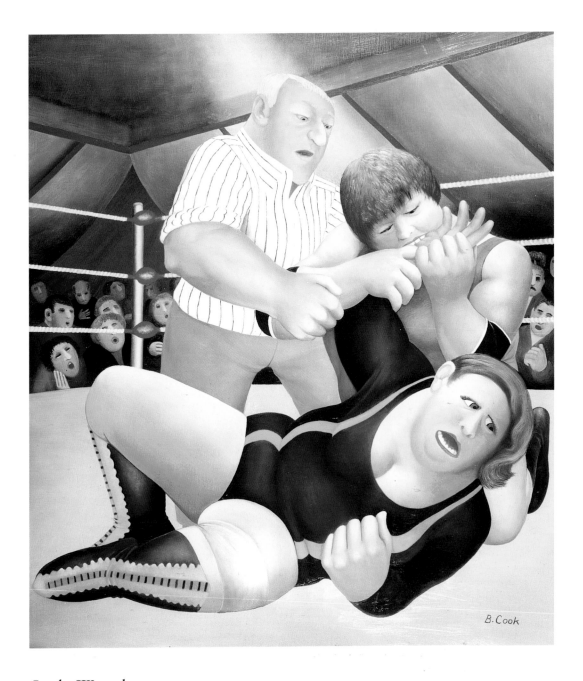

Lady Wrestlers

The first wrestling match I saw frightened me so much I left half way through. Now that I know the cries of pain do not necessarily indicate imminent death, I shout and cheer with the rest.

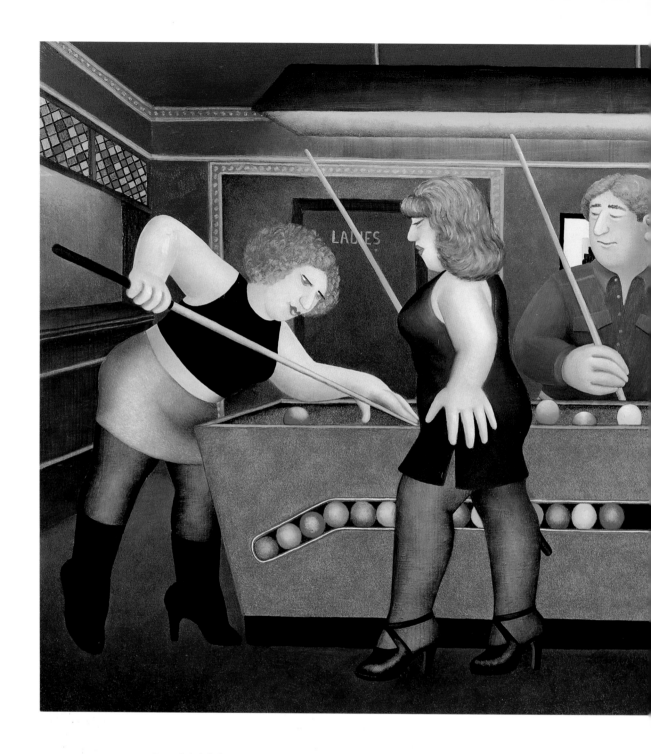

Pool Table

One day a pool table appeared in the back of a shabby pub we used to visit occasionally, and to my great pleasure three attractive girls, dressed to the nines, were enjoying a game with one of the locals. I'm always keen to paint a pool table because of the colours, and this time I had such a good view of it all. So here are the girls at their game, each holding a cue in an artistic manner.

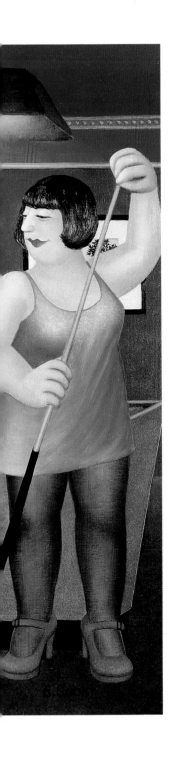

Bingo

I'm sorry to say this is not me winning the big prize, but someone sitting very close to us. I'm not sure if I shall be able to shout when I *do* win, I'm too frightened of finding out I've crossed off all the wrong numbers. It was fairly easy to draw this picture but I haven't yet managed to do one of the outside of the bingo hall, which I also like very much.

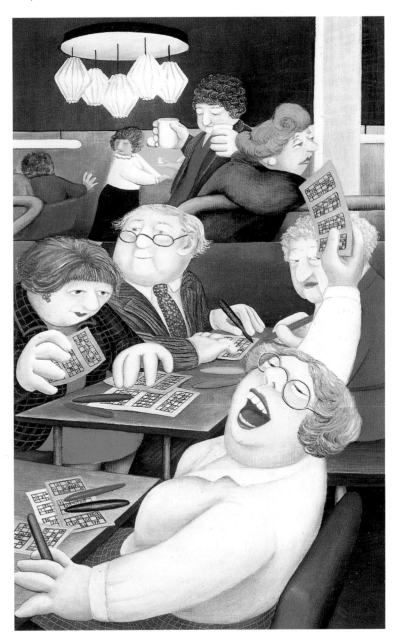

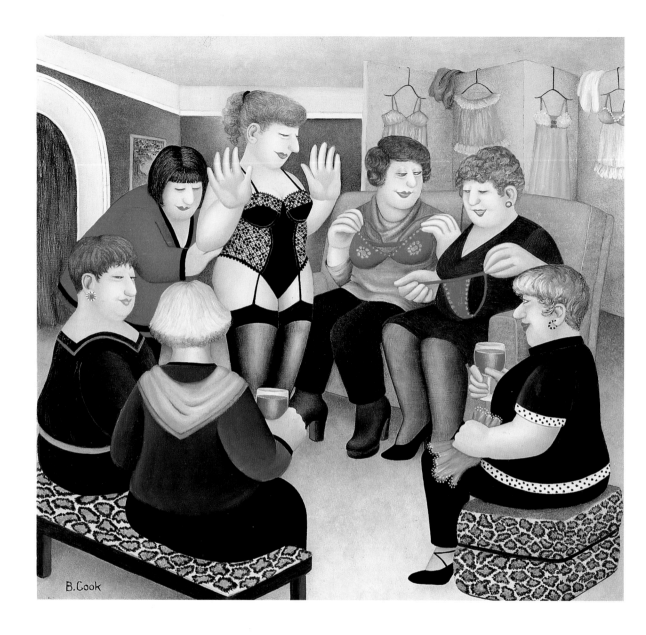

Party Girls

I haven't been to one of these parties although I've been invited. I've heard quite a lot about them and how much they are enjoyed. Are the undies hanging on the screen perhaps a trifle small compared to the size of the ladies? I expect it's just perspective.

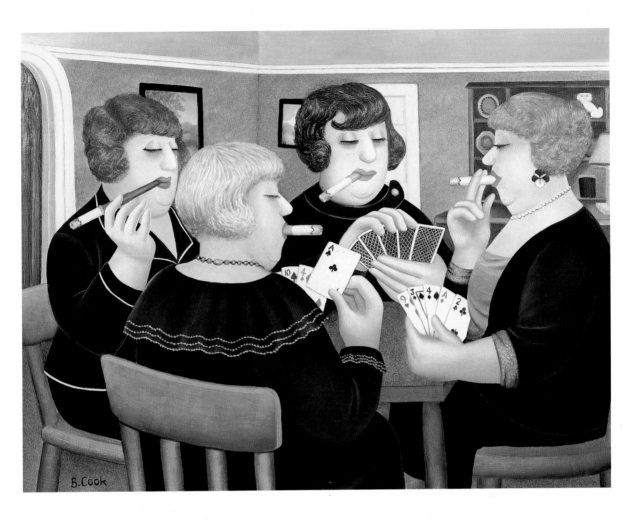

Bridge Party

These lucky ladies are each smoking a nice big cigarette. Reluctantly, I had to give up this habit a few years ago, but one troublesome day, when I really felt I'd like one, I sat down and drew this picture instead. In my room, kept handy for such occasions, is an ancient ashtray with quite a large selection of ash, old dog-ends and half-smoked cigarettes, relics of the smoking days of yore. These I use as models when I'm adding a touch of realism to a gutter or pub floor. However, these are ladies, holding cards which I hope are suitable for bridge. Actually they are the cards with the least number of spots, because I grew tired of painting them in the end. Of greater interest to me are their black dresses, which I think would look nice for an evening card party.

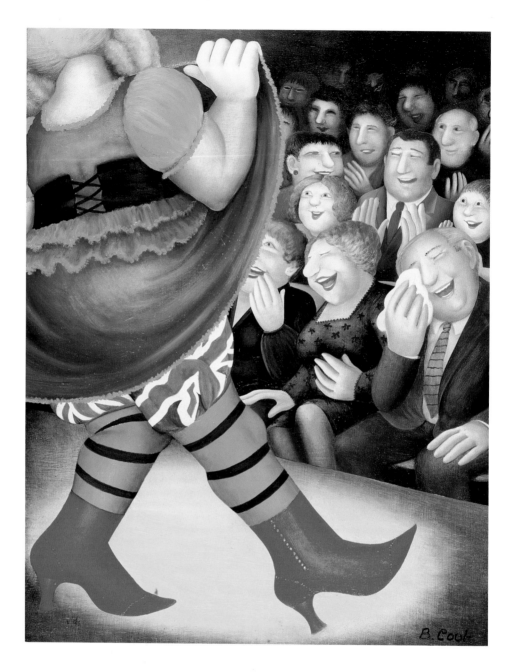

Pantomime Dame

Here is an audience thoroughly enjoying the antics of the Dame at the Christmas pantomime. It was Danny La Rue, being very funny, and he is shown from the back, with just a glimpse of knicker, so that I could paint the rows of happy faces. Putting him in the spotlight took some serious thinking on my part: I settled for a yellow circle round his feet and hope you think this gives the desired effect. I like painting audiences, as I enjoy it so much when they laugh.

Animal Kingdom

● ●

I like painting fur, so cats and dogs make many appearances
in my pictures, though usually accompanied by people. In this
section, however, the spotlight turns on the little furry friends
themselves. All the pets we have ever owned have been immor-
talised in this way, together with several wilder animals and
a horse, the only one, I think, I have ever painted.

Pig in a Wheelbarrow

Many years ago we lived in the country and kept two pigs. We both became devoted to them, and then the dreadful day came when we had to send them off to market, and we knew we'd not be keeping pigs again.

Basil Warthog

Isn't he handsome! Warthogs were great favourites of mine when we lived in Africa, but they are very shy and I mostly only saw their backsides running off into the bush as the car passed by. There was one, though, named Basil, who was kept in an enclosure; we used to visit him sometimes, and always found him happily wallowing in mud. Here he is quietly sitting in front of a splendid display of sweetcorn plants, the one and only time we managed to grow them here.

The Jaguar

On one of our visits to the zoo, for the benefit of our son who was then thirteen, he spent the whole time throwing peanuts into the air for the pigeons to catch, and completely ignored the animals. The next time, on our own, I was determined to see more of them. After leaving the orang-utans, just inside the entrance, our footsteps quickened rapidly to speed us from cage to cage so as to shelter from the wind, for it was a beastly cold day. The big cats, in their beautiful coats, weren't bothered by the weather, or us – safely behind a thick glass window. As his wonderful fur was so especially lustrous, I decided to paint the jaguar, and set him against a suitably wintry sky.

The Tiger

After the jaguar I grew bolder, and thought I'd tackle a tiger. And whilst I was at it I allowed him a stroll through Kew Gardens, where we had been the day before. So here he is, emerging from some exotic foliage we found in the greenhouse there.

Birds in St James's Park

We often have a rest in this park when we're in London, and sometimes walk through it early in the morning before starting the day's activities. There is not much park and a great deal of bird in this picture, and when it was finished I seriously wondered whether I'd ever paint another feather again. As my models were not entirely co-operative about standing together in a graceful group under a weeping willow, I made a lot of notes and then arranged them to my satisfaction when I got home.

Susie

Susie was a dear little dog that lived near the Hoe and I saw her nearly every day when we were out walking. She grew stout with the passing years and although she was still ready to run up and down the street to bark indignantly at cars, much of her time was spent slumped in the sun in the doorway of her owner's house. I liked her hairstyle so much that I photographed her one morning, and when the Portal Gallery asked for a picture for a Christmas show I decided to use this. She is in front of a bench in the park she often ran through to meet her master in the evenings.

Miro

Miro was a much loved cat, owned by Bernard Samuels when he was in charge of the Arts Centre in Plymouth. Bernard was an enthusiastic supporter of music, literature and poetry as well as art, and he helped many people, including myself, to enter the art world. In this heady atmosphere Miro took on the role of cultural ambassador and graciously greeted visitors at the door. He considered he was entitled to only the very best in food – sole cooked in butter and chicken breasts were his favourite. In the painting he is surrounded by delicate china bowls and impatiently waits for them to be filled.

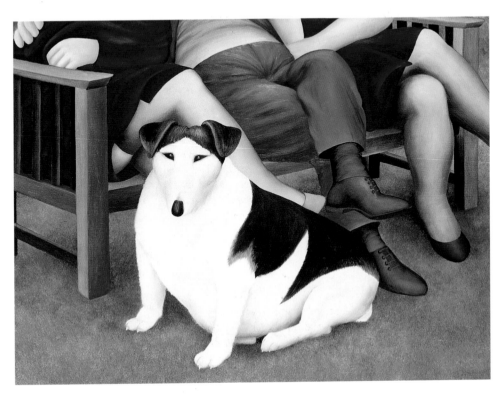

Dogs

I quite often paint dogs. We've had a few ourselves and they always have their portraits done. Minnie the terrier and Lottie the dachshund were ours but are now, unfortunately, only with us in their pictures. Gazing at himself in the mirror we have black Bertie, a rather naughty dog who belonged to a friend. He was obsessed by balls and would catch and destroy any he could get his teeth into, no matter who was holding or playing with them. This became rather costly, and he was finally found a 'good home'. The two little Pomeranians were sitting in their basket in an antique shop, and I asked if I could take a photo. I painted them from this to give to the friend who'd been with us at the time.

Taurus

The signs of the zodiac were the theme for another Christmas show and I chose John's, which is Taurus. He is rather handsome, isn't he, against a celestial background?

Virgo

This is my birth sign and when I needed something suitable for her to ride I chose a zebra, the animal who wears my favourite colour combination – black and white stripes.

Tally Ho

Tally ho indeed! This was painted such a long time ago I can't now remember why. The rider is mounted on a royal horse which I saw in a newspaper photograph, and her outfit is very smart, right down to the string gloves. The horse has a fine row of teeth and a wild eye, possibly at having to carry this rather large and superior rider.

Flights of Fancy

● ●

We were planning to call this section Religion and the Supernatural
– a surprising number of saintly paintings have appeared over the
years, and fairies galore. But when Madame Cyn was looking for
a home, together with some very scantily dressed young ladies, the
title had to be changed, and a new one was suggested by Elvis's
means of transport to the heavenly choir.

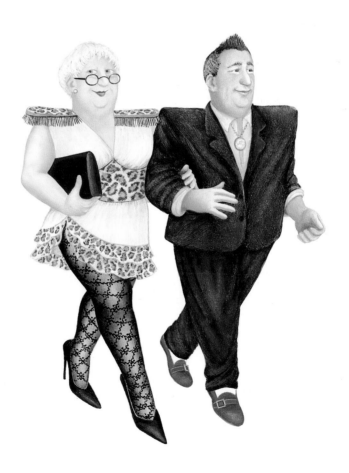

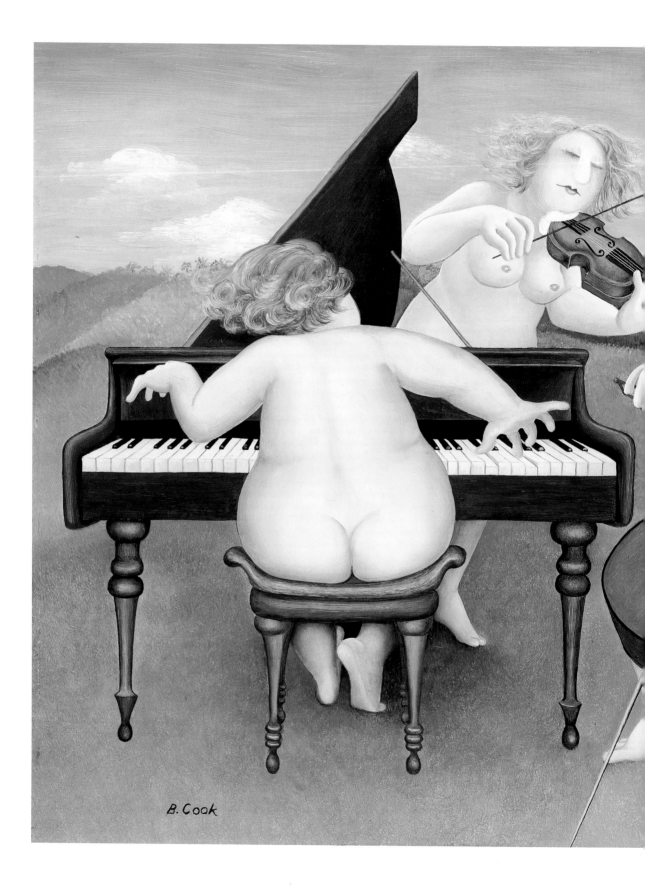

B. Cook

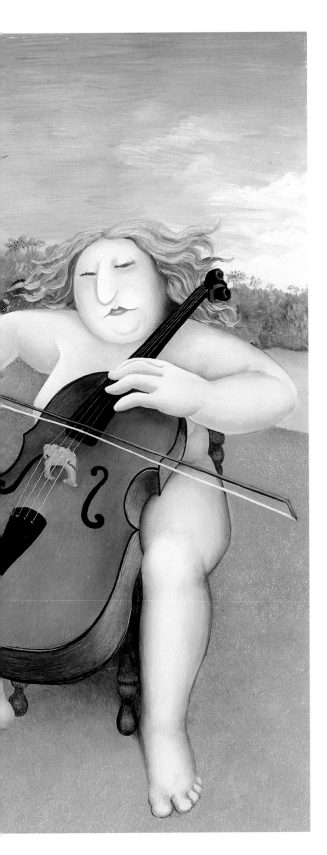

Country Music

How absorbed in their music these girls are, playing away in the serene summer countryside. I rather like musical instruments, and especially the hands which play them. I learned how a cellist would sit, and the correct place for the fingers, from a newspaper cutting I have of Paul Tortelier. The violin I found in a book from the lending library, a most useful place for all sorts of things I suddenly decide I need to draw. But the pianiste may not be on the same musical wave-length as the other two, for she is taken from a drawing I did of a jazz player energetically attacking a honky-tonk piano, which I changed to something rather more upmarket for this scene. A Steinway perhaps.

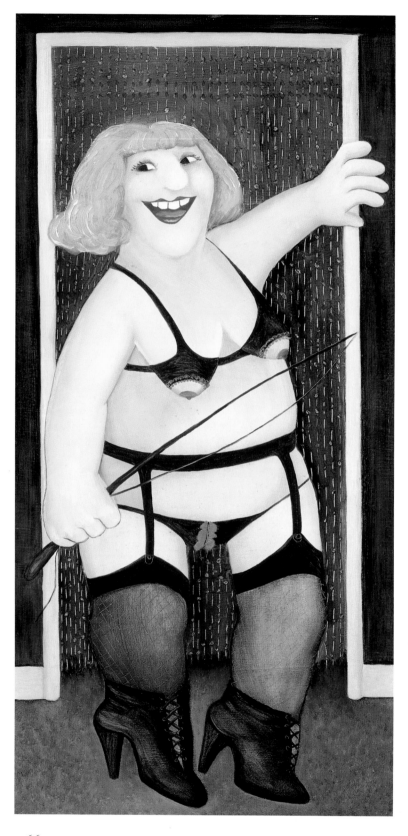

Anyone for a Whipping?

This picture was specially commissioned by John for his birthday. He said he wanted a great big nude – with very naughty underwear, really outrageous. And for good measure I added the whip and placed her against a bead curtain I'm very fond of. Having left myself short of room, she had to have little weeny legs so I could give her some nice black high-heeled boots.

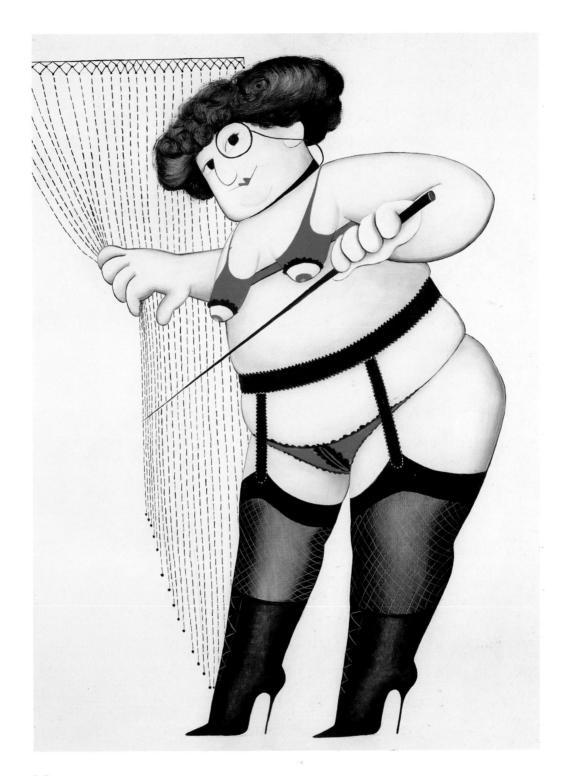

Next!

I was asked to do a poster for an exhibition and this appeared. Other arrangements for a more suitable poster were hastily made and John kept the painting!

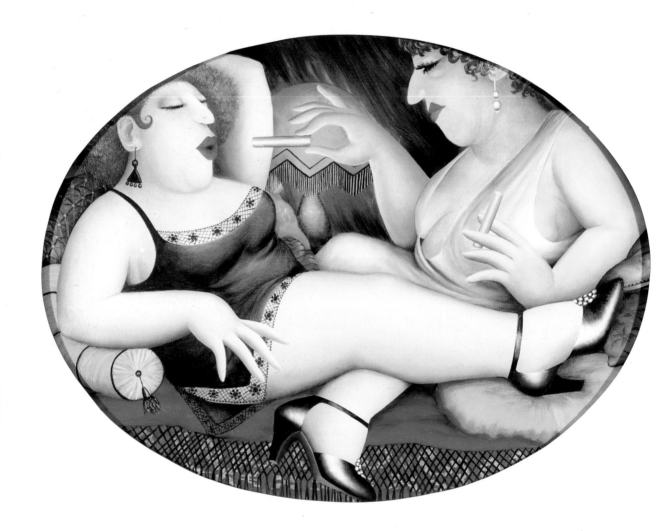

Sultry Afternoon

I think these two may have been to the underwear shops in Soho. We found an ornate oval frame in Bermondsey Market, and whilst lying on the bed in our hotel one afternoon I started to devise a picture to fit it. Later that day I saw a girl in a pub lean forward and place a cigarette in her friend's mouth, and this little incident I added to the sketches already made.

Through the Keyhole

I don't know what is going on here, though someone suggested that it might be a glimpse of a department store during the sales. It is the result of a suggestion that I should paint a keyhole picture, and a very large keyhole it turned out to be. When I had finished the painting, and puzzled for some time over what all these people might be doing, a further suggestion was made – that I might like to paint the butler watching them from the other side of the door.

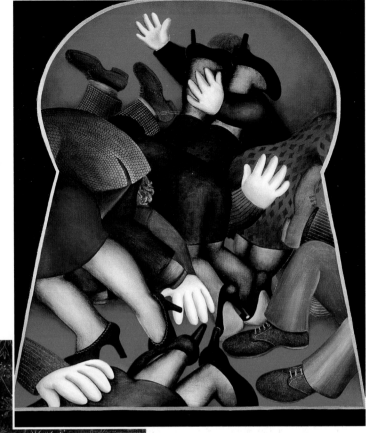

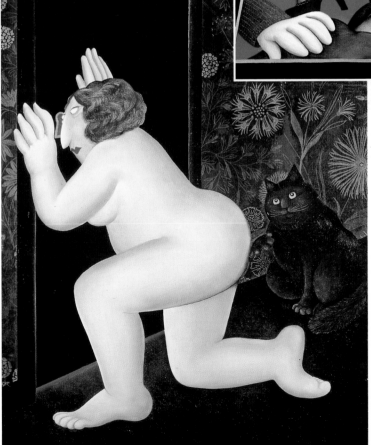

The Butler

And this is the butler.

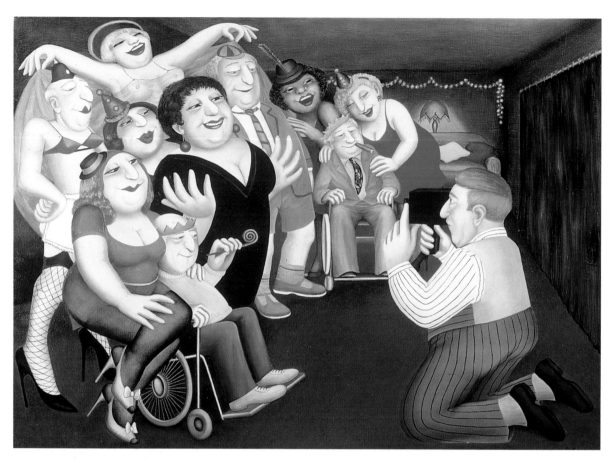

Personal Services 1

I didn't attend this party but it must have been quite something! I had been following Madame Cyn's career with great interest and thoroughly enjoyed the book about her, so I was most pleased to be asked to paint two pictures for the film. In this one they are having a photograph taken at the start of frivolities.

Personal Services 2

And here is someone with a problem.

A Fine Figure

This painting was for a proverbs exhibition at the Portal Gallery: I chose to do 'No Man is a Hero to his Valet'. To illustrate this I decided to put the gentleman into a corset, which I had to imagine, for I am relieved to tell you that no man I know wears one. I had the same problem with the sock-suspenders but after I had completed this painting a fan kindly sent me a pair, in case I ever needed to paint them again. I think I have made quite a good job of his combinations but have not been nearly so successful with his feet. They are quite worrying, aren't they?

Wedding Photograph

For some time I had been planning to paint a really fat family and when John showed me a wedding photo in the local paper I thought perhaps I could base it on this. In my efforts I fear I have rather distorted matters, and I've been told since that this family are doing *everything* that a photographer dreads.

Vultures

This is one of the first big pictures I painted. Intended as a large, exotic countryside scene, it was only after painting the sky and tree that I realised how difficult it was going to be. After some unsuccessful attempts at filling in the lower half with luxuriant plants and vegetation I gave in and used *Come Dancing*. One man is very cleverly managing to dance with no legs, but I overlooked this in view of the fact that I had actually succeeded in covering such a large expanse with paint.

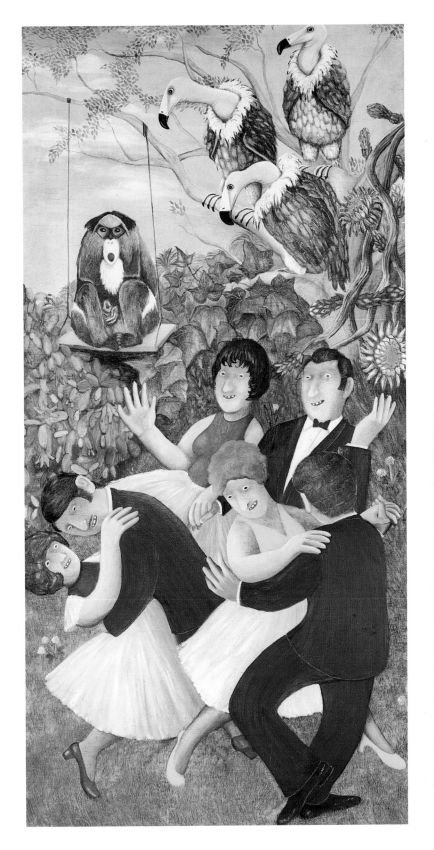

Sunflower

I really don't know what to say about this except that I have always liked sunflowers.

Come Dancing

I'm always excited when I start painting, it seems magical when a picture appears from a blank board. The first pig's face caused me such a fit of hysteria that John had to help me back to the paints. I've always liked pigs since we kept them many years ago, and used a picture book belonging to my granddaughter Alexa to find out how their trotters should be. This is another picture inspired by *Come Dancing*: I love watching the formation teams, when they all come in together perfectly in time.

Three for a Quango

Another proverb for a Portal Gallery Christmas show. Having discarded all those likely to give me problems, I chose the easiest – 'It Takes Two to Tango'. But I had been doing rather a lot of dancing pictures and was trying to wean myself off them, so to make it a little different I decided I would just use men. I started off with the two on the right, and then found another I'd drawn so I added him too. Then I had to alter the proverb to fit them, so it became 'It Takes Two to Tango, and Three for a Quango'. Fortunately I managed to stop there. The background is made from strips torn from a high-class ladies' magazine, carefully pasted and positioned – a very satisfying way to while away a few hours.

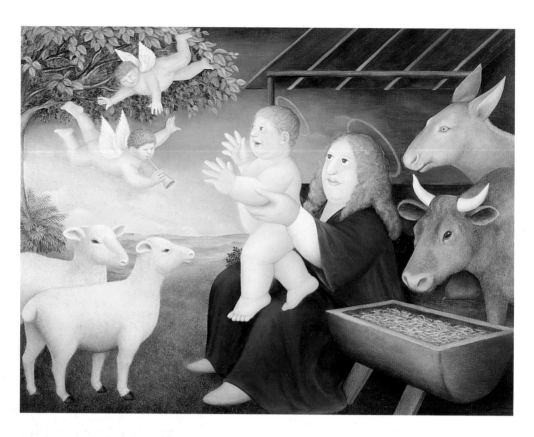

Virgin and Child

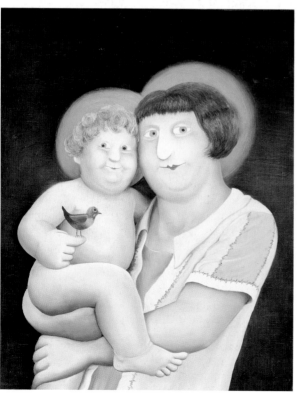

A friend asked me if I could paint a nativity scene to celebrate an anniversary and this is what appeared. It is based on a photograph I have of my mother firmly clasping to her hip an enormous, sprawling baby – me. The size of the child she is trying to hold up and the clothes have always given this photo great appeal to me. A similar one of my husband proudly clasped to his mother's bosom shows a baby of rather more usual proportions, and easier to hold in a steady pose for the photographer. A few more details were needed to make a suitable painting, so I added some golden curls, a roguish smile and a bluebird. I like nativity scenes and old religious paintings and look for them in galleries, which is where I found out how to do the haloes.

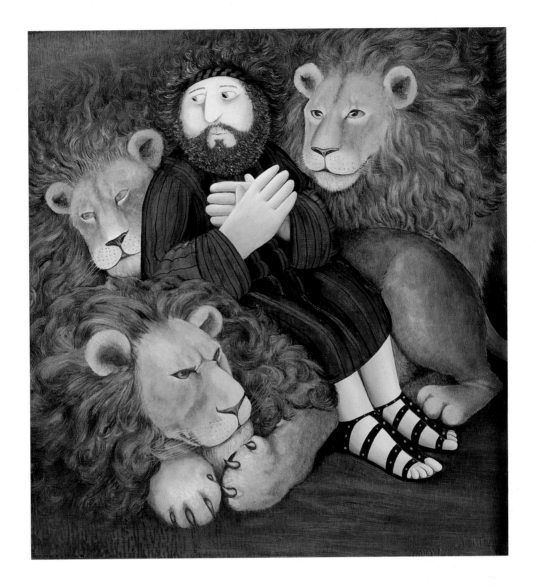

Hair

My intention was to tease out both Daniel's and the lions' hair so it would fill the top half of the painting completely, and I nearly succeeded, but I find that things rarely turn out as intended. Usually the final appearance of the paintings comes as a grave disappointment, but I know that if I keep them for a while I will come to accept them for what they are, and feel glad I was able to paint them at all.

Nativity

(opposite page, top)

There's a nice big baby Jesus in this painting too, with a rather more delicate halo.
I read once that blue is the most religious colour for the Virgin Mary so here she
sits in a sumptuous blue gown.

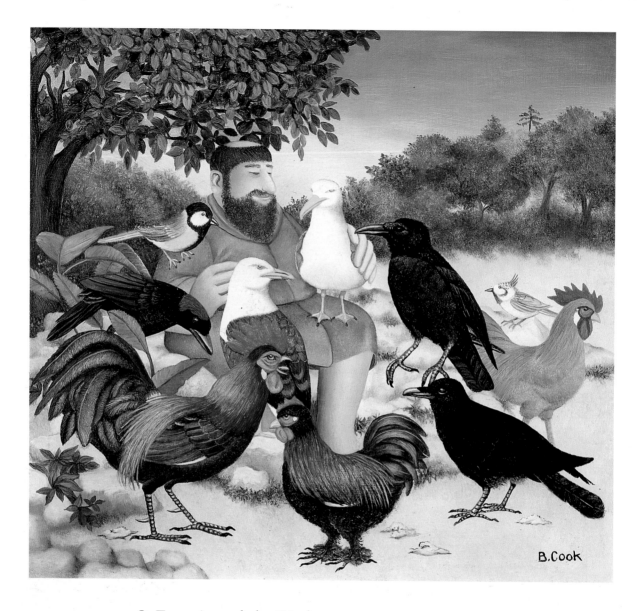

St Francis and the Birds

This picture was painted jointly by John and myself. I did the main part and he added the realistic touches, beneath the birds' tails, afterwards. Francis was chosen during a discussion about what sort of religious subject I should do, not least because I like painting birds (sometimes) and animals. I had plenty of models for the crows and seagulls up on the Downs, and the chickens were added for their lovely colours. The little one in front isn't wearing fluffy slippers – I've tried to give her feathered legs.

The Peaceable Kingdom

A friend gave us a print of the lovely Edward Hicks painting of this subject. It used to hang just outside a doorway, where I could see it every evening as I sat on the sofa, and I liked it so much that one day I decided to paint my own version. I'm very fond of warthogs and this is the one I sponsored at the London Zoo. The lion came from an old children's book of Bible stories, and since I like doing hair he got plenty. The two little cherubs are there to give it a religious tone.

Jonah and the Whale

I painted this a long time ago for an exhibition, and was very pleased to see it again recently when it appeared in the Alexander Gallery. It seemed to me to be rather good – magical, in fact, for Jonah emerges from the whale's mouth in bone-dry clothing. When painting a religious picture I use my book of children's Bible stories for tips on appropriate attire in those days. It's a Victorian book, and my only regret is that it is not twice the size, with many more stories.

Noah's Ark

One year the Portal Gallery asked for a Noah's Ark picture for their Christmas show, and when I realised that this would give me a chance to show animals, which I like painting, coming down from the top of a mountain, I became enthusiastic, for it seemed such a good way to display them. How easy it all sounded, and how difficult it turned out to be, with absolutely no co-operation from Noah's wife. She is meant to be emerging gracefully from a leafy glade but looks more as though she's wrestling with the undergrowth.

B. Cook

Fairy Dell

I'm fond of fairies and this is the first picture I ever painted of them. I used plants in the garden for a background, inserting the marrows for the audience to sit on while they watch Poppy dancing. It was only when I'd finished that I realised fairy Dandelion had come out without her knickers.

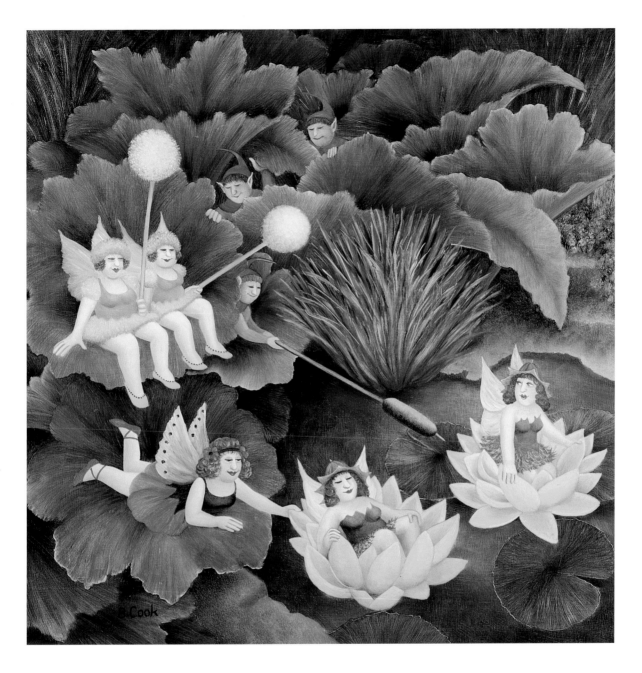

Fairies and Pixies

And here is a fairy picture with the big green leaves and water lilies from our pond. I blame Mabel Lucie Atwell for these paintings – her desk has been in our house for some years now and it must be sending out vibrations.

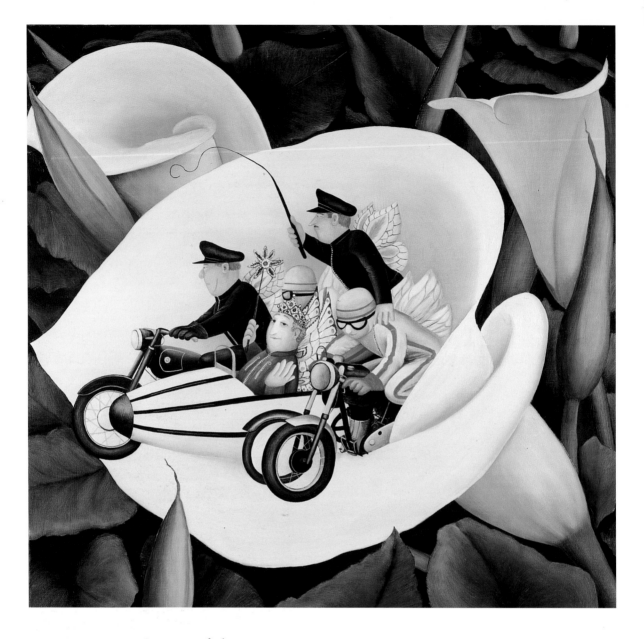

Queen of the Fairies

My flower fairies, and there have been quite a few, are usually sturdy girls dressed in petals busily engaged in appropriate fairy business. A huge white lily growing in the garden gave me the idea for this picture. As a change the fairies would be modern, dress in leather clothes and ride bikes – something I wish I had enough nerve to do myself. In a picture of antique motorbikes I found a smart black and white sidecar, which was just the right thing for a Fairy Queen to ride in in comfort. Now they can speed off by wheel and wing to a very important engagement in the vegetable garden.

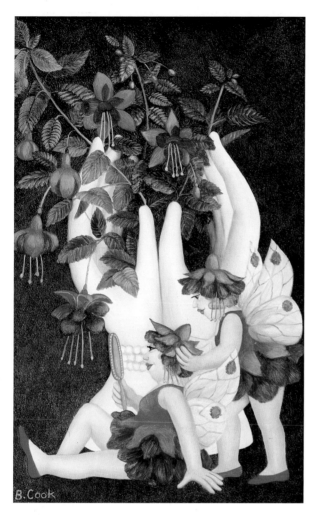

Fuchsia Fairies

My son found this handsome firescreen for me at a boot sale. I decided it was an ideal size for a fairy picture for my granddaughter Sophie, and as she is very fond of the pair-of-hands vase we'd bought from a market stall I used it to hold the fuchsias from the garden. I don't often paint flowers – it's mostly great big green leaves that I like – but these aren't bad, are they?

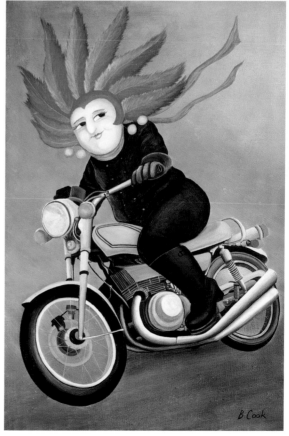

Brian on a Motorbike

Brian and I would really like to have a customised motor bike. He will drive it very carefully at 30 m.p.h. and I will sit in the side-car, both dressed from head to toe in all the right gear. We have discussed this many times, our clothes growing ever more elaborate and the bike more fantastic. However, this small painting I did for Brian is probably the nearest we'll get to it.

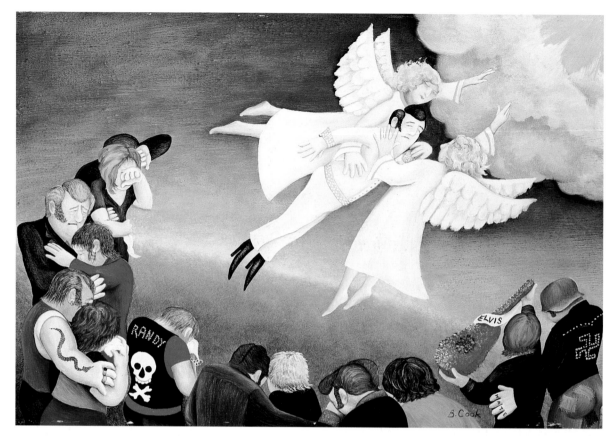

Goodbye Elvis

I used to have a picture of a Victorian deathbed
scene, with all the family mournfully sitting round
the bedside, and I was working on a pair to go with
it: the deceased man up in heaven looking down on
his grief-stricken relations. Then Elvis died and I
found myself painting him into the picture. Elvis was
one of my heroes and I was very sad when he died,
but also astonished at the sight of all those ageing
rockers in their leathers sobbing at the memorial
services; I felt they'd finish the picture off nicely.

Two Greek Gods

I had been gazing in wonder at a small cutting from
the *Sunday Times*, showing a line-up of muscle men
for a Mr Universe contest, and suddenly decided to
give all their bodies to friends. As I had to use a
magnifying glass (it was a *very* small cutting) I soon
realised I might be ten years working on this master-
piece and settled for the only two I had managed to
draw – Lionel and Eric.

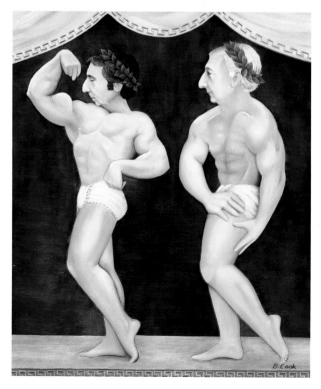

286

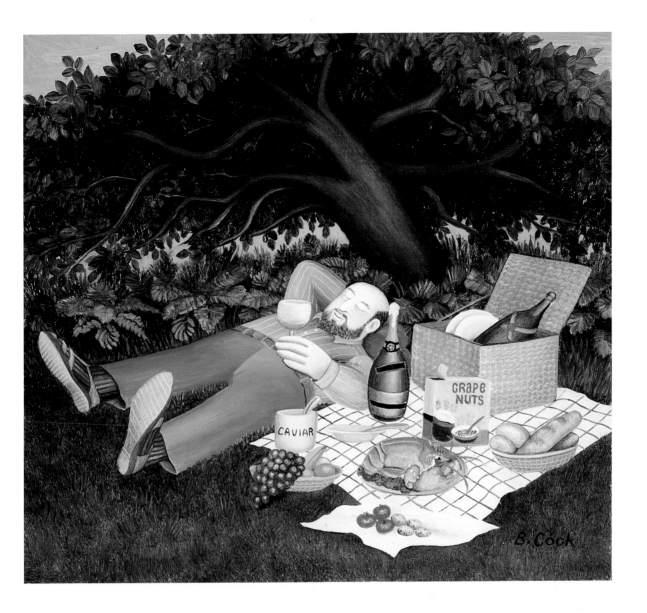

A Picnic

Rather a grand picnic, a feast fit for a king. This isn't a king asleep beside it, however, but Sir Clement Freud, having forty winks in the shade of a tree. I listened to a talk he gave on the radio one afternoon and he happened to mention how difficult it was to buy Grape Nuts. I love these little morsels and I heartily agreed with him – I had been forced to write to the manufacturers complaining that I couldn't find them any more. I'm glad to say that they are readily available again now, and I've painted him a nice big box of them to go with all the other goodies laid out on the cloth.

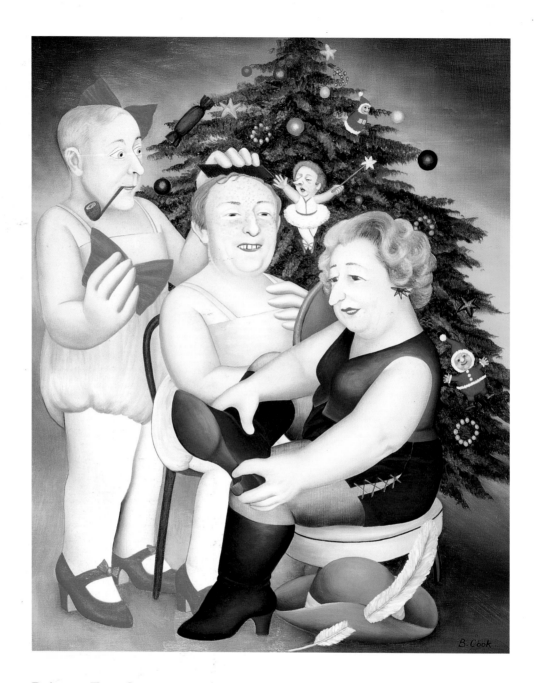

Private Eye Cover

I was pleased to be asked to do this cover for *Private Eye*, since I have enjoyed reading the magazine for many years. Most of all I like the cartoons, and one, of a chef mooning to a couple who dared to complain about the food, kept me laughing for about three days. It might be rather alarming for people to see an old lady like me permanently grinning and cackling to herself in the shops, but I expect at my age it is put down to senility. As you can see, this picture was painted some years ago, when these people were in the public eye, and for their faces I collected drawings and photographs from the newspapers. They are getting ready for a pantomime.

Queen Dancing

I am a great admirer of the Queen
and thought it would be nice to do a
special Jubilee picture of the Royal
Family sitting in one of the municipal
shelters on the Hoe. I collected all the
Jubilee pictures from the papers, but
just couldn't get the composition
right. Then I saw an old engraving of
Elizabeth I dancing with her courtiers
and being swept into the air by one of
them. It was just what I needed. I felt
the picture warranted a really *royal*
frame, and made this by sticking plas-
tic flowers onto the wood and spray-
ing it silver; or rather, Teresa, John
and Alexa did the sticking.

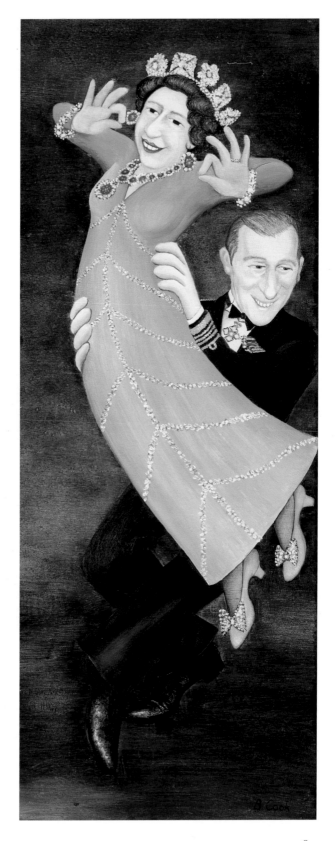

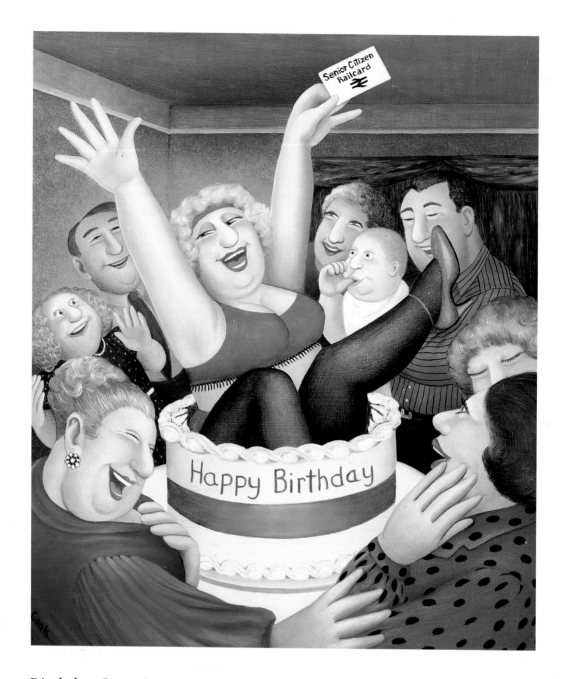

Birthday Surprises

Grandma's railcard has certainly enabled her to give a very big surprise indeed to the happy family. I really enjoyed doing this painting for British Rail, since I have one of these cards myself, and the suggestion that she should emerge from a cake appealed to me enormously. The grandmothers I know are very trendy these days and buy their clothes, like me, in the teenage departments. It's not easy to squeeze the mature figure into a tiny teenage size, I can tell you. But this particular granny is wearing a comfortable green two-piece with shoes to match, designed by me as suitable gear for the fun-loving older woman – travelling by cake.

Index

 The Sheffield College

Hillsborough LRC